POP ART

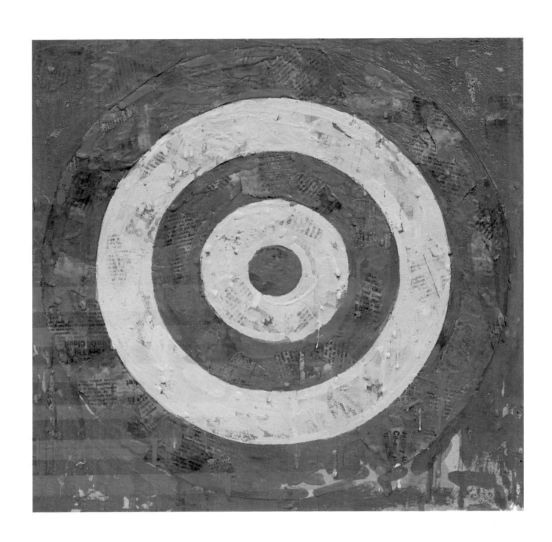

Tilman Osterwold

POP ART

TASCHEN

KÖLN LONDON MADRID NEW YORK PARIS TOKYO

Page 2:
Jasper Johns
Target, 1974
Encaustic and mixed media on canvas,
40.6 x 40.6 cm
Collection Ludwig, Aachen

© 1999 Benedikt Taschen Verlag GmbH
Hohenzollernring 53, D–50672 Köln
© Succession Marcel Duchamp / VG Bild-Kunst, Bonn 1999
© The Andy Warhol Foundation for the Visual Arts 1999
© for illustrations, unless by the artists:
1999 VG Bild-Kunst, Bonn: Arman, Artschwager, Blake, Caulfield, Erro, Fahlström,
Grooms, Hains, Hamilton, Hausmann, Johns, Kanovitz, Léger, Lichtenstein, Lindner,
Marisol, Morris, Paolozzi, Ramos, Rauschenberg, Ray, Raysse, Rivers, Rosenquist,
Rotella, de Saint-Phalle, Schwitters, Segal, Tilson, Vostell, Wesselmann
English translation: Lain Galbraith
Cover design: Angelika Taschen, Cologne

Printed in South Korea
ISBN 3–8228–7021–8

Contents

Pop Art – A Movement in the Sixties

What is Pop? A play on words, a lifestyle, a particular generation, a new understanding of art? And what is Pop Art – the term for an influential cultural movement of the sixties?

Pop Art does not describe a style; it is much rather a collective term for artistic phenomena in which the sense of being in a particular era found its concrete expression. When we apply the epithet "Pop" to art, we tend to associate with it various superficial aspects of society. Pop Art performs a balancing act between the more euphoric, progress-orientated prospects of the epoch on the one hand, and its pessimistic, catastrophic outlook on the other. The increasing commercialization which permeates our social reality has reduced notions of value such as "the good, the true and the beautiful" to inflationary husks. The rules of civilization mould our images of people and things, of nature and technology. Pop is a buzzword. It is cheerful, ironic and critical, quick to respond to the slogans of the mass media, whose stories make history, whose aesthetics shape the paintings and our image of the era, and whose clichéd "models" determine our behaviour.

Pop culture and lifestyle became closely intertwined in the sixties. Pop characterized those particular vibrations of a new epoch which were making inroads into every sphere of public and private life – a prevailing tone reflected programmatically in contemporary art. Never before in the history of art, except perhaps partially in the decadent formal exuberance of the twenties, had there been such an obvious and publicly accessible overlap, such a universally visible proximity, between life and art. The subject matter, forms and media of Pop Art reveal the essential characteristics of a cultural atmosphere and way of life we associate with the sixties.

Pop is entirely a Western cultural phenomenon, born under capitalist, technological conditions in an industrial society. Its programmatic epicentre was America. As a result, the cultures of the entire Western world have become Americanized, a consequence felt particularly strongly by the Europeans. Pop Art analyses this state of affairs and provides a visual seismogram of our societies' achievements in industry and fashion, but also of their absurdities; it traces the limits of a mass media society bursting out at the seams. Pop Art thrives in big cities. The cities of its birth were New York and London, the new art centres of the Western world. Later on, as Pop Art spread in the sixties, other, secondary centres sprang up in Europe. But artists in the communist countries of Eastern Europe have only picked up the sparks and residual traces of this movement.

In order to understand the significance of these cultural changes, and the impulses which were generated by this new era in art, we shall need to look at

several factors of far-reaching importance which indicate the complexity of the changes experienced in art, society and the life of the individual. The growing political and economic stability of the post-war era led to a reappreciation of what is normally referred to as "the people" or "the popular." An English word for the people as a mass is the "populace"; the "popular" thus has its roots in the traditions and habits of the people. It is what is loved by the masses. This points us to the origins of the term "Pop Art."

Research undertaken by sociologists into consumer habits and mass behaviour was put to use in marketing systems. Producers could now no longer successfully exploit the customer's needs by super-imposing some sales strategy of their own design. In order to stake their claims, they had to adapt their production to the attitudes and fashionable whims of the masses. The effect of this convergence of consumer and retail interests was a massive restructuring of demand for consumer goods and mass-media programmes, which, in turn, had its effect on individual behaviour and personal relationships. People felt a new licence to like Kitsch, to collect all kinds of knick-knacks, to read comics, to eat hot-dogs and drink Coca-Cola. Academics in gym-shoes and leather-jackets produced scientific treatises on the trifles of everyday life. Professors, university lecturers and adult education teachers, encouraged by progressive education policy, soon integrated these studies into their curricula. The classification of historical monuments was extended to include factories, industrial buildings and housing estates. The commonplace, the trivia of everyday life, soon became the object of common interest, breaking through all class barriers to become socially acceptable and respectable. It was through this process that a gradual convergence of "high" and "low" culture took place. This naturally led to a fundamental reappraisal of received ideas of art and culture. The "elitist" art of the subjectivistic Abstract Expressionists found itself confronted with demands for a broader-based culture.

The subject matter of Pop Art is rooted in everyday life; it mirrors contemporary reality and provokes and reflects upon cultural change. The readiness of a new generation to recognize the *Sturm und Drang* tones of the "underground" as the powerful force determining culture and revolutionizing art and style was linked to the fact that it expressed itself in the language of that generation. Unorthodox, provocative behaviour, shock-tactics, breaking taboos and scoffing at prudery were the hallmarks of this counter-culture. A process had been set in motion whereby hitherto existing values in human relationships were being overturned and traditional social roles called into question. The "cultural revolution" promoted anti-authoritarian education, women's liberation, new career structures and a freer approach to sexuality. Pin-up girls and various magazines (Playboy) of a dubious nature were brought out into the open. A new system of education emerged in the form of underground magazines, fan magazines, posters, placards and leaflets.

The "beatnik" movement of the fifties was succeeded by the "hippies". The writer Allen Ginsberg now exercised a considerable influence on sections of a younger generation intent on overthrowing established cultural values, social hierarchies and moral patronage. In the fifties, Elvis Presley and James Dean had become the idols of a youth culture whose aim was (sexual) liberation and emancipation from the constraints of a petty-bourgeois star cult which was subordinated to the clichés of the Hollywood movie industry. This revolt was taking place in a society characterized by excess, affluence and the easy availability of people and things. It led both to radical changes in viewing habits and behaviour, and to a new understanding of objects and art.

The politicization of youth and criticism of the capitalist system – especially on the Left – was accompanied by the introduction into the debate of various "alternative" ideas about life, culture and society. Progressive methods of thinking brought forth provocative conceptions of lifestyle, which, in turn, led to new modes of expression and new fashions which became unusually widely accepted. It was not as absurd as it seemed when artists, critics, teachers and professors surrounded themselves with the trivia of popular culture and filled their flats with pseudo-ethnic art and nostalgia, with souvenirs, Kitsch and advertising symbols, indulging in banalities and succumbing to comics, science-fiction, trashy novels and television addiction.

This positive reappraisal of commercial and popular culture occurred at several levels. Kitsch, souvenirs and the imagery of the mass media, consumer goods and packaging industries not only became the subjects of art and research, but were also collected by museums. Historical drama was now set among the banalities of everyday life, its thematic material was extracted from its historical context; it was thus freed of conventional frames of reference and presented anew. Fleeing the haste of life around them, young people sought orgiastic, sensual self-fulfilment in various forms of communal living. The entertainment industry was now thriving on Pop music. In the sixties, the younger generation's sense of identity and reality, their longings, "highs" and feeling of potency found expression in the texts and music of the Beatles and the Rolling Stones. Artists like Peter Blake, Richard Hamilton and Andy Warhol designed LP covers for pop groups – Blake and Hamilton for the Beatles, and Warhol for Velvet Underground. The mass media encouraged an internationalization of styles and forms of expression, making every symbol and art universally accessible. The increasing entry of trivial subject matter into art and the intense interest shown by artists for the trivial led to more and more people wanting to produce art themselves. This tendency was encouraged by misleading and widely circulated slogans such as "art is life" and "everyone is an artist" (Beuys and Warhol). Such views were also popularized through the curricula of various art colleges. Museums and galleries opened their doors to the commonplace and trivial in intermedial and interdisciplinary exhibitions, and the traditional structures of museums were called into question. For, it was argued, the reversal of values and questioning of hierarchies, the breaking down of barriers between art and life, between art and triviality, also necessitated a critical revison of received modes of collection, organization and presentation in museums of art.

An earlier art movement around Robert Rauschenberg and Jasper Johns had countered the subjectivism and obsessive cult of self-realization in Abstract Expressionism and Action Painting with a new objectivity (a process not dissimilar to that whereby Neue Sachlichkeit had replaced German Expressionsim). Pop Art rejected the inner restlessness of the expressive mode in favour of intellectual clarity and conceptual order. Pop artists reacted away from personal language, replacing it with impersonal representation. And they responded to the painting of subjective, psychosomatic mood with objective reflections of contingent reality which they saw as symbols of life as it was lived. They repudiated what they saw as a spontaneous and haphazard intermingling of colour and form and replaced it with the clarity of coherent compositions which referred the viewer to levels of meaning in form and content. The dematerialization of the pictorial image as a vehicle for mentally engrossed, deeply contemplative expression or inspiration was now succeeded by an interest in its material aspects – themselves seen as both the content and means

of representation. Pop Art counters abstraction with realism, the emotional with the intellectual, and spontaneity with conceptual strategy.

The intellectual, objectivistic components of Pop Art incorporated a quality which at that time was termed the "social relevance" of art. (This concept regrettably led interpreters in the late sixties to the mistaken conclusion that introverted art was socially insignificant and therefore irrelevant.) Pop artists themselves have emphatically professed depersonalization and anonymity in the production of art, including their own, and have theoretically substantiated their definitions of the role of the artist in mass society as objective rather than subjective. The public reaction to Pop Art had at first been hesitant, and only individual representatives of the art establishment (Lawrence Alloway, Henry Geldzahler, Richard Bellamy, Leo Castelli, Ivan Karp and others) had been prepared to make the effort to understand it. It now became essential to develop a new critical apparatus, if the mirror Pop Art held up to contemporary life was to be made comprehensible. One difficulty resided in explaining that there was a subjective stance inherent even in the commitment to objectivity, in the artistic expression of intellectual processes. Even the use of chance, the apparently arbitrary presentation of everyday symbols, demanded a personal reaction. And even selection or definition was an expression of will. Thus chance had become an integral component of Action Painting, while action as an element of art provided the initial detonation for an innovation which exploded previous conventions – the Happening. This was the theatrical use of images, colours, space, objects, people, action and art in a kind of performance. The Happening was a parallel development to the use of the everyday images of Pop Art in painting, sculpture, music, film, photography and literature. At the same time, however, many Pop paintings were highly personal: Jasper Johns and Robert Rasuchenberg have used painting with almost tachist or impressionistic features to smudge and dissect trivial images; in doing so they take figurative elements and blot them out, analysing, restructuring and drawing them in such a way as to make them almost abstract.

Any picture of the artistic character of this period would remain incomplete if it were not made clear that the roots of Pop Art are to be found in the fifties. Moreover, it is necessary to relativize certain aspects of this picture: intellectuality and objectivization also epitomize a number of art movements of an entirely different nature whose development ran parallel to that of Pop Art: Colour-field painting, Hard Edge painting and Minimal Art appear in both content and formal technique to have sprung from worlds quite distant from that of Pop Art. However, their resolute formal clarity, the theoretical objectivization of their means of expression, their concentration at every level of production on the desired effect and the conceptual formulation of their intention can all be seen as the products of a common generation and historical period. Artists like Robert Morris, George Brecht and, to a certain extent, also Joseph Kosuth epitomize the spiritual conjunction of Pop Art, Minimal Art and Conceptual Art – and their proximity to the Happening. Andy Warhol and Frank Stella created their first, challenging pictures at the same time; both were infused with that revolutionary power of their epoch, which was to emancipate form and content. If we examine the Pop Art scene in greater detail, we shall find not only variants in subject matter and technique, but also distinct ruptures and extreme poles. The sources of these differences and uneasy contradictions are to be found in the individual artistic stances of the protagonists; but also in the origin of "fine art" in the socially and personally structured milieu of a materialistic *Zeitgeist*.

The Signs of the Times - The Themes of Pop Art

The "myths of everyday life" which surface in consumer culture, in the mass media and in the euphoria surrounding technology are ambivalent: they express the general optimism of construction, but also the general syndrome of decay; a belief in progress, but also a fear of disaster – they stand for both dreams and traumas, luxury and poverty. Civilization has come to feel the nightmare of its own vulnerability and destruction. The total availability of consumer goods has turned into the waste-disposal problem of a "throw-away" society in which the desires and fates of individuals disappear in the mass. Automobile varnish and automobile wreckage symbolize the illusions and realities of consumer society, which are suffered in private, and which collapse into nameless statistics. The idols in Andy Warhol's silkscreen multiples look spiritually broken, as if drawn inwardly to melancholy; the veneer, the lustre of things – reflected in Tom Wesselmann's assemblages – was peeling. The "New Wave", the idealism of the Kennedy era, had stood for a belief in the future which now had to be measured against hard facts. Reality had come unexpectedly, and in a form which was not easily digested: the assassination of John F. Kennedy in 1963, the outbreak of the Vietnam War in 1964, the race riots and drug addiction in the USA revealed the vulnerability of what had purported to be the perfectly calculated affluent future.

The star cult of the era was also a sign of its sufferings; made-up faces, adapted to their functions as the icons of the sixties, were a source of compensation for the feelings of frustration and impotence of consumers suffocating in their anonymity. The image projected by these stars, the personal element feigned in their facial expressions, hid their real fragility and vulnerability to the hard realities of everyday life. Liz Taylor's depressions, Marilyn Monroe's suicide in 1962 and the loneliness of Elvis Presley are features in the true face of an era permanently running up against the boundaries of its supposed "boundless possibilities".

Andy Warhol's series of *Marilyns,* produced in 1962 after her death, reveal the inauthenticity of her image by repeating her face – or her lips – in rows (pp. 12, 13). He translates the manipulability and inflationary character of her image into a mechanical form containing apparently meaningless pictures. Using the silkscreen technique, he arranges some design or other of Monroe, a well-known photograph, in apparent random sequence, and then transfers them onto the canvas in a slipshod, slovenly, average sort of way. Warhol turns the stereotyped persona of the star, who is forced to reproduce herself constantly in staged scenes and settings, into a series of identical images, merely touching up her face with various colour nuances. The garish lack of subtlety of her make-up relies on her expected pose – a "mask" which the viewer is invited

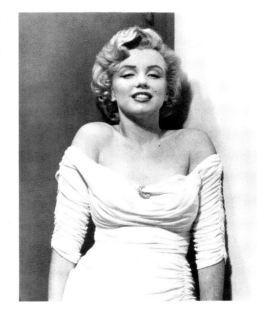

Philippe Halsman
Marilyn Monroe
LIFE 7, April 1952

James Rosenquist
Marilyn Monroe 1, 1962
Oil and spray enamel on canvas,
236.2 x 183.3 cm
Collection, The Museum of Modern Art,
New York, Sidney and Harriet Janis Collection

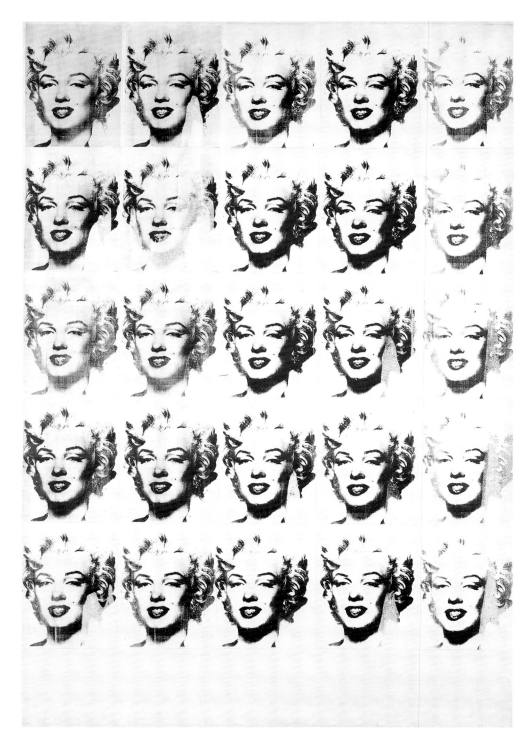

to identify with and imitate. Her glossy hair, bright eyes and sensual lips simulate beauty, affluence and happiness – a marketable persona. Warhol plays his own game of colour and forms with these images. Into the brash, sexually stimulating gestures of these faces, Warhol instills a quality which is both alienating and unpredictable.

The media industry systematically exploits mass-reproduced, stereotyped expectations, longings for love, unfulfilled fantasies. Robert Indiana takes *LOVE* (p. 18), the quintessence of the epoch, literally: he translates the word itself into pictorial form or into sculpture. As an invitation "LOVE" seems highly stylized; as a logo, however, it is absurd. In his layout of the letters "L.O.V.E."

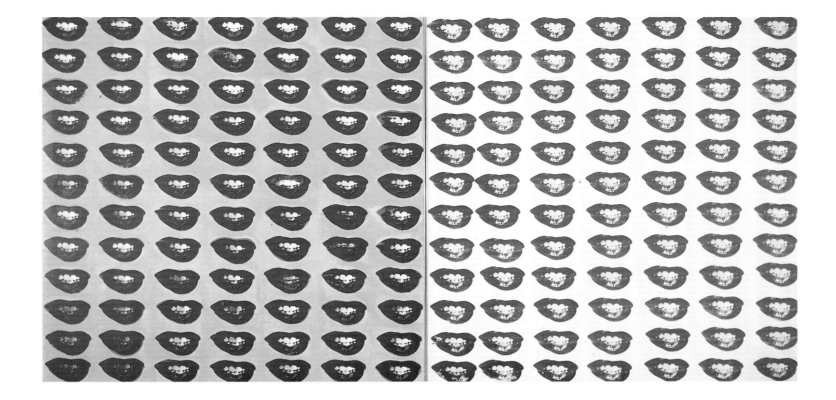

Indiana exploits ingenious techniques of using colour and form developed by commercial design. He perfects these by using the sensational energy generated by the colours and letters as signs and forms, thereby creating a balance between artistically unrestrained levels of expression on the one hand, and functionalized representational conformity on the other.

One sign of the times with far-reaching consequences was design: consumer goods design, car design, furniture design, commercial design, photo design, packaging design, media design and fashion design. Various branches of business expanded, creating their own "types" in accordance with the patterns of taste and norms dictated by demand – advertising stereotypes engineered in close cooperation with marketing departments, statistical research and behavioural science. These "types" were then portrayed in relation to certain accessories, to things they (supposedly) loved. They were shown applying make-up or perfume, doing their hair, reading, driving, smoking, eating, drinking and travelling, shown surrounded by the objects of their preference. They were, in fact, shown just as they really were – externally controlled human beings caught up in the image-dependent web of a perfectly functioning, integrated system of brand names.

In the course of the sixties – with America well out in the lead – design was professionalized and perfected in such a way that it became no longer necessary to link specific characteristics with a product in an obvious way. Instead, the creative aspirations of designers were applied to forging such links psychologically at a subconscious level – to making inroads into the private sphere of the addressee at a subliminal level. This exploitation of depth psychology – though difficult enough to grasp in any concrete sense – enabled design to out-manoeuvre the consumer's freedom of choice. The "unlimited freedom" of the consumer society was thus built upon the seducability, lack of independence, lack of freedom and indeed addiction of the consumer. Many artists were stimulated to take on work designing requisites for domestic,

Andy Warhol
Marilyn Monroe's Lips, 1962
Acrylic, pencil and silkscreen on canvas, two panels: 210.2 x 205.1 cm; 211.8 x 210.8 cm
Hirshhorn Museum and Sculpture Garden, Smithsonian Institution, Washington D.C., Gift of Joseph H. Hirshhorn

"Sometimes I think that extreme beauty must be absolutely humorless. But then I think of Marilyn Monroe and she had the best fun lines."
ANDY WARHOL

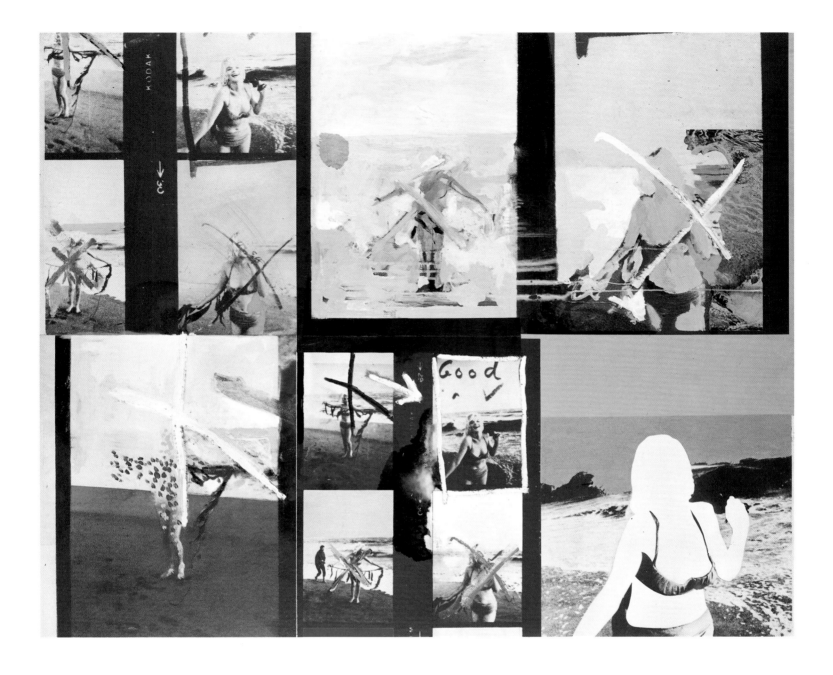

environmental and consumer product promotion; the homgeneity this process encouraged, the loss of everything personal and vital, was felt as a challenge to their whole sense of being and art. For their part, the artists were able to "perfect" certain aspects of consumer goods design, of layout, and of the adaptation of subjects to the photographic process, thus acquiring techniques of communicating the more suggestive and brash elements of trivial behaviour. This development in the language of images corresponded to a similar development in vulgar colloquial language, whereby advertising slogans were viewed as a kind of literature and ghostwriters' and copywriters' texts assumed the status of art. Similar reactions occurred in the cinema, in music and in other art forms.

What did the artists do with these commonplace subjects, these images and techniques? Their took their own "perfection" one step further, for they no longer subjugated themselves to the predictable dimensions of applied design, but exposed these and modified them to obtain a new effect. They made an exact analysis of this functional language, giving its subject matter a new

Richard Hamilton
My Marilyn (paste-up), 1964
Photographs and oil on canvas, 50.4 x 61 cm
Museum Ludwig, Cologne

Peter Phillips
For Men only. MM and BB Starring, 1961
Oil and collage on canvas, 274.3 x 152.4 cm
Centro de Arte Moderna, Lisbon,
Fundação Calouste Gulbenkian

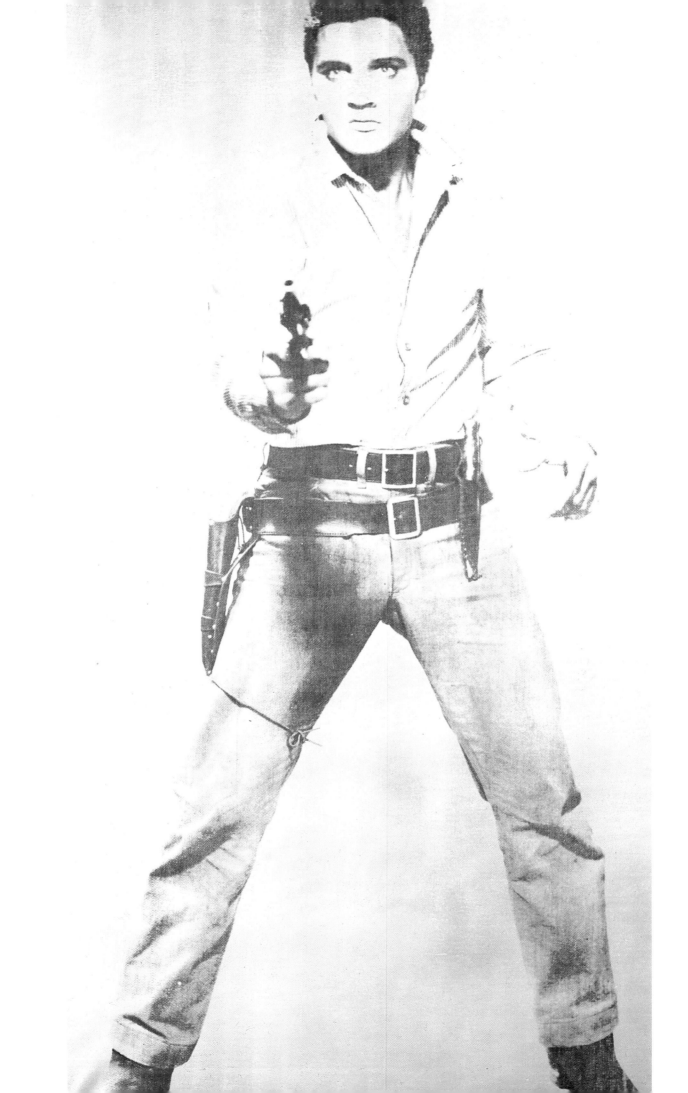

Ray Johnson
Elvis Presley No. 1, 1955
Tempera and India ink on newspaper,
27.9 x 20.6 cm
William S. Wilson Collection

Andy Warhol
Single Elvis, 1964
Acrylic and silkscreen on canvas,
210 x 105 cm
Ungarisches Ludwig-Museum, Budapest,
Gift of Ludwig

meaning by redefining the levels at which these techniques were applied. Here, "perfection" has nothing to do with routine or conformity, but with making commonplace imagery transparent, with isolating and exposing the manipulative elements of design. The harmony of form and content in an advertisement is inverted and alienated by the artist. The moment of suggestivity is overcome by separating it from the design to which it was so addictively clinging. The seductive attributes of the imagery exploited by these artists thus tend to have a disconcerting quality. A trace of melancholy inhabits the euphoria; the gloss and finish assume an enigmatic, threadbare patina; precision, turned thus on its head, becomes a challenge to the eye. Whereas the designers had merely displayed products, the artists were now displaying designed products. Liberating these from the prescribed parameters of their utility value, they placed them in contexts unusual enough to provoke reflection. In doing so, they offered no defined, critical position, but left things suspended as they really

Robert Indiana
Love Rising, 1968
Acrylic on canvas, 4 panels, 370 x 370 cm
Museum moderner Kunst, Vienna,
Ludwig Collection

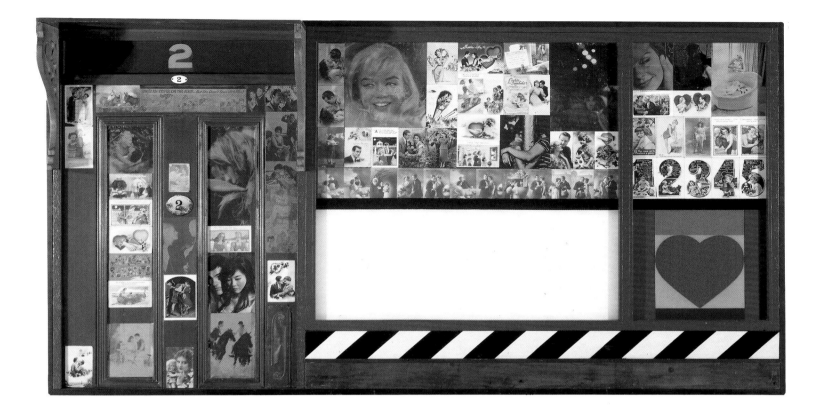

Peter Blake
Love Wall, 1961
Collage and painting, construction,
125 x 237 x 23 cm
Centro de Arte Moderna, Lisbon,
Fundação Calouste Gulbenkian

were, and left the spectator to decide which qualities belonged to the work of art, and which to its subject.

In Tom Wesselmann's sterile interior styling, the individual personality is fully absorbed by the design. Advertising and design both stimulate and satisfy expectations which become reality in the middle-class milieu. The smooth surfaces of objects are reflected in the lack of contour and incorporeality of human beings moving like marionettes in clichéd poses between bathtubs, towels, flowers, cigarettes and other accessories in their bedrooms and bathrooms (p. 20-23). The combination of painted passages, reliefs and real objects lend his pictures the environmental quality of a film set, reminding one of the artificial décor in a TV commercial.

In one picture Wesselmann demonstrates how the personality of a woman lying on a bed in a vulgar pose disintegrates to become the sexual object of a peepshow voyeurism. In her artificial manner, she represents the consumable, standardized *American Nude* reminiscent of soft pornography. But here, we find her removed from the world of the cinema and returned to the role dictated for her within the privacy of a lower middle-class milieu pretending to be something bigger. Wesselmann's pictures show what happens when a person is manoeuvered by clever producers into a designed world of sterile artificiality. The debasement of real, vital desires for a better world is reflected in apparently superficial pictorial environments. The supposed seductiveness of the scene has been annihilated. For the closer one looks, the more one sees how individuality is robbed of its meaning, is devalued to the status of a stage prop which can be substituted at will.

James Rosenquist's large panoramic pictures unmask the pre-produced world, expose the artificial vision of a euphoric dreamworld in which every desire is fulfilled. The mixture of everyday objects and emotion creates the impression of shreds in a frenzied recollection of shattered reality. The figures and their environment blend into one another in an ingeniously combined,

spatially almost infinite, orgy of colour and form (p. 25). The rainbow, an optimistic symbol of progress, whose colours are vehicles of energy, spurs on the force which dominates the age. A gigantic, brightly coloured "paintbrush" — which looks like the cross-section of a telephone cable — enters the picture, transforming its dimensions. Small things become enormous. Everything blurs, and the alienated abundance of things is whirled round and round as if sucked into the currents of a poisonous, infernal maelstrom, into the nightmarish chaos of a roaring, drunken mass. The commonplace acquires a new value in these pictures, and stereotypes are deconstructed. Things come and go, seem unfamiliar, strange. Between 1952 and 1960 Rosenquist worked as a billboard painter for industry and the cinema. His enormous, panoramic paintings, which remind one of film montage on a screen, are ambiguous. Their luminosity, the extreme radiance and brute spectral force of their colours and compositional vortex is reabsorbed by the grey, livid sections which contain parts of bodies and objects.

Rosenquist's complex assessment of reality comes out particularly clearly in *Rainbow* (p. 24), painted in 1961. Painting, relief and the inclusion of prefabricated fitments (shutters) combine to form the segment of a house wall —

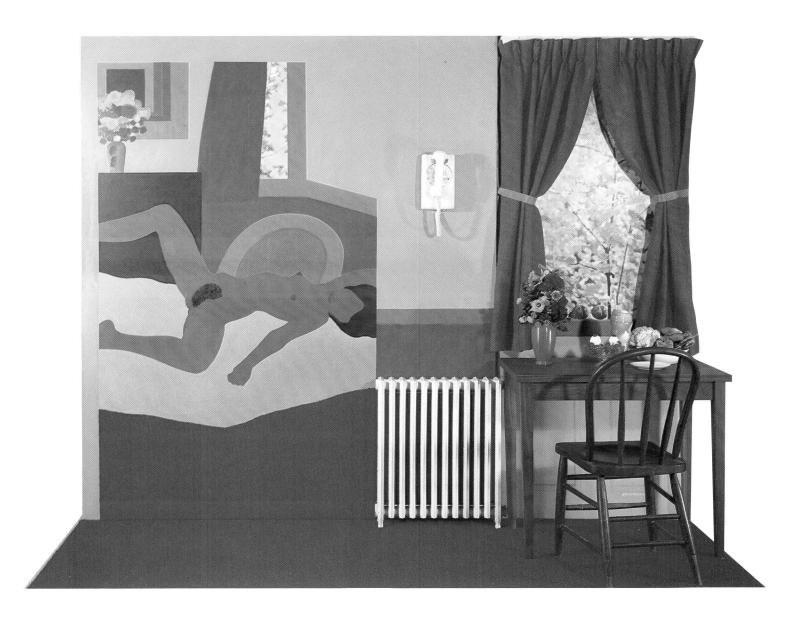

Tom Wesselmann
Great American Nude No. 54, 1964
Oil, acrylic and collage on canvas with assembled items and sound effects,
177 x 215 x 99.06 cm
Museum moderner Kunst, Vienna,
Gift of Ludwig

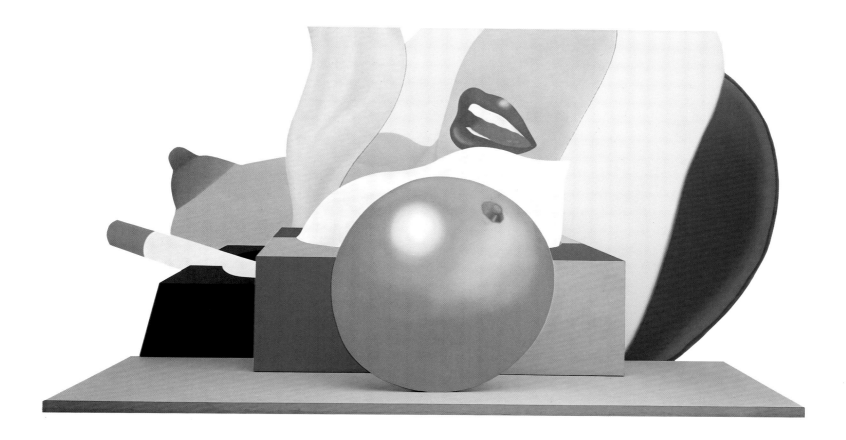

the raw, concrete wall of a typical prefab. The rainbow, previously the optimistic symbol of cleanliness, success, progress and freedom, has now become a melancholy liquid running down an outside wall from a broken window, dripping into the void beneath an aggressive-looking fork. Here, the rainbow is presented as a symbol of social and domestic order threatened by chaos. In the cramped composition and formal simplicity of this picture we see how Man embellishes even the ruins of his broken dreams.

The accessories of everyday life and public interest in the consumer goods which make life more attractive and enjoyable tend to concentrate on particular stereotypes and brand names. Certain consumer goods became the symbols of the era; they made history as components of a new mass culture. Lollies, ice-cream, cakes, Seven-up, Pepsi, Coca-Cola, toothpaste, soup cans, cigarettes and matchboxes, the insignia of a culture obsessed by affluence, also became the iconography of Pop Art. The "match" relief produced by Raymond Hains — an artist known for his use of décollage, or torn posters — in 1964, monumentalized an object normally seen as devoid of meaning or value into a probing image. The obtrusive rows of joined-together red matches are reminiscent of individuals conforming to a military formation. Their broken-off heads, and the sense of ruin emanating from the insistent shallowness of their form and colour, are raised here to pointed abstraction, assuming even a decorative or ornamental dimension. The anonymous packet of matches gains a "personality", individual features, an inner life. A mass-produced article with its standardized style has become meaningful and unique.

In 1962 Andy Warhol treated the same subject at a different level. He showed the packaging, not the content. He shows us the contents through the packaging, as it were. The latter is a vehicle for the advertisement of Pepsi-Cola (p. 29), or Coca-Cola (p. 31). The bottle-top with the Pepsi trademark and the

Tom Wesselmann
Great American Nude No. 98, 1967
Five canvases arranged behind one another in three planes, 250 x 380 x 130 cm
Museum Ludwig, Cologne

PAGES 22/23:
Tom Wesselmann
Bathtub 3, 1963
Oil on canvas, synthetic material and assembled items (bathroom door, towel and linen basket), 213 x 270 x 45 cm
Museum Ludwig, Cologne

21

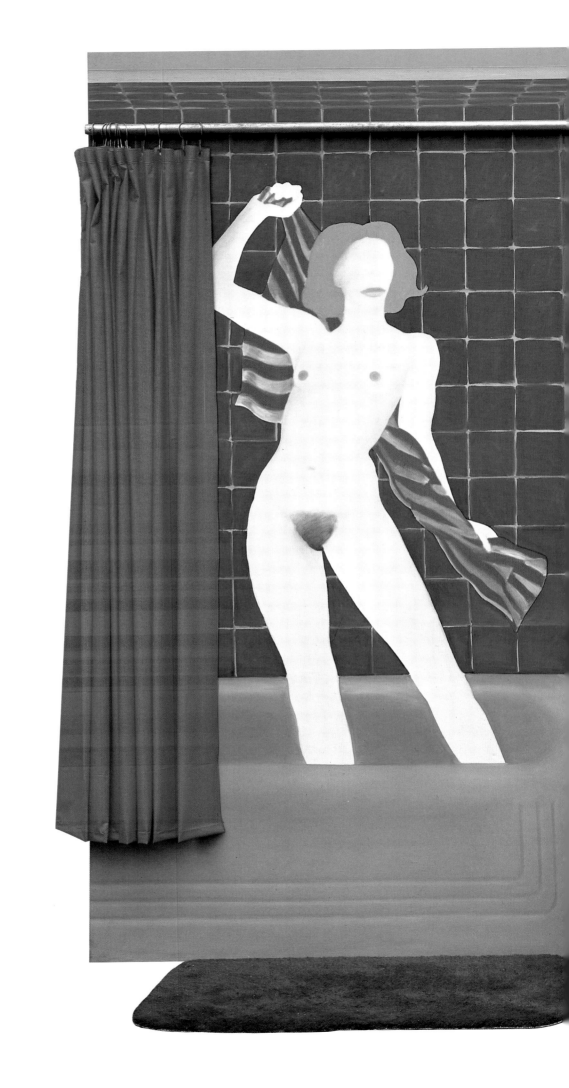

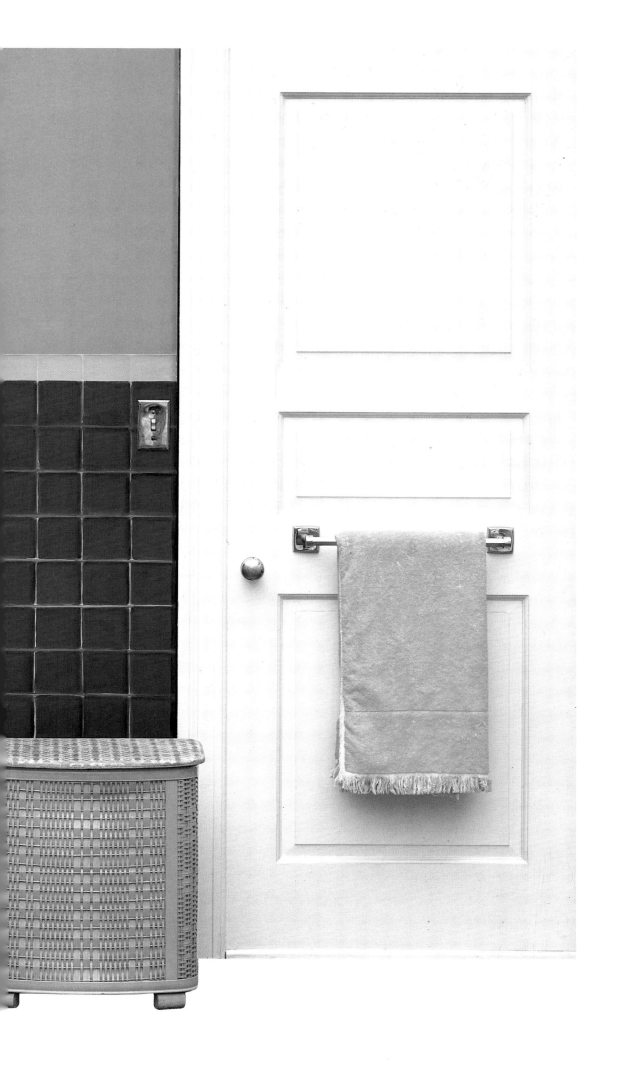

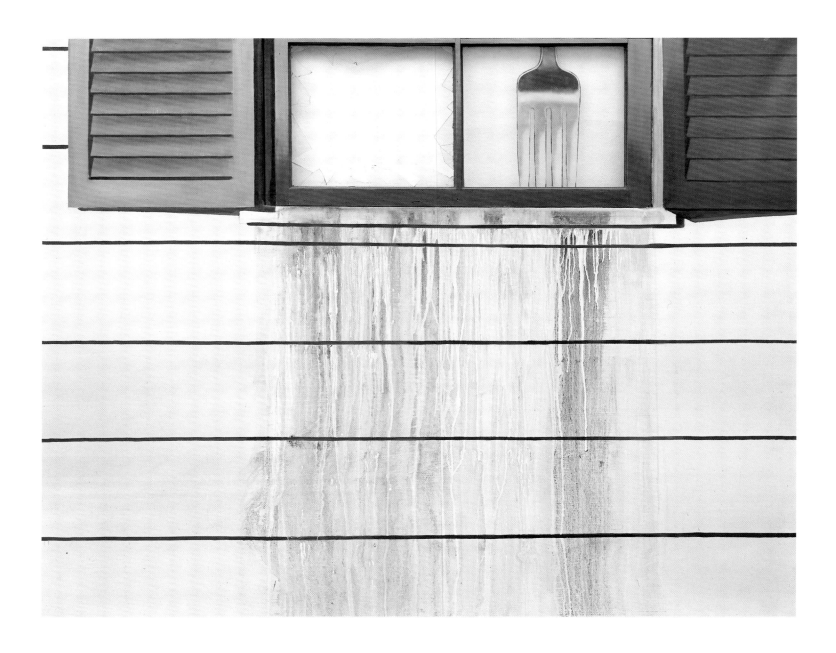

James Rosenquist
Rainbow, 1961
Canvas, wood, glass, 121.3 x 153 cm
Museum Ludwig, Cologne

exhortation beneath it to "say Pepsi please" are shown in gigantic dimensions. The viewer's attention is thus diverted away from the real function of the article; the less obtrusive inscription, the advice to the user to "close cover before striking," gives the whole a threatening, dangerous feeling. The recommendation points to the unreliability of this inconspicuous article (in two further versions, Warhol paints only this lower part of the picture – in yellow and in red). The colours and forms, the "layout" of the picture, constitute a decorative composition which reacts to the quintessential elements of the packaging. Again, the effect is one of pointed abstraction, in dimensions which cause one to forget the actual utility value and relative insignificance of the article itself. The trivial is aesthetically overstated by the large scale of the painting; it is lent a strangely insistent quality by the unwieldy monumentality of what is otherwise a convenient, handy object. Despite what appears to be a mechanical, impersonal technique, Warhol achieves a painterly exaggeration of the smooth perfection of the original design and substitutes its mere functionality with a surprisingly visual and sensual appeal. The unusual size of the marks left by matches on the striking surface of the original create the impression of abstract painting.

The star of the consumer world is Coca-Cola. The capitalist system of American, and Americanized, consumer culture culminates in the success of this product. Coca-Cola is one of the supreme symbols of the "American way of life", and its influence has spread even to the remotest corners of the globe. Many American and European artists have created monuments to this fetish of the consumer goods world (Andy Warhol had started painting Coca-Cola in 1960). In doing so, they have alienated the product by their use of form and colour, materials and size. In sculpture, they have taken the image to the extent of ironic anthropomorphism, have monumentalized it, or repeated it in countless, inflationary rows.

Art is used here to decode a characteristic of this product which is both superficial and yet also psychologically effective at a subliminal level. Rarely has a brand product been turned into such a popular means of entertainment. It was here that the trend of integrating the consumer into the promotion of the product was launched. "Coca-Cola" appeared on all sorts of knick-knacks, on T-shirts and posters. A whole world of Coca-Cola consumer goods emerged, from the key-ring to the dust-bin, influenced and inspired by Pop Art. The relations between supply and demand, between product, producer and consumer, had been reversed, and were now entering their absurdest, their most extreme phase.

In their translation of consumer goods into paintings, sculptures or objects, the artists' desire to subvert or overthrow established views and behavioural norms associated with the original products is clearly indicated by certain elements of formal technique.

Jasper Johns, for example, made two beer cans, opened and unopened, whose design he liked, in painted bronze. He thus gave these everyday, tin-packed products a certain refined quality, but concealed this very quality, or denied it, by painting over the bronze, relegating the cans to their place as worn-out, trivial images. The convenience lent the products by their design assumes a material weight, and a non-material content. The paint gives the gravity of the bronze a lightweight, almost ornamental façade, so that the apparently identical cans assume an irregular, formal singularity.

> "Art is the greatest risk of all because when you're making something, you're constantly asking yourself what the hell you're doing."
> JAMES ROSENQUIST

James Rosenquist
Area Code, 1970
Oil on canvas, four parts, and seven plastic panels in different sizes, 289.6 x 701 cm
Walker Art Center, Minneapolis, Gift of the T.B. Walker Foundation

Claes Oldenburg transforms ice-creams, cakes, Seven-ups, sausages and hamburgers, bitten apples, toilets, washbasins and bathtubs, cigarette butts, pistols, American flags and other objects into unshapely sculptures and ensembles which range from the small to the colossal. The familiar objects they represent are hardly recognizable, so extreme is the alienation and distantiation to which they have been subjected. He uses plaster and cloth (canvas), hard and soft materials; he applies both garish and pale colours in an apparently slapdash and arbitrary manner to give the pleasant sobriety and intricate design of the original object an appearance which is both squashy and shapeless, in other words repulsive – but at the same time abstract and exemplary. All charm seems forgotten here; by depriving the commodity of its utility value, Oldenburg undermines the appeal of the consumer society itself. With cheerful, but also macabre, irony the articles of the consumer goods industry are exposed to a process of disintegration and destruction (cf. p. 28).

Formal interventions and transmutations of this kind changed the conditions under which art was produced and received. Typical conventions, which had hitherto been expected of art, and which art had complied with, had to be reexamined. For previously binding boundaries of visual and aesthetic representation and perception had now been transcended. The Pop Art of the sixties was changing the course of art history by expanding both content and form into the realm of the trivial!

With his *Campbell's Soup Can* (pp. 166, 167, 171) Andy Warhol turned to organizing the complex *mise en scène* of a brand product which denoted the calculated reduction of culinary taste to a common denominator far below the

Richard Hamilton
Stillife, 1965
Coloured photograph on wood, 89 x 91 cm
Museum Ludwig, Cologne

potential of even the least creative cuisine. The original can lives more from the surface of its label than from its content – the outside is the guarantor of the inside. The relative insignificance of "individual" taste beside the uniform appeal of its image and varieties it offered were the reasons for its massive success. By removing it from its context and demonstrating the artwork behind it, Warhol overloads its functional grid. This defuses its commonplace consumer value, while isolating it as a sign of the times. Warhol did versions of the soup can in 1962, 1965 and again in 1985. He painted and printed it in huge formats, both individually and in stereotyped series, in different colours and variants. He produced silkscreen prints of it on paper bags and canvas, and overprints on the image of Elvis Presley. He turned the object itself into a work of art by signing it, and painted it in a state of decay, like a ruin. In *Big Torn Campbell's Soup Can* (*Vegetable Beef*) in 1962, the staging of a consumer article takes on the contours of a drama. The label is shown peeling off, depriving the metallic packaging of its gloss and robbing a perfect design of its intended aura. The large scale of the picture and its pointed manner of representation turn an otherwise unspectacular process into a dramatic event suggesting "romantic ruins", allowing the viewer associations of negativity, fragility and melancholia. The charm of such associations, however, lies in their being neither intended nor located in the picture itself. The apparent ambiguity of the subject matter resides in the contrast between its mass-produced anonymity and the individuality with which it has been depicted. Warhol's equivocal method of rendering this object into art places it in a new and unexpected light, balancing it insecurely on the edge of what appears to be a personal question:

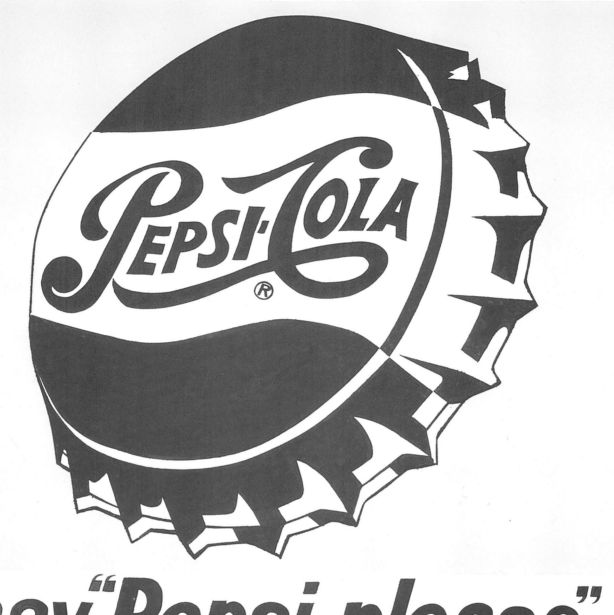

say "Pepsi please"

CLOSE COVER BEFORE STRIKING

AMERICAN MATCH CO., ZANSVILLE, OHIO

What is "good", what is "beautiful"? Warhol's artistic technique is an indefinable mixture of design and sensuality, of free aesthetics and figurative functionalism. His achievement perhaps lies in having subverted the desire to consume this product by making it psychologically unpalatable. No longer worshipped by consumers, the consumer article has become the recipient of a dubious, macabre, indeed absurd homage.

Obsession with money was a particularly conspicuous sign of the times. The belief in progress prevalent in the sixties grew from a faith in the economic potency of the West. The dollar had become a symbol of superiority, freedom and economic power. The dollar could buy everything; it guaranteed the total availability of all things (and people); it made life worth living — and the American dream come true. It was the universal remedy for all frustrations, and compensation for every new disappointment. It became an American icon and, like the registered trademark "reserved" by Coca-Cola, was marketed on everything from T-shirts to towels and ashtrays. Artists soon turned their atten-

"What's great about this country is that America started the tradition where the richest consumers buy essentially the same things as the poorest. You can be watching TV and see Coca-Cola, and you can know that the President drinks Coke, Liz Taylor drinks Coke, and just think, you can drink Coke, too. A Coke and no amount of money can get you a better Coke than the one the bum on the corner is drinking. All the Cokes are the same and all the Cokes are good. Liz Taylor knows it, the President knows it, the bum knows it, and you know it."

ANDY WARHOL

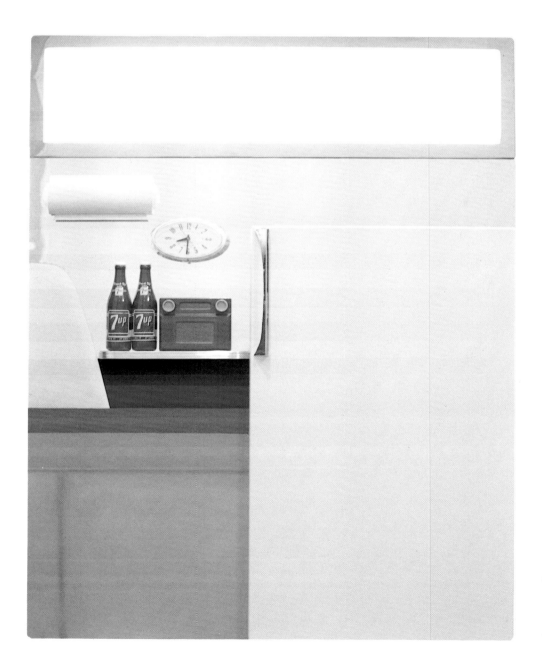

Tom Wesselmann
Interior No. 3, 1964
Acrylic, polished metal, assemblage on cardboard and various objects (work-lamp, clock and radio), 142 x 111.8 x 7.6 cm
Collection Dr. Hubert Peters, Brussels; courtesy of the Sidney Janis Gallery

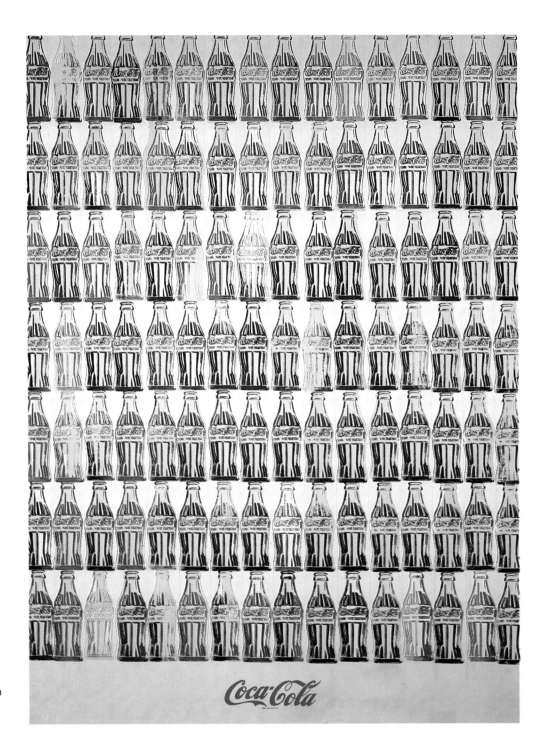

Andy Warhol
Green Coca Cola Bottles, 1962
Oil on canvas, 208.9 x 144.8 cm
Collection of Whitney Museum of American
Art, New York, Gift of the Friends of the
Whitney Museum of American Art

tion to looking behind the facade of this much hyped symbol of the times, and exposed it as inflationary and average (cf. pp. 36, 37).

It was particularly in their drawings that Pop artists portrayed the dollar as alienated, and even debased. This is illustrated in a series of drawings by Andy Warhol from 1962: dollar bills, apparently draughted by a stylist, stuffed into Campbell's Tomato Soup; next to this, a tied-up bundle in which the image of the bank note can only just be made out; or sections of one-dollar bills with Lincoln's and Washington's portrait. One is made aware of the consumer's indifference towards the historical image enshrined in the dollar he constantly carries around with him. And yet it is this drawing more than perhaps any other which emphasizes the power of America: in the boldness of the printed word, in

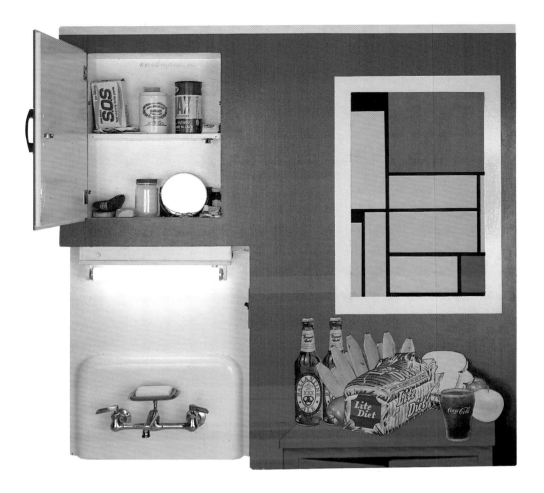

Tom Wesselmann
Stillife No. 20, 1962
Collage and assemblage, paint, paper,
wood, lightbulb, switch, etc.,
104.14 x 121.92 x 13.97 cm
Albright-Knox Art Gallery, New York, Gift of
Seymour H. Knox

the sombre smiles on the faces of the Presidents, those symbols of American Independence, who radiate an almost uncanny, and mysteriously childlike vivacity. Warhol is exploiting physiognomy here to play on the psychology of types.

And then there are the unfinished dollars, the dollar signs – $ (another of Warhol's themes in the eighties – the unrecognizable dollars, the blurred and washed-out dollars, the contours of dollars, dollars with shadows, impressionistic and abstract drawings of dollars, dollars drawn to simulate "technical drawings", and "portraits" of dollars. His fascination for the old, historically almost unchanged tradition of the dollar sign is obvious here. The creased or crumpled dollar, thrown down indifferently or simply "chucked" away is – like the ruin of the Campbell's can – especially ambiguous. By contrast with the large silkscreens, it reveals the vulnerability and fragility of this symbol of American power. The silkscreen prints on canvas alienate the dollar image by robbing it of the perfection of its traditionalistic design, the automatic radiance of its aura. As a result, everything about it is changed: its familiar visual and tactile feel, its convenience, its appearance, its meaning, its beauty and – particularly when it is reproduced *en masse* – its value. Copies, made to look like the badly done schoolwork of beginners, become transformed by the serigraphic process into enormous stamps. The faces on the front and rear of the notes become almost interchangeable. The aura of the faces' owners fades away. Instead they are repeated on large format canvases in obtrusive rows, black stencilled on green or black-white-grey: *18 One Dollar Bills in 6 Rows, 40 Two Dollar Bills in 2 Rows (red), 80 Two Dollar Bills in 20 Rows (Front and Rear, black and green)* (p. 37); in effect, a large number of messy, mixed up, unloved

Robert Rauschenberg
Coca Cola Plan, 1958
Combine Painting, 67.9 x 64.1 x 12.1 cm
The Museum of Contemporary Art,
Los Angeles, Panza Collection

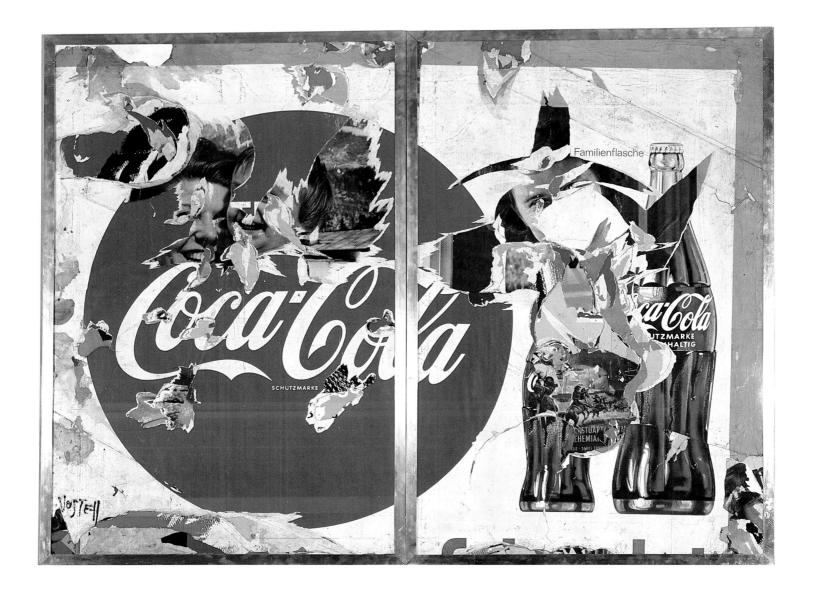

Wolf Vostell
Coca Cola, 1961
Décollage, paper on hard-board, in two
parts, 210 x 310 cm
Museum Ludwig, Cologne

one dollar bills, coldly thrown down, as if by chance, and yet all landing face up. This thematic concentration on the dollar amounts to its aesthetic and artistic revaluation; but for the dollar itself, for its material aura, the effect is one of devaluation. The entire complex of programmed relations associated with the dollar is undermined by these pictures: as money, the dollar denotes an abstract value which guarantees security; as a bank note, it is mere paper; as an icon, it is the registered trademark of America.

For Americans, money is one of two comprehensive and dominant factors. The other all-inclusive symbol of American identity is the nation – "America" as a concept and way of life, as a metaphor and as a source of social and national identiy binding both individual and community.

The national flag thrives on its inflationary omnipresence. No event, whether family reunion, anniversary, flag day, procession or open air concert, is complete without the "Stars and Stripes". The flag has enormous currency in the American bric-a-brac and entertainment industries. The flag decorates everything, and can appear as a background prop at any event. The flag is America's seal, and as the symbol of a prosperous state, it is the icon of the American dream, recognized – by Europeans too – as the guarantor of European security. Against this background, it is not difficult to see why it became one of the first, and most widespread, subjects of Pop Art. As such, it became

Robert Rauschenberg
Dylaby, 1962
Combine Painting, 250.2 x 170.2 x 45.72 cm
Sonnabend Gallery, New York

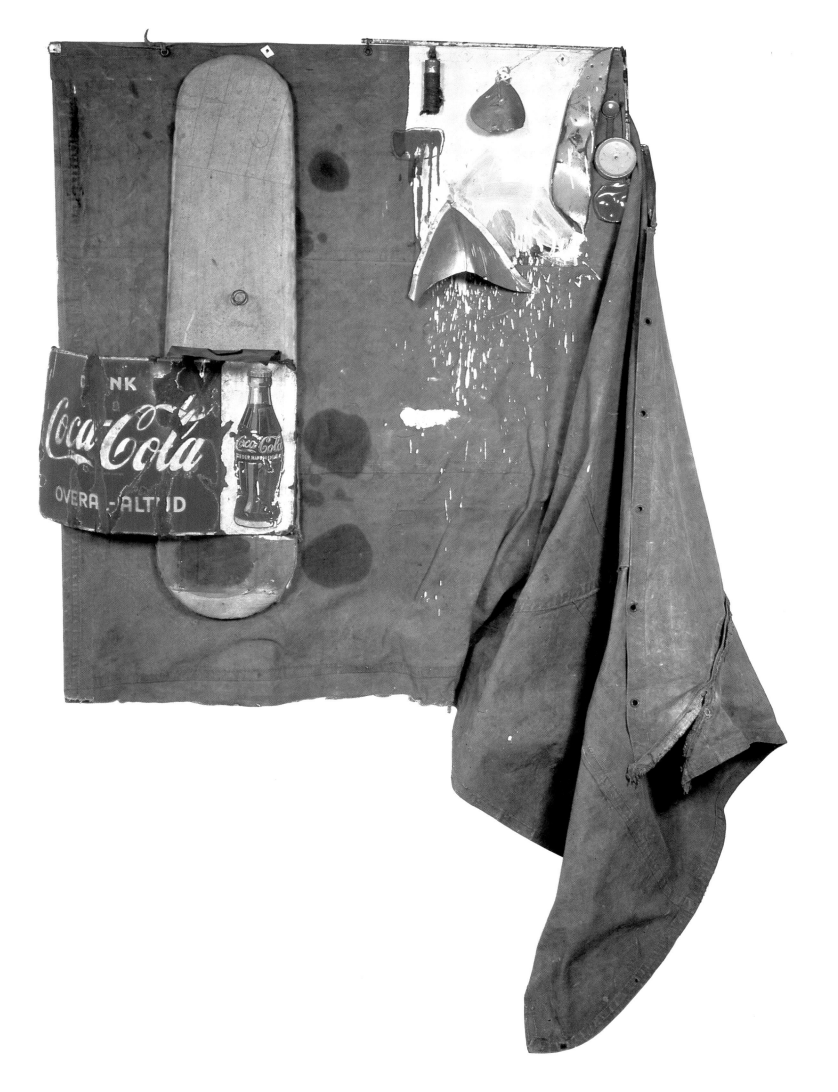

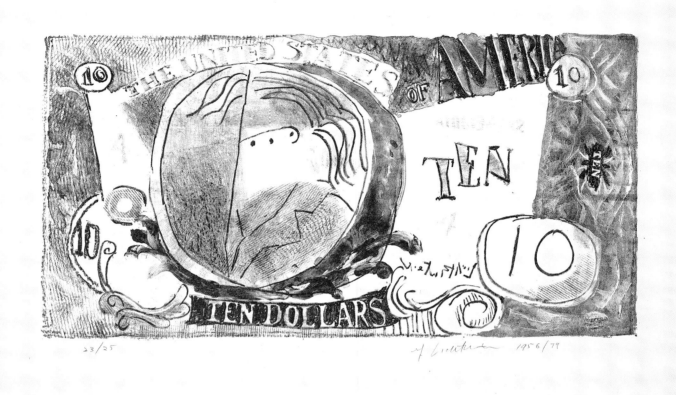

Roy Lichtenstein
Ten Dollar Bill, 1956
Lithograph, 14 x 28.6 cm
Collection of the artist

Andy Warhol
Two Dollar Bills (Front and Rear), 1962
Silkscreen on canvas, 210 x 96 cm
Museum Ludwig, Cologne

the vehicle of a a new idea of art. Jasper Johns, who started doing flag paintings in 1954-55 (p. 135), provoked the art world with the question: "Is it a flag or is it a painting?" The question, challenging as it is, has a simple answer: the flag – which had appeared to him in a dream as his own painting – is clearly a painting. There are painterly passages, the colour structure is almost impressionistic or informalistic; while the brushwork itself is light and nuanced, it seems to have been applied to the underlying shreds of newspaper in an indifferent and routined manner (p. 39). In appearance, John's paintings have the brashness of posters, but in composition this is far from the case. In terms of technique, his panel painting makes great use of tradition, but the painting itself lacks subjective features. The brushwork, the use of form and colour, the composition are unmistakably John's own, and yet they disclose nothing emotional. The stance of the artist towards this – socially and politically – powerfully emotional subject also remains open.

The question as to whether we are looking at a flag or a painting refers to our tendency to seek unambiguous recognition; this becomes especially acute when the entire painting is filled out by the flag. The banality of perceiving the painting as a thing stands at one pole of this conundrum; at the other is the perception of the flag as a non-representational pictorial order, an even balance of colour and form, lacking in compositional emphasis and far from anything remotely concerned with contingent reality. The alternatives "flag" or "painting" expose our propensity to identify representation with reality, a tendency which Pop artists exploit to manoeuvre even the experienced viewer of art towards questions which seem quite absurd, and which appear to lead

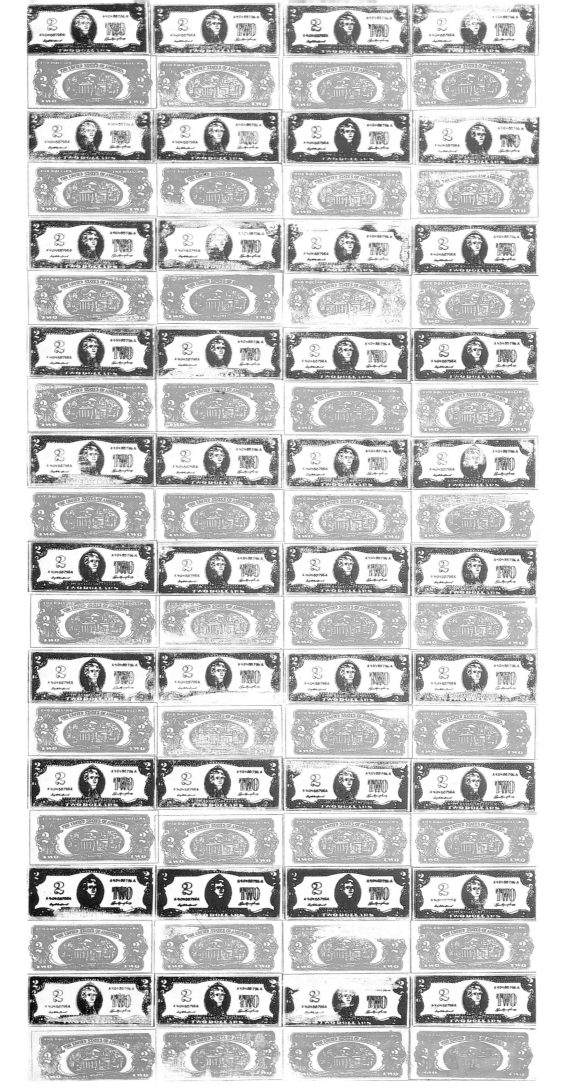

Edward Kienholz
Detail from: The Portable War Memorial,
1968
Environment with mixed media and objects,
tape, Coca Cola vending machine,
285 x 240 x 950 cm
Museum Ludwig, Cologne

Jasper Johns
Flag above White with Collage, 1955
Encaustic with collage on canvas, 57 x 49 cm
Kunstmuseum Basel, Basle (on loan)

him into the inextricable confusion of his own perceptual habits. "Flag or painting?" – the question throws a dual light on the dimensions of perception, on the different levels of content, and on the question of artistic value. The representative of mass society will immediately recognize the flag; his irritation will spring from its being allowed to appear as the subject matter of what he sees as élitist art. The representative of the art scene will immediately see it as a painting, and investigate its degree of abstraction. He is quite used to this approach and is likely to be taken aback when something non-artistic, a flag for example, becomes the sole form and content of a painting. It is the existence of these two quite different cultural traditions, and of the habits and expectations they encourage, which permits this either-or to become the source of such confusion and insecurity; although the alternative itself is posited in rhetorical form by the artist, not by the work of art. Its answer could also be: It is both, painting and flag; the flag as, or in, the painting; the painting in the form of a flag; a superficial, unpretentiously flat, and yet felicitous aesthetics which even captivated Johns (even if he only painted 48 stars, or 60 in a different version, but never the 50 which reflected reality at the time!). The ordinariness of consumer reality was seen as a difficult problem in art, unless, of course, the artist interpreted and criticized it. This feeling of insecurity stemmed from habitual modes of viewing art which were only just beginning to comprehend the use of shock as an extreme form of opposition to conformity, and as a means of repudiating ideological uniformity. It was the problem of weighing up or adjusting to these two extremes which led to the insecurity and confusion which made itself felt in reactions to John's paintings of the American flag – or indeed to other works of Pop Art.

Tom Wesselmann's *American Nudes* are witnessed luxuriating in a sterile, intact world of bathrooms and bedrooms. "Naturally", there is an American flag to be found in the background, either stuck to a wall or visible through a window. The flag encloses her like a kind of background music which lulls everything into pleasant, harmonious complicity. The flag is also a symbol of childlike fascination, of upbringing, and can be found in traditional folk art. Subordination to it – as to the dollar – is a sign of personal immaturity and of voluntary loss of identity. Pop artists, however, show that whatever is necessary for the survival of a society must also have its place in any art sensitive to the dynamics of contemporary culture. The people and things which belong to a particular society are that society's products – the signs of its times. Our picture of the epoch is the product of our identification with the interaction between human beings, the world and objects. The forms and norms of behaviour which result from these interactions are the vehicles of our general impression of a national (in this case, American) way of life. An art which deciphers and demonstrates these relations is simultaneously the diagnostic seismogram of the age; its roots are in the everyday reality of which it, too, becomes a part, offering us a moving, close-up – or distanced – view of our own condition. The artists' own theoretical contributions to the theory of Pop Art also point us in this direction: Art renders the signs of the times transparent – its effect on society derives from this act of reflection. And in so doing, art takes a decisive step forward in its own development. For it explores the new artistic terrain it finds within its immediate environment, and the habits of perception which go with it.

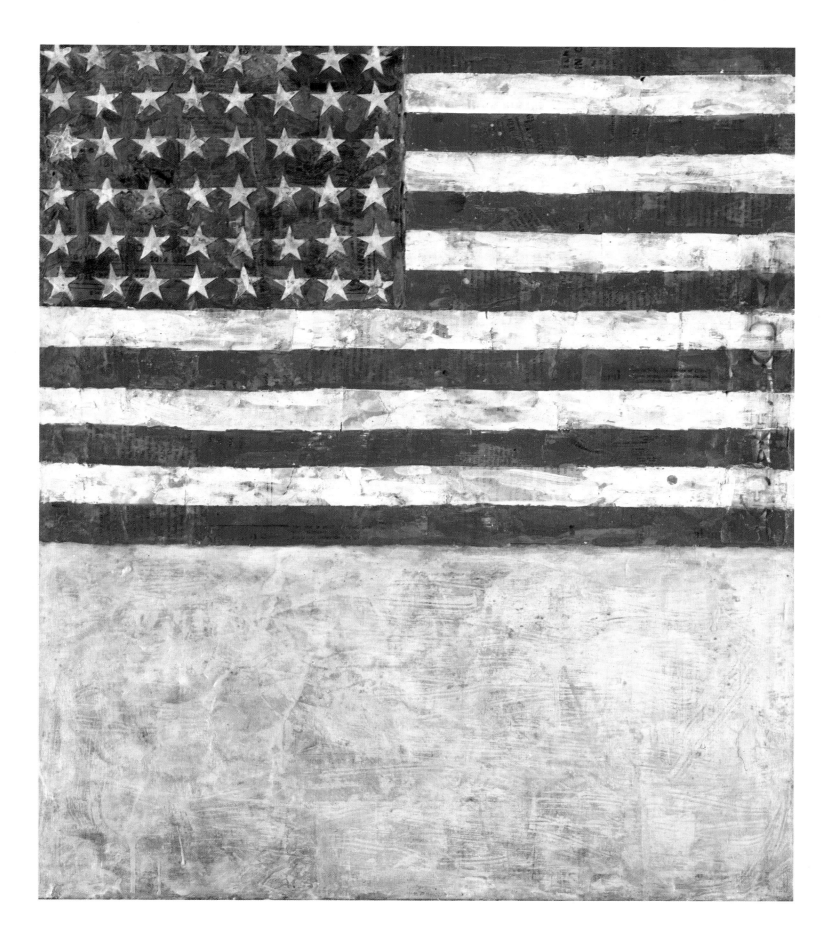

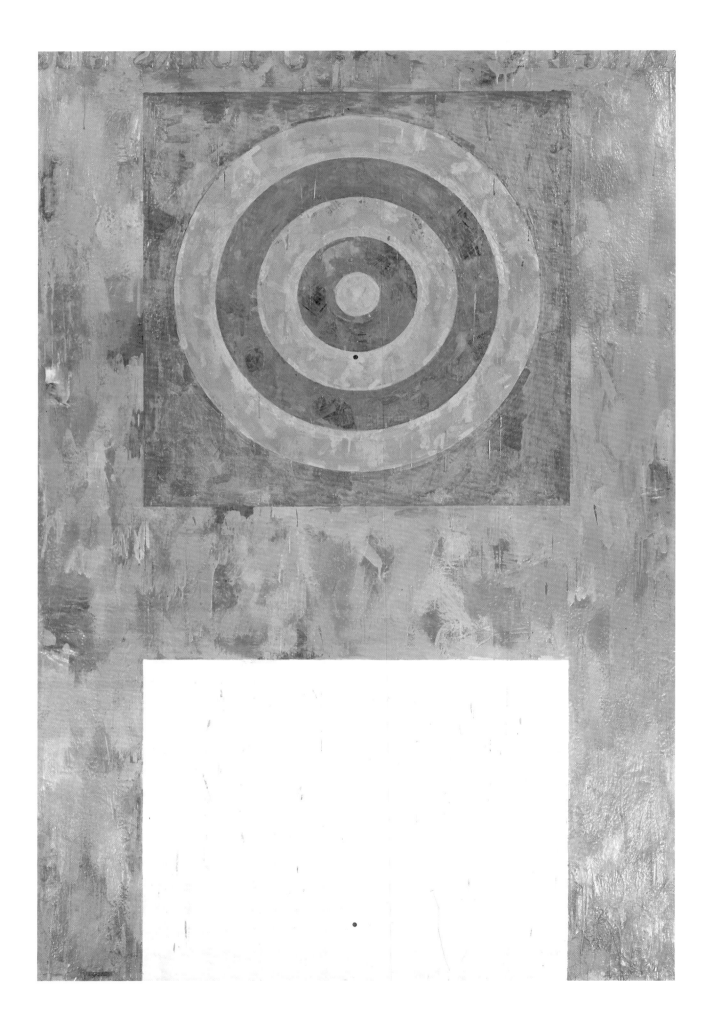

The Mass Media and the Arts

"The medium is the message" – this was Marshall McLuhan's diagnosis of the psychological and sociological consequences of the mass media. In the sixties his thesis became a slogan. In his important essay "The Work of Art in the Age of Mechanical Reproduction" (1936), Walter Benjamin had analysed the effects of technical reproduction upon our understanding of art and had shown the "mass" character of our modern culture. A generation later, Marshall McLuhan took this analysis a step further. McLuhan's investigation of the signs of the times describes the birth of a new media landscape. He found that the mass media industries changed the culture, art and behavioural norms of a society by changing the consciousness of the people in it. The mass accumulation of information and packaging of all things in compliance with standardized consumer design were developments which would prove ominous for humanity. Media dependency produces externally controlled human beings who can be shifted around like chessmen on the great chessboard of society.

"The medium is the message" – how was this reflected in the culture of the sixties and the pictorial world of Pop Art? The reality and environment of human life can generally no longer be understood without understanding them as manmade. The concept of the "mass media" refers to those industries which produce entertainment, consumer goods, information and consciousness. The medium not only transports messages, is not only the form and vehicle of communication, but is also its own subject or theme, an end in itself. The mass media are interested primarily in themselves. They are the key to all communication in society; they are the motor of culture; without them, nothing functions. They replace folk art with preformed products and devalue art and culture produced by people who have no means of competing with the possibilities the mass media have at their disposal. The "success" of the mass media, historically and economically, lay precisely in their development of technologies and strategies for separating people from their own, as it were, indigenous culture and making them dependent on an ingeniously packaged, attractive supply of information. The historical mission of the mass media was a kind of universal re-education programme, designed to penetrate as deeply as possible into people's lives and to gain the widest possible distribution.

These pre-programmed forms of communication, which had soon encompassed every area of human life, also changed the status of art. Art began to turn to the trivial, commonplace aspects of the consumer goods and entertainment industries. High-speed communication between products and consumers also changed the speed with which art was distributed, and produced. The production, reproduction and reception of art had attuned themselves to the high speeds of perception facilitated by functionalized, pre-formed design.

Howard Kanovitz
Journal, 1972-73
Liquitex polymer acrylic on canvas,
273 x 243 cm
Museum Ludwig, Cologne

Jasper Johns
Target, 1966
Encaustic and collage with newspaper on canvas, 183 x 122.5 cm
Museum für Moderne Kunst, Frankfurt/M.

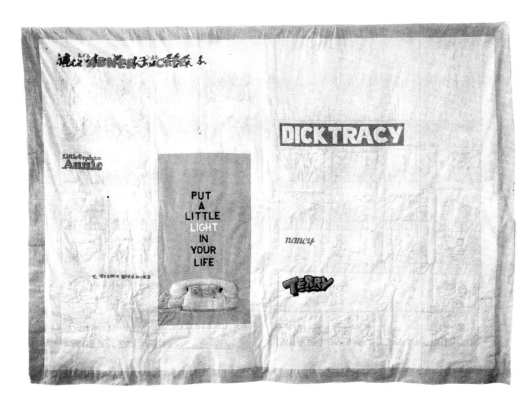

Pop Art homed straight in on these new "signs of the times", and hit the bull's-eye – the theme of Jasper Johns' *Targets* (p. 40). Co-existence, or rather competition, with the mass media had taught artists that the thirst for novelty in consumer goods and imagery had radically altered the relationship between society and the media – and also between people and art.

Pop artists play with the directness and speed with which the viewer picks up images. Image literacy and the new identity of form and content derived from the conditions under which the new imagery was produced. The language developed by artists was not primarily intended to comply with the commodity fetishism of the consumer, but to irritate and experiment with the consumer's own compliance with the short-lived effects of consumption.

The title of Richard Hamilton's famous collage of 1956, *Just what is it that makes today's homes so different, so appealing?* (p. 65) has lost none of its relevance in asking why our lives are structured in such a uniform, standardized fashion. *L. A. Times Bedspread* (p. 42) is the title of an appliqué made by the American Jann Haworth in 1965. In this work, she sews stereotyped images and names (perhaps those of comic-strip heroes) onto a cloth and confronts these with the challenge: "Put a little light in your life." The same exhortation, if otherwise intended, might be found in a product advertisement. The telephone here may be a technological symbol for human communication, but it is also a kind of ear-trumpet for social and political instructions. In this purple cloth, reminiscent perhaps of a quilt-cover or of American folkcraft, mass alignment with the media appears to conflict with human privacy and intimacy, and with the human need to be independently creative. The word "light" is highlighted – a technique we might expect to find in visual poetry. As a symbol for inspiration, or "enlightenment", it appeals to the human creative instinct; this, however, is hampered and suppressed by the mass media, which themselves promise the "light". The contradiction lies in the mass media system itself, as Jann Haworth's work suggests.

Advertisement for "Twent", 1979

The diversity and the almost universal accessiblity of the "messages" broadcast by the media were a decisive source of inspiration to artists. Pop Art rendered transparent the contradiction between the product and reality. It showed that the mass media had forced the potential complexity of human perception into a monotonous and one-dimensional straitjacket. It was their stylization of information and narrative which had given the media their "stimulating" quality, their entertainment value; and it was this quality which became the object of the artists' experiments. Content seemed of secondary importance – it was the language which fascinated them, the medium, the message.

Roy Lichtenstein's paintings revitalize the psychology of banal situations found in the world of the comic-strip, one of the most successful genres of popular entertainment. The drama of human relationships, which the comic conceals, is made transparent here. The drama smoulders under the clichés and "cool", professional design of the surface. The large format emphasizes and monumentalizes the effect of the content. This contrasts with his formal reserve in reproducing the impersonality and dot patterns of simple printing techniques. The contradiction between real and impersonal emotion is crystal clear.

There was one technical aspect of mass media production in particular which changed art. The media are mechanically produced in industrial cooperation between anonymous studios and factories. Within these cooperatives, a complicated system of production levels, personnel hierarchies and power structures determines the content of information and the means by which it is distributed. In order to counter this mechanism with their own "messages" and to render the the mass media system transparent, artists transfered structures found in the media – including their mechanical or impersonal production techniques – onto their work. In so doing, they altered their whole conception of themselves as artists, a conception hitherto characterized by subjectivity and individualism. "I want to be a machine," says Andy Warhol, the founder of an art "Factory" in New York, where pictures were reproduced using photographic clippings as models. Even confirmed painters like Robert Rauschenberg, Roy Lichtenstein and Jasper Johns spoke of the "depersonalization" and "anonymity" of their work.

The manner in which art was transformed by the mass media is also worth mentioning here. Pop Art influenced advertising, design and the bric-a-brac industry and was therefore returned to the everyday world in the form of seedy, secondhand junk produced by a parasitic mass communications industry. The image of the mass media, of the newspaper, the radio and television, was itself a theme of Pop Art; Pop artists thus developed their own extensive, contemporary iconography. It is interesting here to note the traditional character of most mass media communication, their use of conventional means of representation and outmoded formulae to propagate the "new". Their ideals of beauty, their idols and morality all conform to classical norms and romanticized patterns of feeling. The mass media are, in fact, progress-orientated, and yet their image of the human being is entirely retrogressive. At the same time, it is precisely this conventional factor combined with their ideology of progress which makes the media so successful. The works of Peter Blake, which combine traditional techniques with contemporary themes, provide a revealing illustration of this contradiction. They show us modern, even fashionable figures, framed by tradition and convention. Their pretension to modernity is expressed in the form of superimposed accessories: a social inevitability, for how else were the mass

I TRIED TO REASON IT OUT / I TRIED TO SEE THINGS FROM MOM AND DAD'S VIEW-POINT / I TRIED NOT TO THINK OF EDDIE, SO MY MIND WOULD BE CLEAR AND COMMON SENSE COULD TAKE OVER / BUT EDDIE KEPT COMING BACK...

Roy Lichtenstein
Eddie Diptych, 1962
Oil on canvas, two panels: 111.8 x 132.1 cm
Collection of Mr. and Mrs. Michael Sonnabend, Paris

media to replace the popular demand for tradition — for folk art, for example. The new folk art was designed to be popular and was adapted to "national character". It could only function by bringing the products it wanted to sell into line with conventional requirements and the visual and aesthetic habits attached to these.

The levels of meaning transported by commonplace imagery changed the cultural pyramid. The "high" art created by artists received a new function within this context. Business interest and the mass media were relieving the arts of their role as the vehicles of environmental design. In their own work the artists played on the keyboards of the media while subverting their structures and intentions, but the limits of what they could do in public were quickly established. They were almost entirely excluded from the public broadcasting channels and distribution systems; entry was strictly by commission only, or by application. Examples were Claes Oldenburg's projects for public places, or the art contributions for the New York State Pavilion at the 1964 World's Fair in

Richard Hamilton
$he, 1959/60
Oil, cellulose, collage on wood,
260.4 x 208.3 cm
Tate Gallery, London

James Rosenquist
Untitled (Joan Crawford says ...), 1964
Oil on canvas, 92 x 78 cm
Museum Ludwig, Cologne

New York, where Andy Warhol was forced to paint over his *Thirteen Most Wanted Men.*

Art diagnoses both the versions of reality transmitted by the media and the effects of these on people themselves. The human being lives with the TV set, a "receiver", but the interaction between transmitters and receivers is mere pretence. The artists responded to this state of affairs with a renewed sense of responsibility for the content of their work. The mass media generally excluded artists, or, at the most, integrated their work into their standard repertoire, exploiting it to expand their own range. The Pop artists saw through this mechanism. They neutralized the system of values which defined culture in terms of "high" and "low", trivial or valuable, by aligning their work with the average level of social awareness. By treating so-called "high" art in a banal manner, they subverted popular preconceptions which saw art and artists in terms of demanding and difficult contents, artistic aura and the *sine qua non* of originality. The process which now began to unfold provoked the astonishment and envy of established society: the trivial was suddenly dubbed art; the artists had descended onto the cultural lowground, and it was there that they had found the symbols and the true face of the age, images with which they identified, which they loved and hated. The contrast between their exposed status as artists and the triviality of their work amounted to a public repudiation of traditional notions of art: art could now be anything the artist wanted it to be.

In juxtaposing serigraphically reproduced images with abstract passages on their canvases, Robert Rauschenberg and Sigmar Polke give quite different painterly qualities equal weight within one composition. Roy Lichtenstein, in his drawings in 1958, shows Donald Duck and Mickey Mouse emerging from abstract-expressionist structures. There is no either/or here: art is the expression both of the personal condition and of the social bond. Freely formed structures have the same status as preformed images, personal signs stand on a par with·the iconographic symbols of mass society.

Works of Pop Art which take as their subject the marketing of sexist images of women show how the media industry forces women into traditional role structures. In his oil and mixed media picture $he – and in the sketches for it (1958-61) (p. 46) – Richard Hamilton investigates the reduction of the housewife to a sexist cliché, a theme already suggested in the ambiguous title. Her behaviour is standardized, her fashionable poses adapted to certain ideals of beauty and her longings are reduced to stereotypes. In a collage containing both abstract and figurative elements Hamilton introduces trivial aspects of everyday life only to withdraw them again from the main line of view, illustrating the deceptive nature of the theme. Hamilton demonstrates the penetration of the domestic world by male ideology and forcing of women into traditional role structures in his collage *Just what is it that makes today's homes so different, so appealing?* (1956) (p. 65). In advertising and in their Hollywood clichés men produce pin-up versions of women as marketable sex symbols.

The clichés of Hollywood and of the advertising industry are in fact the products of mutual coordination and cooperation: woman as one luxury accessory among others in a mass society dominated by men. James Rosenquist's painting *Untitled* (1964) (p. 47), which shows the screen actress Joan Crawford advertising a "mild" brand of soap or cigarette, illustrates the correlation between Hollywood and advertising – and the clichés they have in common. The artist has selected a section of the original illustration which gives the work a double meaning: an impersonal star is voicing an advertising slogan; but what, if anything, does this tell us about the person herself?

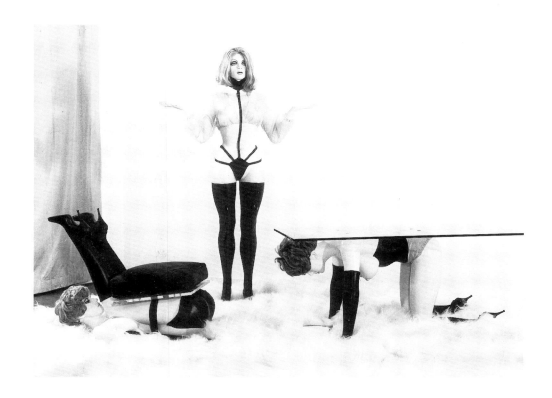

Allen Jones
Table, chair and hatstand, 1969
Painted fibre-glass, leather and hair, life-
size figures, series 6, No. 1
Neue Galerie, Aachen, Ludwig Collection

Marisol
Love, 1962
Plaster and Coca Cola bottle,
21 x 15.9 x 10.2 cm
Collection, The Museum of Modern Art,
New York

Rosenquist pretends to be showing us an unadulterated reproduction of a newspaper clipping. However, the nuances of colour and form, and, more especially, the restrictive compression of the section he has selected, amplify the expressive force of the composition and draw our attention to the obtrusive and stereotyped cosmetic beauty of Crawford's "face". Her proclamatory gesture seems absurd without the text of the advertisement, while the halved "O" turns the psychology of her superficial statement on its head. She now seems to be reacting with astonishment to something unseen, to be listening or taking something in – she appears to be surprised, irritated, perplexed.

The British artist Peter Phillips gives us a biting overstatement of the established roles ascribed to men and of the subliminal methods used in advertising. The car in *Custom Painting No. 5* (1965; p. 75) is a sex symbol, a projection of the male potency fantasy. The pictorial organization confuses the clarity of the banal innuendos, however; the interpenetration of alienated colour forms with one another and with mechanical symbols produces a chaos which is quite remote from the appealing pictorial order of the advertisement.

The pictorial language of the Californian painter Mel Ramos is less equivocal (p. 104). His "bogus" advertisements are the formal embodiment of professional advertising. He perfects both the packaging of the product and the sexual cliché which is normally supposed to establish the consumer's identification with it. We are shown an almost surreal exaggeration of the consumer substitute for satisfaction in a striking sculpture by the New York artist Escobar Marisol. Her theme is the faceless victim, the human object of marketing strategies which penetrate the sphere of human intimacy. The Coca-Cola bottle alone retains its obtrusive "face", its brilliant façade; the consumer's face is lost in the act of swallowing the product – a genital innuendo (p. 48).

The luminously aggressive colours and formal elegance of Allen Jones' paintings and sculptures (pp. 48, 49, 76) take the subject of sexual clichés and the objectification of women's bodies to the borderline of triviality, without becoming trivial themselves. The impenetrability which stems from their con-

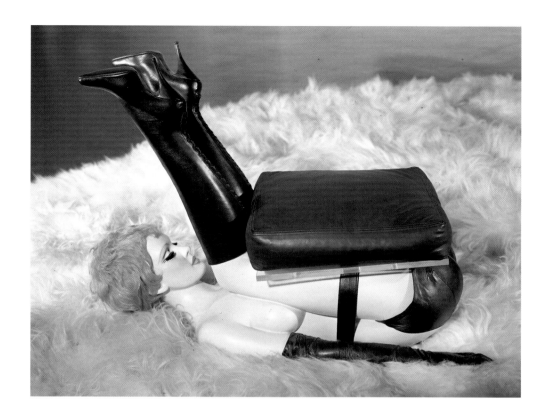

Allen Jones
Chair, 1969
Painted fibre-glass, leather and hair,
life-size
Neue Galerie, Aachen, Ludwig Collection

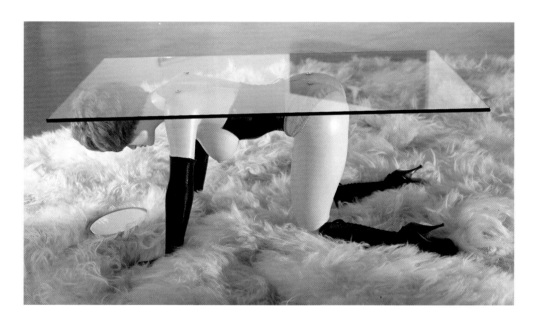

Allen Jones
Table, 1969
Painted fibre-glass, leather and hair,
life-size
Neue Galerie, Aachen, Ludwig Collection

stant alternation between unequivocal eroticism and cynical, provocative am-
biguity, interrupts the familiar voyeuristic process.

The study of the commercial media and their exploitation of popular idols
also led Andy Warhol and Roy Lichtenstein to alter their techniques. In his
paintings Lichtenstein simulated the stylized effect and dot patterns of mechani-
cal prints, while Warhol actually turned to using impersonal techniques of
mechanical reproduction. Both are interested gender clichés. The emphatic
stylization of Marilyn Monroe's or Liz Taylor's lips (p. 13) find their sexual
counterpart in Elvis Presley's energetic, aggressively virile pose as a Western
hero with a drawn Colt (p. 16). The black print on silver canvas lends the
gestural, mimic character of the figure a meaningless, almost sordid quality.

49

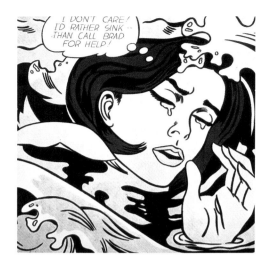

Roy Lichtenstein
Drowning Girl, 1963
Oil and magna on canvas, 171.8 x 169.5 cm
Collection, The Museum of Modern Art,
New York

The cinema-screen scale of the picture monumentalizes the masculine pose – an image whose repetitiveness gives this "star" his inflationary anonymity. Warhol's pictures deprive the idols of their power, but they also illustrate the suggestive power of images, especially those of the film industry. Roy Lichtenstein exploits the comic strip to record the nuances found in dialogues between figures representing established social roles in clichéd surroundings. He juxtaposes the sexual war fought by women with the fictitious war machinery of the male world. The mother and daughter figures in his *Eddie Diptych* (p. 45) of 1962 are close to one another pictorially, but they talk and think at cross-purposes. Eddie is absent, and yet his presence is felt; he dominates the scene via the dialogue. The picture is also about the dependency of children on their parents – a phenomenon professed by parents and expressed here by the cramped composition. Lichtenstein restructures the psychological mechanisms of the original comic illustrations so that trivial aspects become striking and banal emotions take on the contours of authentic human drama. In a world of mass communications where information is universally accessible and its oversimplification allows its consumers to believe they can understand everything and everyone, the personal relationship of a mother and daughter is disturbed. The clarity of Lichtenstein's pictorial order places its individual elements in a field of tension which lends a new dynamism to the false harmony of the original illustration. His *Mister Bellamy* (1961; p. 92) introduces us to a square-built, hollow soldier, a conventional but dangerous puppet, whose costume is decorated with the symbols of military power. "I wonder what he's like, this Mr. Bellamy," says the balloon (in allusion to the art collector Dick Bellamy). The soldier's soliloquy suggests that he needs a preconceived image of the unknown person before he can meet him. Life tends to ambush the unprepared – the soldier's prejudices are a protective shield. Here, too, Lichtenstein's extreme stylization of the scene gives its gloominess an uncanny effect. The human figure as a vehicle of warfare is deprived of its natural vitality by the artist's simulation of a cheap reproduction. The medium has become the message; comics take either a hard line or a soft line, simplifying human feelings and behaviour to suit mass taste.

These paintings give a striking portrayal of the relations between the mass media and society, showing how these affect our lives and our perceptions. The media provide us with a fully formed picture of the world and the people who live in it. The consumer sees himself and others through the eyes of the media. He experiences the world vicariously in the form of staged illustrations. The pictures he sees are realistic, so he believes they are real. His credulity deprives him of the ability to read reality himself, to recognize his own limits and constraints. He therefore loses his ability to see through the structures of the media. The achievement of the media is to make every individual feel personally addressed. They reduce the perceptions of individuals to the same denominator by adapting them subliminally to the products and mechanisms they are marketing. Despite their gigantic scale and complexity as a system, the mass media transmit their "messages" to people's homes simply and with confident agility. Conflicts between individuality and mass society thus seem neutralized. The cultural order has been reversed. Culture is no longer the creative work of a few individuals; instead, the machinery of mass communications produces new truths and new realities.

Pop Art penetrates this process. Its lifeblood is its fascination for the media, and it confesses to its seduction. It is as if the media had the hypnotic powers of a snake. Pop Art counters these powers with its own creative powers and with

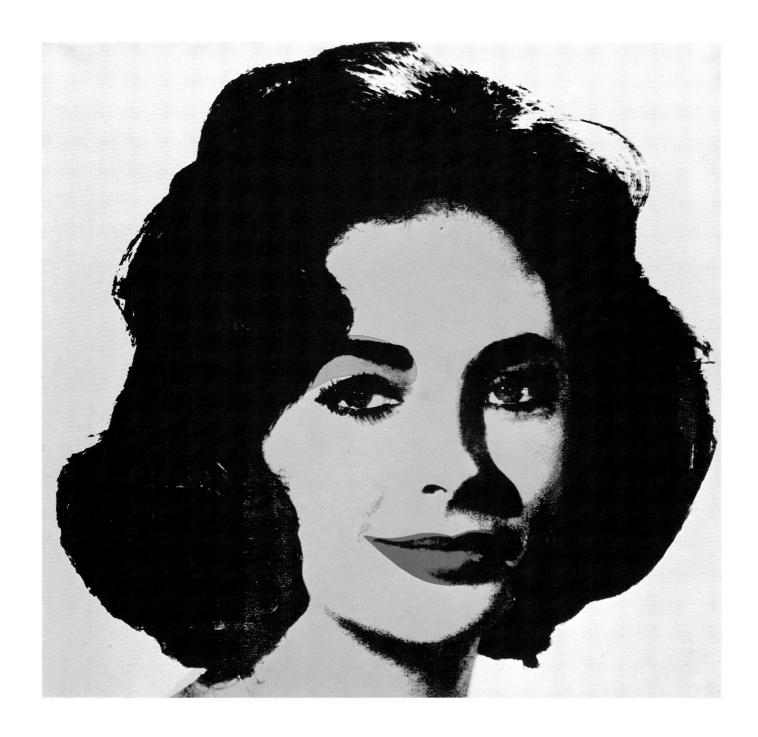

the self-confident stance of the individual towards mass society: the individual and the real world are the message. In their paintings and sculptures Pop artists show that the media have become an ominous and unavoidable reality which has radically changed our consciousness and our perceptions, our sense of values and our relationship to the world and to ourselves.

Andy Warhol
Liz, 1965
Screen print on canvas, 106 x 106 cm
Private collection

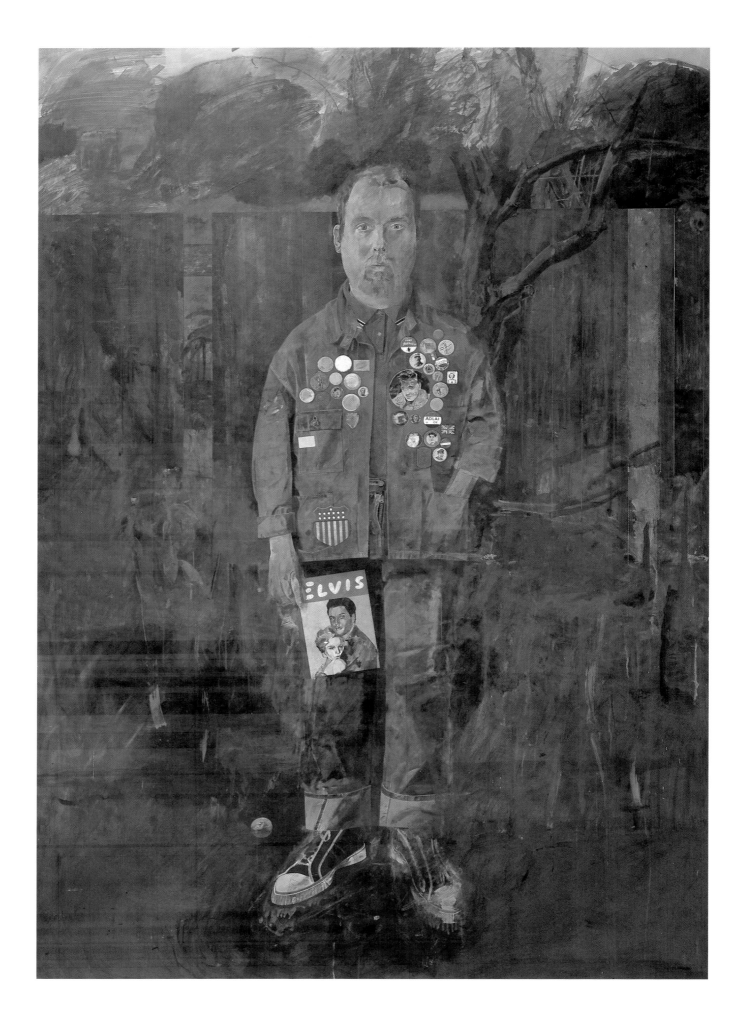

Anonymity and Subjectivity
The Styles of Pop Art

Pop Art reacted to the phenomenon of depersonalization in mass society with styles which were equally impersonal, with pictures which had an equally objectivizing effect. The media had changed the relationship between individual subjectivity and mass consciousness, and Pop Art therefore also wished to redefine the role of individuality in art. In order to come closer to identifying the Pop artists' motivation for using various techniques, it is worth looking at how they portrayed the individual in mass society and how they reflected both the human personality and its stereotypes in their work.

As Roy Lichtenstein's *Drowning Girl* (p. 50) shows, individuals cannot escape the blanket stylization and sentimentalism of the media. Society has become a voyeur, even of personal catstrophes. The media sensationalize these without disclosing what has led to them – a process in which the media themselves are implicated. For who can predict what effects the mass communications industries will have upon individuals in the long term, what subjective reactions and emotional responses may emerge? Individual fate is statistically too insignificant to hamper the optimism of the times. In Warhol's *Suicide Pictures* (p. 54) – sensationalist newspaper photographs repeated in cold and grimy rows on canvas – he exploits mass-media techniques to focus on the fate of the individual.

But how did artists see their own position in the societies and period in which they lived and worked? What personal views are expressed in their pictures? Does the impersonality of their styles preclude those moments of individual expression which would allow us to deduce their subjective stance? Self-portraits by Pop artists provide interesting answers to these questions. The fact that so few of these were painted is revealing enough in itself.

Andy Warhol emphasizes the anonymity of his personality as an artist by painting himself as faceless (1967;p. 55). Although he places his head in a contemplative position, he is really showing us a mask. The model he used for this *self-portrait* was a photograph he had taken with an automatic shutter release. He enlarged this and modified its colours in a series of silkscreen prints, inflating the image by repeating it mechanically in rows on the canvas. His use of insistent, bright colours gives the portrait the brash, superficial appearance of an advertisememt. The severe shadowing of the face and black emptiness of the background on the left of the picture suggest something obscure and melancholic in the portrait. It radiates a kind of spellbound tranquility.

A similar mood prevails in *Self-Portrait with Badges (p. 52),* painted in 1961 by the British artist Peter Blake. He portrays himself as an almost stupid-looking, helpless figure dressed in working (or workers') clothes decked with

Roy Lichtenstein
Self-Portrait, 1978
Oil and magna on canvas, 177.8 x 137.2 cm
Private collection

Peter Blake
Self-Portrait with badges, 1961
Oil on wood, 174.3 x 121.9 cm
Tate Gallery, London

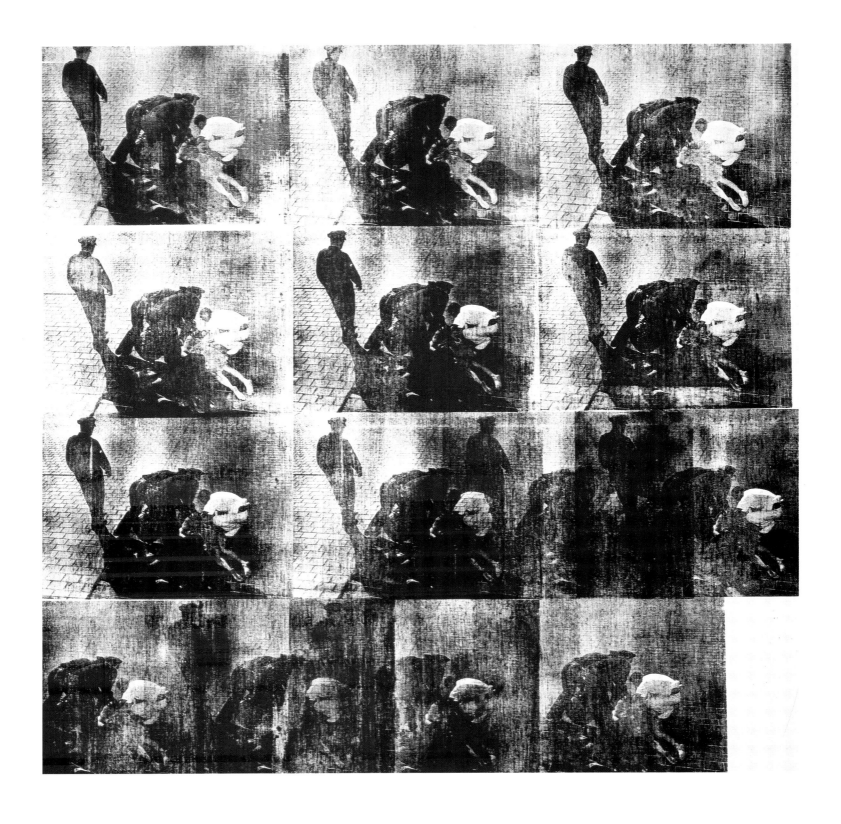

Andy Warhol
Bellevue II, 1963
Acrylic and silkscreen on canvas,
208.5 x 208.5 cm
Stedelijk Museum, Amsterdam

badges, including an American flag (the British one is almost too small to be noticed). The badges are identification symbols – signs of the Americanization of youth. He is fashionably dressed, in gym-shoes and jeans, and has an Elvis poster in his hand. This was the subcultural milieu which produced the Beatles generation. Clad in his bright blues and reds, Blake cuts a rigid, but insistent figure before a simple fence and trees which, though merging into an almost washed-out background of earthy browns and greens, are nonetheless significant. For this trendy, conformist "bloke" may think himself fully in the

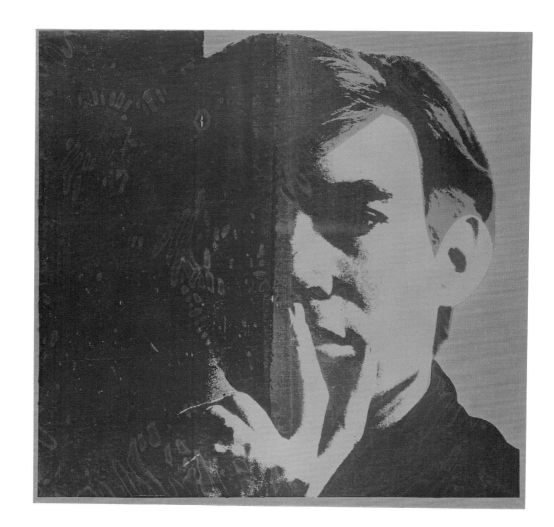

Andy Warhol
Self-Portrait, 1967
Acrylic and silkscreen on canvas,
180 x 183 cm
Saatchi Collection, London

picture, but the portrait has set him up against a background foil of what appears to be a kind of "natural" conservativism. The ambiguous subjectivity of the painting resides in the figure's searching, but apparently expressionless face.

Anonymity and the reproducible "self" appear in various guises. Jasper Johns reprints a photograph of himself on a plate as part of a collage whose theme is the environment (p. 157). Robert Rauschenberg veils his self-portrait photograph with a plastic foil. Both photographs look worn and are marginalized within the composition. Claes Oldenburg portrays himself on a column, once the site of a monument somewhere in London (p. 193). Dressed as "Mr. Average", his left hand in his pocket with a newspaper tucked under his arm, he seems about to launch into a speech or to point at something. As an "anonymous" artist, he attracts attention. He performs himself, creates his own, ironic monument!

Pop Art's conceptions of style stem from one of art's central themes, namely its concern with its own medium: art about art, the work of art as an object, the image, the act of painting, the painting itself, painting materials, packaging, art history, parody, abstraction, composition. Pop artists saw their work as anti-art, at least in relation to traditional notions of art. They expressed this in their depersonalization of style, their anti-subjectivism, in the roles they assumed in mass society and in their redefinition of art itself. The most spectacular examples of "art" as a theme of Pop Art are found in Roy Lichtenstein's *Big Paintings* and *Brushstroke* series of 1965 and 1966, respectively (p. 60).

"Business art is the step that comes after Art. I started as a commercial artist, and I want to finish as a business artist." ANDY WARHOL

55

Lucas Samaras
Self-Portrait Box, 1963
Construction in wood, red, white and blue
woolen thread, nails, 50 portraits of the
artist, closed: 9.5 x 15 x 11.5 cm
Saatchi Collection, London

These paintings ironize the inspired painterly gestures of Abstract Expression-ism and Action Painting, a style through which Lichtenstein, like other artists of his generation, had himself passed. He concentrates here on abstract forms and their moments of origin as things in themselves. This is a professional comic draughtsman's impression of a creative brushstroke. Lichtenstein's parody takes the theatrical heightening of pretentious meaningfulness to absurdity.

Lichtenstein's painting *Art* (1962; p. 58) indicates that the whole concept of art had become questionable. The two words which made up the term "Pop Art" implied that "art" was to become "pop". For when Lawrence Alloway coined the term in 1958 in Britain, he was joining together two contradictory concepts whose traditions were rooted in two quite distant camps in the cultural hierarchy. However, when placed in an everyday environment, these concepts became "classless" and actually belonged together – as the Pop Art of the sixties clearly showed. In his *Modern Art,* painted in 1968, Sigmar Polke guides art back towards the figurative by playing on the irritations caused by abstract art. He "paints" "modern art" in the way monkeys might be shown daubing on paint in a caricature. In doing so, he exploits typical prejudices and antipathies towards non-representational art. The painting nonetheless reveals the enig-matic quality of abstract signs and goes further than Lichtenstein in showing the freedom of the artist to choose from an unlimited range of materials. For by the sixties, artists had come to the conclusion that everything which had its place in the world also had its place in art, that there could no longer be areas outside

art. An abstract painting was no less a part of everyday life than any other trivial or fashionable accessory. The strokes across Polke's painting clearly signify that something has been repudiated, put aside; he has rid himself of a traditional attitude, a burden. This gesture resurfaces — although with the opposite intention — in Boris Lurie's crossed-out picture of a politician, though this had little to do with anti-art as such. As an exponent of the New York "No" group, Lurie rejected both superficial wit and works of Pop Art he saw as conformist.

In his *Sculpture in a Landscape* (1966; p. 61) the British artist Patrick Caulfield plays elements of abstract and figurative painting off against each other. He depicts an off-balance sculpture standing obtrusively in an anonymous landscape, painted like a comic. Sculpture and landscape are simplified to a banal graphic system, while the balance of colours is subtle and discreet. The trivial, simple, non-representational form seems particularly struck with its own importance in these surroundings: the awkwardness of art as a symbol of repressed creativity. Against this, he sets the livelier, freer contours of the landscape; its lines are more pleasing to the eye than this silly, irritating sculpture. The coexistence of sculpture and landscape in a new common reality appears in an uncertain light. The sculpture has become a thing, a concrete object — a stumbling block.

This theme exemplifies the intellectual, objectivizing side of Pop Art. Several artists, such as George Brecht, Robert Morris or John Baldessari, developed this tendency systematically at a conceptual level. In his picture *Quality*

Jim Dine
Double Isometric Self-Portrait (Serape), 1964
Oil, wood and metal on canvas,
144.8 x 214.6 cm
Collection of Whitney Museum of American Art, New York, Gift of Helen W. Benjamin in memory of her husband Robert M. Benjamin

Material (1967), John Baldessari paints a typographically arranged text which praises the artistic qualities of advertising: the text offers us quality material, careful service, good handiwork – in short, a perfect painting. Though his own "painting" is perfectly executed, its inner form lacks publicity appeal – it is too matter-of-fact, too sober, too cool. The painting questions our prejudices, our established criteria in judging quality in art. It is everything but pushy, repudiating the unoriginal, insistent tone of advertising by demonstrating the inadequacy of the aesthetics it formulates.

In an early pencil drawing in 1961, Robert Morris, who later became a leading exponent of Conceptual Art, manages to put an almost absurd idea of structural, non-representational art into practice. He signs the drawing at the bottom right and adds the date and formal principle: *37 Minutes, 3,879 Strokes* (p. 61). These 3,879 pencil strokes of about the same length and breadth are arranged in 15 lines and define their aesthetics through the process of their own origin. The underlying idea shows that while the strokes are meaningless and interchangeable in themselves, the repetitive and apparently anonymous technique which has produced them can establish a new aesthetics. Signs, material and time have fused to form a concrete entity.

In Jim Dine's graphic work and Arman's objects colour points to itself as an object through its own conspicuous materiality. Jim Dine's rainbow panels are constructed from nothing but colour, structures and surfaces; the picture is empty but for the flat primary colours of the rainbow – the symbol of euphoric hope. In the work of Robert Rauschenberg and Clive Barker, and in the paintings of James Rosenquist, banal things such as pots of paint, palettes, brushes and packaging materials – in other words, basic materials needed for the production and use of works of art – are converted into images and elements of sculpture. Jasper Johns made a sculpture in painted bronze: brushes dripping with paint put aside in an old coffee tin whose advertising

Nicholas Krushenick
Duckleswan, 1966
Acrylic on canvas, 213 x 180 cm
Stedelijk Museum, Amsterdam

appeal continues to captivate us in spite of the patina it has obtained through its use in the studio. The dirty painting materials, refined by the bronze – "refined" still further by the paint – have assumed the status of sculpture. Johns was interested here in the coexistence in an artist's studio of unrelated objects, the relationship between a trivial commodity article and apparently equally trivial artist's tools.

The styles of Pop Art were the product of the artist's development of technique and choice of subject matter. Their stylistic subjectivity and individuality, however, were neutralized by the anonymity of the environment to which their art responded. Pop Art followed various paths, some of them leading in opposite directions. The following were particularly significant: work whose forms and subject matter referred to the structures and methods of the mass media – by actually using mechanical techniques of reproduction, or industrial methods of manufacture (Warhol); or paintings in which the reference to the media takes place primarily through an analysis of their content, and the formal reference is simulated by means of various painterly techniques (Lichtenstein). Lichtenstein's intention in painting such precise representations of the original illustrations is to make us forget that we are looking at a painting. In Warhol's

Roy Lichtenstein
Yellow and Green Brushstrokes, 1966
Oil and magna on canvas, 214 x 458 cm
Museum für Moderne Kunst, Frankfurt/M.

work, subsequent to his early paintings (1960-62), the opposite is the case: his mechanical production techniques do not aim to be perfect, but intentionally include flaws and imprecisions.

In sculpture, the French artist Arman arranges large numbers of identical objects in box-like sculptures. The inflationary accumulation of consumer products, though these may fascinate the artist in themselves, deprives them of their value, turning them into junk, into mere garbage. George Segal places his impersonal plaster casts of lonely individuals in real, familiar environments. Tom Wesselmann, on the other hand, integrates real objects into the environments of his painted figures. Segal and Edward Kienholz offer stiking embodiments of two extremes: the apparently superficial submission to reality (Segal), and the expressive visionary intensification of reality (Kienholz). Claes Oldenburg makes small objects large and large objects small. In changing these he also changes the spectator's perceptions of them. Soft becomes hard and hard becomes soft; straight becomes crooked and vice versa; design dissolves into formless matter.

In Pop Art painting there are tendencies whose brash poster-like manner is so accentuated that we forget we are looking at a painting. But there is also work in which painterly technique has a central role. There are mixed media works or assemblages of objects and highly suggestive images, sculptures and environments of "found" reproductions, objects and materials. Then there are painterly, individualized structures, signs and symbols; then ingeniously executed sculptures and actions with figurative intentions. A comparison of paintings by the German artists Sigmar Polke and Gerhard Richter reveals that technique and expression often contradict one another at different levels of the work: Polke combines, alienates and trivializes techniques of representation which depict reality as a cliché; Richter's painting analyses the effect the process of reproduction has on its object. In British Pop Art we find abstract tendencies, in Eduardo Paolozzi's sculptures or Richard Smith's painting, and, by contrast, the highly personal figurative work of Peter Blake or David Hockney.

It was a combination of the spirit of the times, cultural theory and a shared understanding of the role of the artist which made Pop Art into a movement — irrespective of geography or generation. Its exponents, however, had extremely different views of the relations between art and reality, subject and object, content and form. Their contradictory opinions led to exteme polarities in the debate surrounding the term "Pop Art" itself — a concept with which the artists only partially identified, if at all.

At the end of the sixties, and particularly in Europe, Pop Art's ambiguous stance towards political reality and artistic tradition became the subject of a heated debate. Traditional criteria of value in art were employed in the sixties to question the "seriousness" of Pop Art; Dada had been similarly criticized in the twenties. Is it art's job to provide clear illustrations, explanations and criticisms of the relations in society? Can an art, whose chameleon-like deconstruction of the barriers between art and reality makes it both fully open to interpretation and as impenetrable as reality itself, activate our own discernment and creativity? The majority of Pop artists have indicated that works of art should fascinate us in order to expose their role as both the seducer and the seduced: the puzzling balancing act of a movement which rejected (self-) definition.

Robert Morris
37 Minutes 3879 Strokes, 1961
Pencil on paper, 61.9 x 49.5 cm

Patrick Caulfield
Sculpture in a landscape, 1966
Oil on cardboard, 122 x 213.4 cm
The Arts Council of Great Britain, London

Pop Art in Britain

British Pop Art arose out of a new understanding of contemporary life. It was intellectual, interdisciplinary and programmatic in character. Detailed study shows that its emergence as an artistic phenomenon was gradual, developing out of the wider cultural context in Britain at the time.

In the early fifties artists and intellectuals began to realize that their culture was increasingly determined by the mass media, by new technology and by social change, and that this process was also leading to the increased Americanization of Europe. This cultural transformation was not reflected in the introverted, expressive, abstract-figurative art of the older generation of British artists, such as Henry Moore, Graham Sutherland or Barbara Hepworth. It was, however, with these new conditions in mind that the Independent Group was convened in 1952 to hold informal discussions and cultural events at the Institute of Contemporary Arts (ICA) in London. Among its founding members were Richard Hamilton, who taught industrial design, the photographer Nigel Henderson, Eduardo Paolozzi, who was lecturing in textile design, the sculptor William Turnbull, the architects Theo Crosby, Peter and Allison Smithson and Colin St. John Wilson, the furniture designer Nigel Walthers and the art critics Reyner Banham – the organizational mind of the Group – and Tony de Renzio, the Secretary of the ICA. From 1953 these were joined by the band leader Frank Cordell and his wife, the painter Magda Cordell, the graphic designer John McHale and the art critic Lawrence Alloway. The Group was not large, nor did it convene particularly frequently. Despite their heterogeneous cultural and professional provenance, its members found an area of contact in the interdisciplinary interests of the Group. But it was also this heterogeneity which determined the sheer variety of subjects they discussed and the priority they attached to approaching problems from an anthropological rather than artistic point of view.

The topics discussed at their meetings can be listed as follows: the expansion of artistic techniques beyond traditional forms of representation, action painting, helicopter design, car-body design, nuclear biology, cybernetics (a new science at the time), folk culture, the mass media and municipal culture, machine aesthetics, advertising, the cinema, comics, science-fiction, "trashy" literature, pop music, fashion and the theories of Marshall McLuhan. These themes were indeed remote from the preoccupations of the cultural establishment of the time! They discussed them with the intention of bringing their alternative views to bear on contemporary cultural problems and of formulating a response adequate to the demands of their day.

Two members of the group, Richard Hamilton and Eduardo Paolozzi, are generally seen as the fathers of London's Pop Art. The starting signal was a

Eduardo Paolozzi
Page from Scrapbook "Mechanics and Handicrafts," 1949

Eduardo Paolozzi
I was a Rich Man's Plaything, 1947
Collage on paper, 35.5 x 23.5 cm
Tate Gallery, London

lecture held at the first meeting of the Independent Group in 1952. The lecture, entitled *Bunk,* was delivered by Eduardo Paolozzi, born of Italian parents and brought up in Scotland. *Bunk* was a kind of projected collage using pictures mostly from American illustrated magazines (LIFE, LOOK, Esquire), from comics and science-fiction literature; a jumble of images from the media and advertising. Projected onto screens, their insistent banality and trivial components were intensified to irritating effect.

Paolozzi was the only British artist to have started working with collages made up from comic strips, magazine clippings, commercial imagery and other trivia as early as 1947. In 1947, the year Kurt Schwitters, in exile in Britain, created his famous collage *Für Käthe,* Paolozzi made his collage *I was a Rich Man's Plaything* (p. 62) during a visit to Paris. It was reprinted in a lithographic edition, the *Bunk* series, in 1972. The collage exhibits precisely those trivial contents and formal characteristics which we have since come to associate with Pop Art: Coca-Cola, pin-up girls, militaristic elements and alienated typographical components – such as "Real Gold" or the combination of the words "True" and "Pop" emerging in a balloon from the mouth of a revolver. The original title *Highworth a Rich Man's Plaything (Bunk)* was an ironic comment on the affluent society, a parody of the total accessibility of products and images and of the games played with reality, or what the media considered to be reality. "Bunk" is, of course, rubbish, and apart from the noise "pop", "pop" probably already meant popular here – in the sense of light entertainment (and, later, "pop music"). The themes encompassed by its textual and pictorial elements included private life, practical thinking, the combination of images, domestic affluence, the politics of society and Americanism, reflecting at different levels the essential ingredients of the media age which was emerging after the Second World War. The *Bunk* and *Scrapbook* collages – as Paolozzi called them – of the early fifties were the first works of Pop Art. His lecture was the first event to subject the trivial world of media imagery to theoretical analysis and discussion.

ABOVE LEFT:
Advertisement for modern wall paper

ABOVE RIGHT:
Eduardo Paolozzi
Untitled, 1949
Collage on paper, 39 x 25.8 cm
Collection of the artist

Richard Hamilton
Just what is it that makes today's homes so different, so appealing?, 1956
Collage, 26 x 25 cm
Kunsthalle Tübingen, Tübingen

Exhibition "Parallel of Life and Art," 1953
Institute of Contemporary Arts, London

Richard Hamilton
This is Tomorrow, Perspective of Exhibition,
1956
Collage and ink on paper, 30.5 x 47 cm
Petersburg Press, London

The Independent Group made no attempt to disguise the fact that their critical engagement went hand in hand with a sympathetic attitude towards the popular clichés of everyday life. The self-identification of the artist with the mass media society was one of Pop Art's essential characteristics. The general theory developed in the Group's discussions found its expression in the events they held at the ICA. In 1953 Paolozzi, the photographer Nigel Henderson, the architects Allison and Peter Smithson and the engineer Ronald Jenkins organized the exhibition "Parallel of Life and Art", a synopsis of photographs from magazines such as LIFE, American Vogue, Art News and Contemporary

Peter Blake
On the Balcony, 1955/57
Oil on canvas, 121.3 x 90.9 cm
Tate Gallery, London

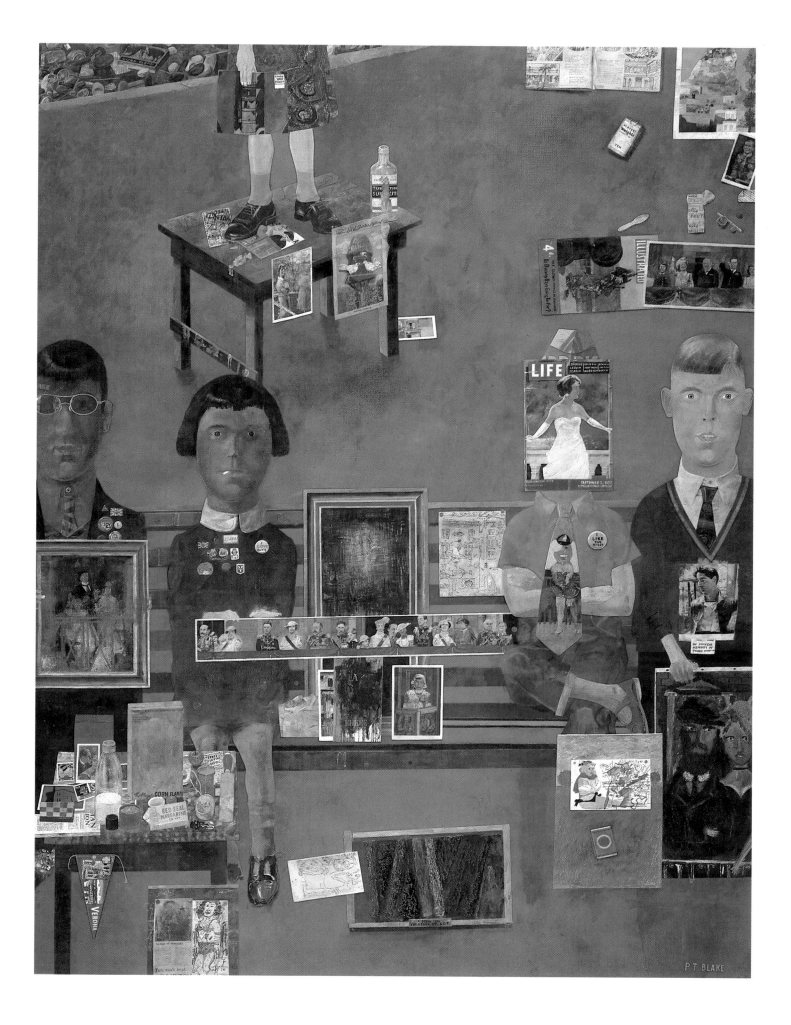

Peter Blake
The Fine Art Bit, 1959
Enamel and mixed media on wood,
91.4 x 61 x 25 cm
Tate Gallery, London

Future, and from encyclopedias and scientific literature. The exhibition in-
cluded newspaper photos, X-rays and photographs of ruins, as well as historic
examples of motion photography by the Frenchman Etienne Jules Marey and
the American Eadweard Muybridge; there were also anthopological ma-
terials, children's drawings and graffiti. Under the heading of "Art" were ex-
amples of classical art, tombstone sculpture (George VI), non-European cul-
tures, Jean Dubuffet and Jackson Pollock. As far as exhibition technique was
concerned, the project also broke new ground, for the pictures were not shown
in the original, but were enlarged; nor were they merely hung from the walls,

but also from the ceiling. It was in fact more like an Environment than an exhibition, for.the visitor was forced to make his own way through its perplexing arrangement of exhibits and to make his own decisions about where to stand, how to look and what to think. The sources of the exhibits were not categorized in the exhibition itself, but in what looked more like a department store catalogue than an exhibition catalogue, under the headings: Scale, Anatomy, Architecture, Art, Calligraphy, Motion, Nature, Primitivism, Stress, Football, Science Fiction, Medicine, Geology and Material.

The central themes of Pop Art were sub-culture, folk cultures, media imagery, new technologies, design, the consumer goods and engineering industries, the inter-relationships between these phenomena and their effect on human beings. In 1955 Richard Hamilton planned and designed the important exhibition "Man, Machine and Motion" at the ICA. In content, this was reminiscent of László Moholy-Nagy's work *Vision in Motion,* created in Chicago in 1947, and also of the book "Painting, Photography and Film" published by the Bauhaus in 1927. The themes of the exhibition were the correlations between

Richard Smith
Package, 1962
Oil on canvas, 172.7 x 213.3 cm
Centro de Arte Moderna, Lisbon, Fundação
Calouste Gulbenkian

David Hockney
Two Men in a Shower, 1963
Oil on canvas, 152.4 x 152.4 cm
Waddington Galleries Ltd., London

Man and the machine, and photographic reality as a substitute for the human imagination. The thematic complex linking technology, the mass media and modern mass culture was a kind of exposition of the new position of the individual in mass society, and, as such, expressed the need for a new concept of art, a demand clearly also made by the earlier "Parallel of Life and Art" exhibition. This new multi-media concept of art is also formulated in Hamilton's programmatic collage *Just what is it that makes today's homes so different, so appealing?* (p. 65). He had conceived this as a design for the catalogue and poster of the exhibition "This is Tomorrow," whose themes were multi-media

Derek Boshier
First Tooth Paste Painting, 1962
Oil on canvas, 76.4 x 137.4 cm
City Art Galleries, Sheffield

art, communications, domestic reality, design and technology. The exhibition was held by the Independent Group in 1956 at the Whitechapel Gallery in London (p. 66); the title of Hamilton's collage was an advertising slogan. Paolozzi's and Hamilton's contributions – their archeological and mythical relics, robots and images of Marilyn Monroe – were of central importance. Spatial distortions and unusual formats gave the exhibition the character of a fairground. The architectural contributions of the Smithsons were symptomatic of the ICA's increasing number of home décor and furnishing projects.

Besides the Independent Group member Reyner Banham, Lawrence Alloway was one of the first critics to write on Pop culture. It was during these years, too, that he wrote his critical analyses of Hollywood films. His writings and statements show that theoretical work on modern popular culture preceded Pop Art itself. According to Alloway, he had been using the terms "pop culture" and "pop art" since 1958 to refer to "mass-produced culture" rather than to works of art. The term "Pop Art" had then been increasingly employed to describe new works of art produced in this period and, in this way, had spread to become the central stylistic concept of the Pop scene and a synonym for the cultural movement of the period in general.

Past, present and future, utopia, the assimilation of reality, the problems of perception and the relationship between mass-produced imagery and the individual imagination – these were the coordinates of a new "anthopological culture" (Alloway) in which art had confidently set out to develop its own ideas and forms. In a letter to the Smithsons, Hamilton listed the epithets he associated with Pop Art: "popular, transient, expendable, low-cost, mass-produced, young, witty, sexy, gimmicky, glamorous, and Big Business." The home of this new kind of art was far from the art establishment, outside the area defined by art criticism and museums. In 1958, Lawrence Alloway published his essay "The Arts and the Mass Media" which, focussing on the contemporary period,

PAGE 72:
R.B. Kitaj
Kennst Du das Land, 1962
Do you know the Country
Oil on canvas, 121.9 x 121.9 cm
Marlborough Fine Art Ltd., London

PAGE 73:
R.B. Kitaj
Good News for Incunabulists, 1962
Oil on canvas, 155 x 155 cm
Waddington Galleries Ltd., London

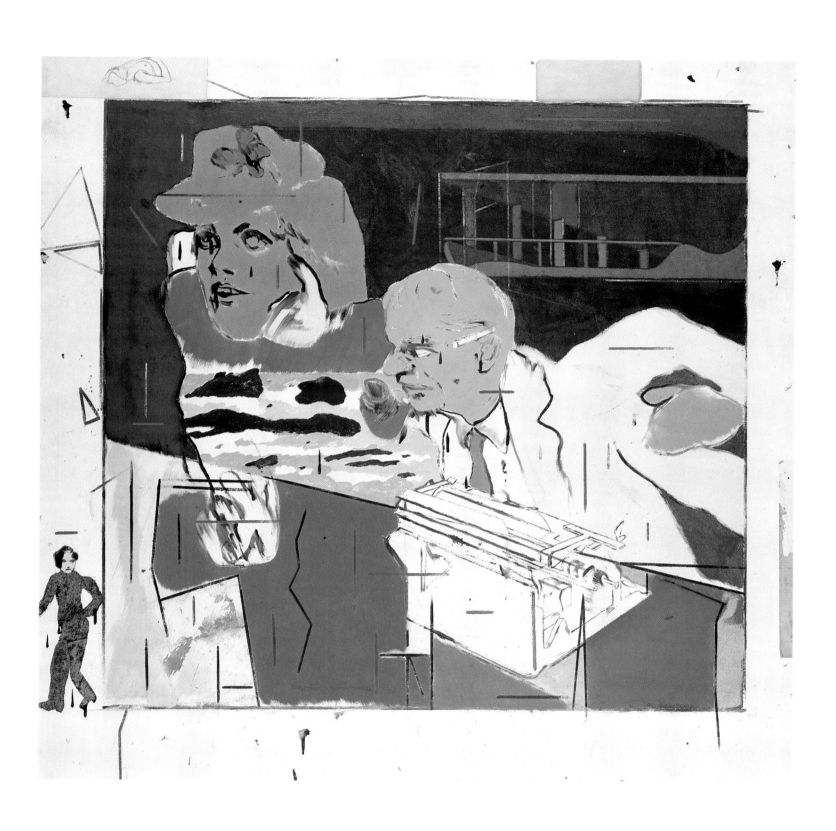

Peter Phillips
Lion Versus Eagles, 1962
Oil on canvas, 213 x 152.5 cm
Museum van Hedendaagse Kunst, Ghent

contained a résumé of all these developments and an "anthopological defini-
tion of culture" which made all forms of human activity the object of aesthetic
judgement and appreciation. It was while the first theoretical foundations of
Pop Art were being laid that Hamilton painted his programmatic work *Hom-
mage à Chrysler Corp.* (1957).

Richard Hamilton was teaching design at the Royal College of Art in
London, where the young artists Peter Blake and Richard Smith were studying.
Paolozzi taught textile design from 1949 to 1955 at the Central School of Art
and Design in London, and from 1955 to 1958 at St. Martin's School of Art, also
in London. Blake and Smith belonged to the second generation of British Pop
Art. Blake's work inclined strongly towards figurative realism, while Smith
tended towards pronounced abstraction. At "The Young Contemporaries"

"The main motif, the vehicle, breaks down
into an anthology of presentation. . . . Pieces
are taken from Chrysler's Plymouth and
Imperial ads, there is some General Motors
material and a bit of Pontiac."

RICHARD HAMILTON

exhibition in 1959, Smith showed his picture *Blue Yonder* which, although still abstract and expressionistic, was influenced by the first wave of American Pop. Blake's work reflects the position of the individual in mass society. Smith, on the other hand, reacts to the changes in the structures of visual perception brought about by the mass media: brash visual effects, simplified relations between colour and form, dynamic pictorial rhythm, optical clarity and high-speed image legibility, compositional polish and colour dynamics reminiscent of neon advertisements and colour television, or of the banal layout of cigarette packet designs.

While the first phase of British Pop Art had focussed on preformed media imagery, the impulses for its second phase came from a more immediate appreciation of changes in society and their influence on the personality. During this period Blake was working on collages, assemblages and paintings which combined mass-produced imagery with abstract signs and suggestively decorative fields of colour. Even abstract painters like Robyn Denny used the pure colours and generous arrangements of form in their non-representational compositions to refer to the new levels of perception and the relation of these to the new subject matter in art – as the ironic titles of his paintings suggest.

The influence of Pop Art spread quickly, both in geographical terms (Cambridge University) and among the younger generation. In 1958, R. B. Kitaj came to London on a scholarship and decided to stay on there. It was largely due to his influence that British Pop Art responded with such intensity to American imagery and the early phase of American Pop Art. Later, Richard Smith (1959-61) and Peter Blake (1963) visited America themselves. A third phase of British Pop Art developed and made its presence publicly felt for the first time at the exhibition "Young Contemporaries" in 1960 – the first exhibition to provide a general survey of the new art movement. Once again, Lawrence Alloway, who had been working for the Tate Gallery since 1950, wrote the text of the catalogue. He did so without using the term "Pop Art" for these young

Peter Phillips
Custom Painting No. 5, 1965
Oil on canvas, 172 x 300 cm
Zurich, by courtesy of Galerie Bruno Bischofberger

PAGE 76:
Allen Jones
Perfect Match, 1966–67
Oil on canvas, three parts, 280 x 93 cm
Museum Ludwig, Cologne

PAGE 77:
Allen Jones
Something Like Sisters, 1962
Oil on canvas, 213.5 x 213.5 cm
Hamburger Kunsthalle, Hamburg

artists, all of them students at the Royal College of Art since 1959/60: Barrie Bats (identical with Billy Apple, his pseudonym), Derek Boshier, Patrick Caulfield, David Hockney, Allen Jones, R.B. Kitaj, Peter Phillips and Norman Toynton. This generation was highly individual, critically exploring a wide range of figurative themes and aspects of form and composition in painting, drawing and graphic techniques. Several of the artists had, in fact, already distanced themselves from the term "Pop Art".

Kitaj's pictures — painting, collage and sharply defined graphic elements — and his drawings focus on personal relationships and human activity in interiors and exteriors (p. 72, 73). There is a ludic tendency here, a predilection for the combination of contradictory techniques and figurative details. The energy of the pictures derives from their narrative movement and compositional intersections: he composes a kind of chaos with narratives leading the eye in different directions, with various centres and climaxes. He sees colour as a self-sustaining energy: his use of it has the brashness of the reproduction while managing to be painterly at the same time. Unrelated signs and abstract forms either underline or withdraw connections, gestures, actions or movements suggested psychologically or dialectically. Kitaj links personalized elements with stereotypes at various levels, combining or reflecting standard types borrowed from the mass media or from art history and relating them to both figurative realism and levels of abstraction. He projects his figures and space onto a plane so that the painting has the appearance of a foil packed with dynamism, allusions and irritations.

Kitaj was not the only artist to use his pictures as a screen for the projection of traces of contingent reality along with his own, more personal signs. Derek Boshier also painted the conflict-ridden interface of internal and external human reality (p. 71). Boshier's expressive Pop paintings concentrate on the interplay of glamour and decadence, euphoria and fatalism, ambition and ruin. Painterly passages have a prominent place in his work and are used to emphasize the thematic background. His paintings might be described as visions of a negative utopia. The individual is devoured by technological progress, drowned in secondhand imagery and mass-produced models. This restless torment takes place before a façade of meaningless measuring devices, indices, coordinates, registers and scales. The cold language of calculation symbolizes the oppressive manipulation of the helpless human being and his environment: an increasingly Americanized "ratrace," as Boshier called it (cf. also the American Jim Eller's use of the word "rat" in his *Scrabble Board*; p. 106).

Against the ironic cynicism of Boshier's reflections on a world threatened by progress, David Hockney set his very personal picture of private lives (p. 70). Hockney reveals yearning, hope, the sheer existence of a place like Hollywood with its dreamlike idylls become reality, relationships, love, homsexuality and beauty as the sources of a liberating energy. His paintings suggest layers of romantic feeling, attempts to liberate the self from its clichéd surroundings. While his early work is aggressive, wild, restless and dynamic (1960-62), his work in the late sixties radiates a serene tranquility — a harmonious reality. His painterly technique and fine use of line reveals the nuances of relationships and detail. He confronts the all-affirming consumable amusement and statutory contentment propagated by the media with his own, very personal ideas of happiness.

Allen Jones' paintings and sculptures took sexuality to be the dominant theme of the new era and explored an ideal of female beauty which had

Joe Tilson
A – Z a contributive picture, 1963
Painted construction in wood,
233.7 x 152.4 x 102 cm
Collection of the artist

OPPOSITE PAGE:
Eduardo Paolozzi
The Last of the Idols, 1963
Aluminium, oil paint, 244 x 61 x 11 cm
Museum Ludwig, Cologne

Joe Tilson
Painted Vox-Box, 1963
Painted wood, 152.4 x 121.9 cm
Tate Gallery, London

become merely superficial (p. 48, 49, 76, 77). The insistent nature of Boshier's scenes refers us to the hollow euphoria of a preprogrammed eroticism with sadistic features. He concentrates on flashy, demonstrative colours in his paintings; their vitality derives mainly from their complementary reds and greens. Their drastic vulgarity gives them a hybrid quality; they appear to hover between advertisement and art. In Allen Jones' work the new gods are pin-up girls, whereas in Paolozzi's sculptures of the sixties they are machines — technically overwrought things which look like giant toys or robots (p. 78).

The representatives of the third, and last, generation of Pop artists whose use of media language was the most prounounced, the most conceptual and intellectual were Peter Phillips, Patrick Caulfield and Joe Tilson. Phillips translates his conception of the machine age into dynamic forms, uninhibitedly exploiting the language of advertising (p. 74, 75). He sees technology as the mirror of natural and vital laws which technology, in turn, deceives, commercializes and destroys. His harsh paintings visualize the nightmare of a vicious circle releasing its aggression, propaganda and chaos into an overcharged atmosphere. Painterly passages are never free of function in Phillips' paintings; as planes of pure colour, they always serve to underline the content — as is also the case in commercials.

In his early reliefs, Joe Tilson exploits professional techniques of advertising and photo design, tightening them up and concentrating them into bewilderingly enigmatic statements. The confrontation between typographical and pictorial components turns banal and self-evident elements into riddles. He expresses words like "Vox", "key", "secret" and "Oh!", evoking the power of the human voice and reactions, in urgent typographical forms and confronts them with the stylized symbols of a savage reality. The combinations of images and texts are like alienated versions of the stereotyped picture/key explanatory techniques found in children's books, picture puzzles, instructions and other codes. In his *Vox Box* (1963; p. 80) explanation marks in a mouth become teeth; a caustic language is made aesthetically and typographically visible; its tones are insistent, biting, persuasive, appealing, agitated and defensive.

Pop Art in Britain — as in America — was an art about art and style. In what follows, I shall introduce two works by members of the younger Pop generation which fall back on more conventional means. Joe Tilson's work *A − Z a contributive picture* (1963; p. 79) is an encyclopedic collection of art and the questions relating to it, a diagramatic assemblage of trivial objects. A number of artists, members of Tilson's family and friends contributed to it; their contributions are like "objets trouvés", objects found in everyday life. Among the artists were: Frank Auerbach, Peter Blake, Clive Barker, David Hockney, Eduardo Paolozzi, Bob Freeman, Harald Cohen, Allen Jones, R. B. Kitaj, John Latham, Tony Messenger, Peter Phillips, Richard Hamilton, Richard Smith, Anthony Caro and Brian Wall. Joe Tilson himself added the "NO" and "?" to the box and made the attachment "A − Z" in the form of a radiant star — reminding us, perhaps, that the stars and gods of art come and go.

How different the loneliness of the Cubist painter Juan Gris in Patrick Caulfield's *Portrait of Juan Gris* (1963): the famous painter looks as if he has been inserted into an infantile comic drawing, a "typical" middle-class conformist, helplessly exposed to an artistic sign language which has grown independent of him. The roles are reversed: the abstract signs can now be taken for granted; it is the new figuration which seems alien. To the classical Cubist artist Juan Gris, the world of Pop is foreign, whereas to the Pop artist, it is the Cubist formalism which is alien. Reducing colour and line to familiar, trivial

patterns, Caulfield portrays an artist who attempted, with his abstract composi-
tions, to free art of those very same elements of triviality. Caulfield's pictures,
themselves like illustrations, show that a strictly avantgardist development in art
could no longer be expected after Pop Art. Both the achievements and fashions
of previous art had been more or less swamped by the dictates of the present.
Pop Art had stepped outside the traditional boundaries of artistic development
to tread the path of self-analysis within a consciously perceived and reflected
present-day existence.

Patrick Caulfield
Artist's Studio, 1964
Oil on wood, 91.4 x 281.4 cm
The Arts Council of Great Britain, London

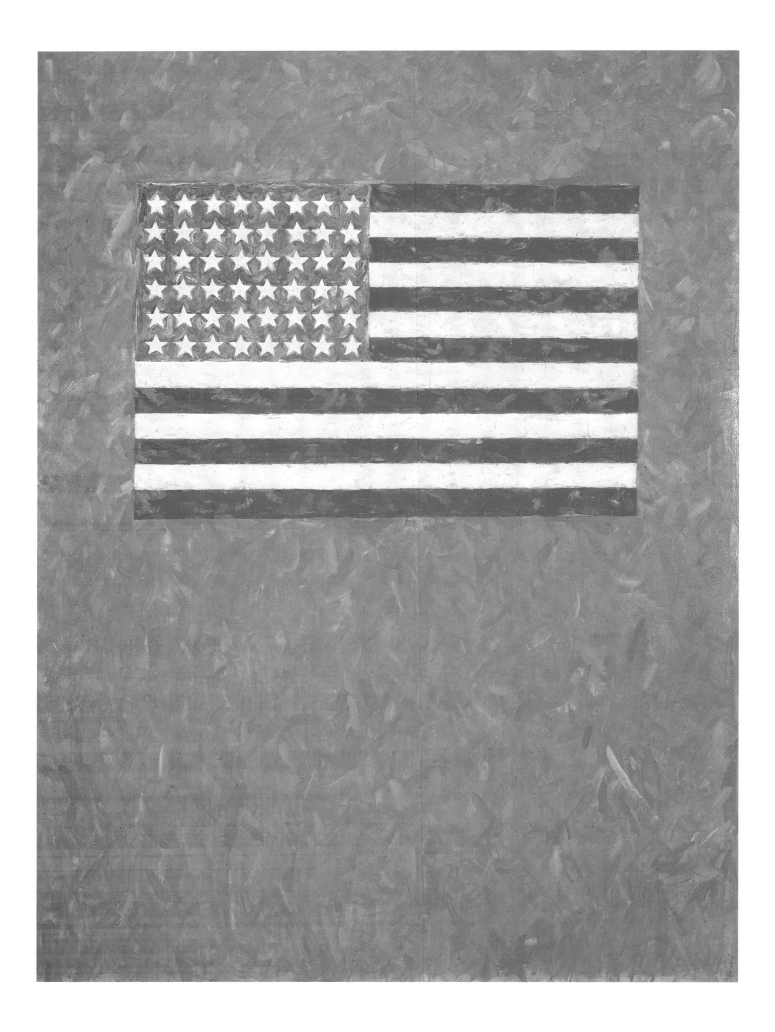

Pop Art in America

American Pop Art was a child of the newly found self-confidence with which American art had asserted itself in the fifties against European influence. The subject matter which provided the intitial impulse was Americanism itself. The idea of progress, the media industry and the star-cult were experiencing a boom in Hollywood and, more especially, in New York, the cultural centre of the USA. In relating their art to the present day, artists were able to build on New York tradition. Around the turn of the century, the Ash Can School had sought its roots in the milieu of American everyday life – especially that of the "lower classes" – and had repudiated the "l'art pour l'art" of European Impressionism. At the great Armory Show of 1913 in New York, American artists had demonstrated an inclination for European abstract formalism; but they had also exhibited a regional art whose subject matter was American life, the new technology and the dawning media age. These antithetical positions – a more introverted art on the one hand, which was centred on formal accomplishment, and, on the other, an art committed to material reality, to the world about it – continued to unfold throughout the twenties and thirties. During the upheavals of the forties and fifties, the generation which preceded Pop Art brought forth a new tendency in realism using contemporary subject matter, which paved the way for the American art of the sixties. Guided by the changes which were occurring in society, a younger generation of artists had begun to outgrow the abstract-expressionist style of the fifties, whose development and success they had partly experienced themselves as pupils, and to replace it with a new art of contemporary relevance.

A work by Robert Rauschenberg, *Erased de Kooning Drawing* (1953; p. 83), is highly symbolic of the process by which this generation cut through its umbilical attachment to the preceding one. It documents the act of eliminating, eradicating, rubbing out one of Willem de Kooning's abstract-expressionist drawings. The traces of this action, the smudges, are clearly visible on the paper, the original outlines of the drawing can only be guessed at. De Kooning had no objection to Rauschenberg's intervention and provided him with the drawing himself. From 1951 to 1953, Rauschenberg had been painting monochromatic pictures with fabric patterns, while de Kooning had begun to introduce elements of collage into his paintings. His first attempt at this after 1950 – with the Camel advertisement – when he was beginning his series of female figures, was discarded, however, and in 1956 he began to introduce newspaper print into his painting *(Easter Monday*, 1956). De Kooning had gained his reputation as a leading exponent of Abstract Expressionism; but his figural themes (women, Marilyn Monroe) and artistic temperament enabled him to follow the activities and ideas of the younger generation.

Robert Rauschenberg
Erased de Kooning Drawing, 1959
India ink and traces of pencil on paper,
48.3 x 36.8 cm
Collection of the artist

Jasper Johns
Flag on Orange Field, 1957
Encaustic on canvas, 167 x 124 cm
Museum Ludwig, Cologne

Rauschenberg's encounter with John Cage, who was teaching at Black Mountain College, was highly significant both for his own artistic development and also for the direction later taken by American Pop Art. The composer Cage was intensely interested in Zen Buddhism, in the incorporation of chance into artistic technique and in absorbing levels of trivial reality into his musical language, which he composed as a kind of objective process, or action. It was Cage who posed the first important theoretical questions about the relationships between art and the media, between representation and reality: Was a truck in a music school more musical than a truck driving past on the street?

This "nonsense" question, which was both seriously meant and seriously taken by those who heard it, was followed by another, which, for some time, dominated, or rather disturbed, the art scene in general, and the first critical interpretations of Pop Art in particular. Jasper Johns, who was painting his first American flag pictures at this time, added the absurd question: "Is it a flag or is it a painting?" Johns' intention here was to subvert prevalent conceptions of reality and certain habitual modes of perception, and, at the same time, to open the channels through which art was mediated for a new, objectivist realism (this had also been Cage's intention with the example of the truck). Johns, who had moved into the same studio neighbourhood as Robert Rauschenberg in the middle of 1955, is generally seen as being the second most important figure of pre-Pop art in New York. In 1958, his post-1954 flag and target paintings were shown in a private New York gallery and provoked quite a controversy. Johns' pictures subverted the structural approach of the New York art scene and undermined what was generally expected of art. There was an important

James Rosenquist
President Elect, 1960-61
Oil on fibreboard, 213.4 x 365.8 cm
Musée National d'Art Moderne, Centre
Georges Pompidou, Paris

Robert Rauschenberg
Quote, 1964
Oil and silkscreen on canvas, 239 x 183 cm
Kunstsammlung Nordrhein-Westfalen,
Düsseldorf

PAGE 86:
Larry Rivers
Europe I, 1956
Oil on canvas, 152 x 102 cm
The Minneapolis Institute of Arts,
Minneapolis

PAGE 87:
Larry Rivers
Friendship of America and France (Kennedy
and de Gaulle), 1961-62
Oil on canvas, 130 x 194.3 x 11.1 cm
By courtesy of the Marlborough Gallery Inc.,
New York

parallel here with Marcel Duchamp's *Ready-mades* (pp. 129, 130). The realistic representation of trivial reality was not as important to Duchamp as it later became in Pop Art. His ready-mades, however, were intended as attacks on traditional concepts of art and art museums. Duchamp had lived in New York since 1915. His work was naturally an inspiration to the Pop movement, not only in America, but also in Europe, where a new generation of object-artists and neo-Dadaists – and their exegetical followers – more or less knelt at his feet. It is worth remembering that the British artist Richard Hamilton reconstructed several of Duchamp's most important works, *The Big Glass,* for example. Although both had started out from Abstract Expressionism, Johns and Rauschenberg went very different ways. Johns painted or sculpted trivial objects as real objects, but his brushwork was painterly and reminiscent of abstraction, or Impressionism. He builds his compositions so that the trivial objects themselves often seem abstract. Rauschenberg combined different techniques. He trans-

Robert Indiana
Cuba, 1961
Painted wood and metal,
112.7 x 14.3 x 36.5 cm
Private collection

George Brecht
Repository, 1961
Assemblage: wall cabinet containing pocket
watch, tennis ball, etc, 102.6 x 26.7 x 7.7 cm
Collection, The Museum of Modern Art,
New York, acquired through the Larry
Aldrich Foundation Fund

ferred newspaper and magazine photographs by "frottage" onto his "combine paintings", juxtaposing them in collages or assemblages with banal objects and materials. He then confronted these contemporary icons with passages of free, abstract painting or drawing. The result of this interaction is that the abstract passages emphasize or alienate the trite realistic elements or objects; and, vice versa, the commonplace things of everyday reality crowd the abstractions and dynamize, or relativize and subvert, their intensity.

One of the artists who had begun to paint trite or "vulgar" subjects in the fifties was Larry Rivers, whose pictures, both at that time and during the early sixties, reflected American historical clichés and rendered them banal (p. 86). Because of his unorthodox method of painting and drawing these meaningful subjects, he became an inspiration to the younger generation of Pop artists.

The use of collage and assemblage, of simple techniques borrowed from the media and commercial design and the direct incorporation of levels of contingent reality into painting and sculpture sparked off a number of debates and experiments in the late fifties which were centred on a new art, indeed on a new understanding of art altogether. The issue at stake here was not so much that of the status of trivial material in art, but whether art could do creative justice to this important new subject matter, and what the nature of its encounter with the products of the media should be. To what extent should art allow itself to become trivial in order to unmask triviality? Responding to this challenge, the New York artists did not look for their solutions in theory or by forming stylistic groups, but by examining their own experience of everyday life and artistic techniques. In so doing, they arrived at very different conclusions and produced highly individual paintings and sculptures. They also explored the way in which the context which had produced these questions was constantly changing and throwing up new questions.

The American artists' eclecticism and easy access to a wide range of techniques and materials also explain their freedom in exploiting art history. In recreating previous artistic achievements as commonplace images, they manage to be entertaining, ironic, serious, playful and naive. With apparent disrespect, Roy Lichtenstein both lays bare and renews time-honoured, well-established values in art. The act of recasting the resplendent aura of a work of art – an aura generally considered to be timeless, unshakable, final, eternal – is not directed against the work of art itself, but against the *a priori* respect it commands, against the idolization and false sentiments of its environment. To the self-respecting American artist of the sixties, any form of subservience to established values was an insult to his self-esteem.

The development of American Pop Art occurred in four phases, marking different responses by artists to the challenge of their times. The first was the pre-Pop phase, in which Johns and Rauschenberg took their leave of Abstract Expressionism. Then came the heyday of Pop Art: This phase saw the emergence of a number of important artists whose work was rooted in the fifties and partly founded on experience acquired in commercial art, design and poster-painting: Andy Warhol, Roy Lichtenstein, Claes Oldenburg, James Rosenquist, Tom Wesselmann and Robert Indiana. Quite independently of one another, these artists went about translating objects and human figures into vehicles of generalized statement.

With the sponsorship of certain committed and experimental New York galleries, this phase of Pop Art quickly – despite clearly voiced protest – achieved success and recognition as a new art movement. The exhibitions were variously accompanied by Happenings, theatre performances, counter-dem-

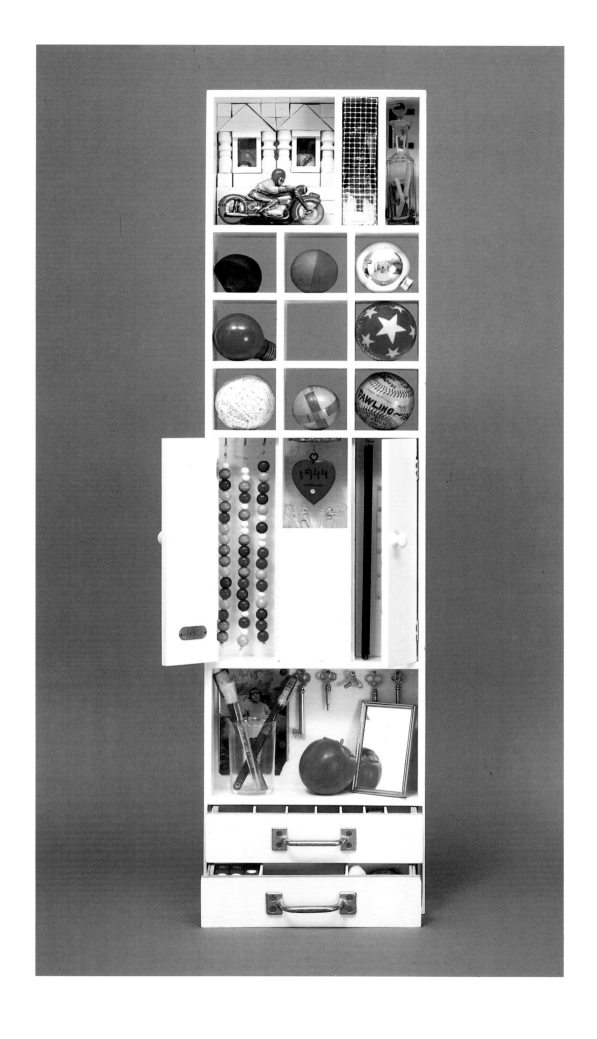

Claes Oldenburg
Oldenburg carrying material for the environment "The Street"
In front of the Judson Gallery, New York, 1960

Jim Dine
Rehearsal for the Happening "Car Crash," 1960

Jim Dine
Dine transporting material for the environment "The House"
In front of the Judson Gallery, New York, 1960

Red Grooms
Happening "The Burning Building," 1959

onstrations and street actions (Claes Oldenburg, Red Grooms, Allan Kaprow, John Cage and Jim Dine, partly also with Merce Cunningham's Dance Theatre). By the middle of the sixties Pop Art was widely known; it had developed and expanded in subject matter, composition and style, but was still apt to fall back on traditional techniques. During this phase, American Pop Art spread from New York to the West Coast and Canada, and later to Europe and Britain, which had already had its own Pop Art for some time. The last of the four phases was characterized by an acerbic, radical realism, largely of American origin, whose subject was urban social relations. Radical realism soon became an international movement, often supported by politically motivated groups. One of American Pop Art's recurring themes was summarized by John Cage, who taught at Black Mountain College and later at the New School in New York. He demanded that art break down the barriers between what was supposed to be "inside" and what was supposed to be "outside" art. Cage spoke of the "objective correlative" of subjective experience, whereby all experience was artistically relevant.

In 1957 Allan Kaprow started to organize his Happenings in New York — a form of art "action" in which artistic ideas were confronted with elements of chance. Kaprow was joined by Claes Oldenburg, Roy Lichtenstein, George Segal, Robert Whitman and Robert Watts. In 1955 Ray Johnson had organized unusual public events which combined different levels of activity. He had assembled loosely arranged mosaics of so-called "moticos", small pictures and photos taken from all areas of American life, from the gutter press and cheap novels, mounting them on the street or in studio corridors and then having them photographed (by Elizabeth Novick). Johnson preferred to exhibit his work in Grand Central Station than in galleries. Johnson clearly wished to redefine the public arena of art — an innovative development also expressed in his "postal Happenings", which incorporated postal communication into art.

One of the early Pop action artists, also influenced by John Cage, was George Brecht. His actions, combining music and trite images, started in the mid-fifties and simply "took place" — without previous indication of time or place — anywhere and everywhere, at any time of day or night. These Happenings can best be described as staged sequences of events in which each element, each detail, was given equal weight and therefore equal meaning. Commonplace reality seen as an artistic "event" also characterizes Jim Dine's Happenings — his *The Natural History of Dream, Car Crash* (p. 90), for instance. Besides Happenings, other forms of visual event also emerged during this period. These included the early activites of Red Groom and Claes Oldenburg — theatre productions, actionistic "Ray Gun" projects, displays in stores, and performances and self-portraits in painted or constructed environments: *The Street* (p. 90), for example, Oldenburg's churned up, macabre, uncanny and inspired garbage pile.

The experience of using the media and new exhibition techniques to expand art into processes which — both in terms of content and quite literally — deconstructed the traditional academic hierarchies of value was an important step in the development of Pop Art and the individual styles of its protagonists. In this context it is particularly worth noting Andy Warhol's silkscreen stencils of commercial boxes, the "Box Show" in the Stable Gallery; and also Paul Bianchini's gallery, where Pop Art works were displayed as if in a supermarket. Both exhibitions took place in 1964. Robert Rauschenberg also gave theatrical performances in the sixties, the multi-media piece *Pelican,* for example, in which he and Alex Hay roller-skated with parachutes to the rhythms of a tap-

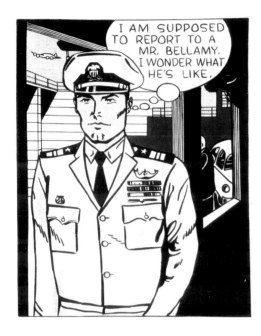

Roy Lichtenstein
Mr. Bellamy, 1961
Oil on canvas, 143.5 x 107.9 cm
Vernon Nickel Collection

OPPOSITE PAGE:
Roy Lichtenstein
Masterpiece, 1962
Oil on canvas, 137.2 x 137.2 cm
Collection of Mr. and Mrs. Melvin Hirsch,
Beverly Hills (L.A.)

PAGE 94:
Robert Indiana
Red Diamond, Third American Dream, 1962
Acrylic on canvas, 259 x 259 cm
Stedelijk Van Abbemuseum, Eindhoven

PAGE 95:
James Rosenquist
I love you with my Ford, 1961
Oil on canvas, 210 x 237.7 cm
Moderna Museet, Stockholm

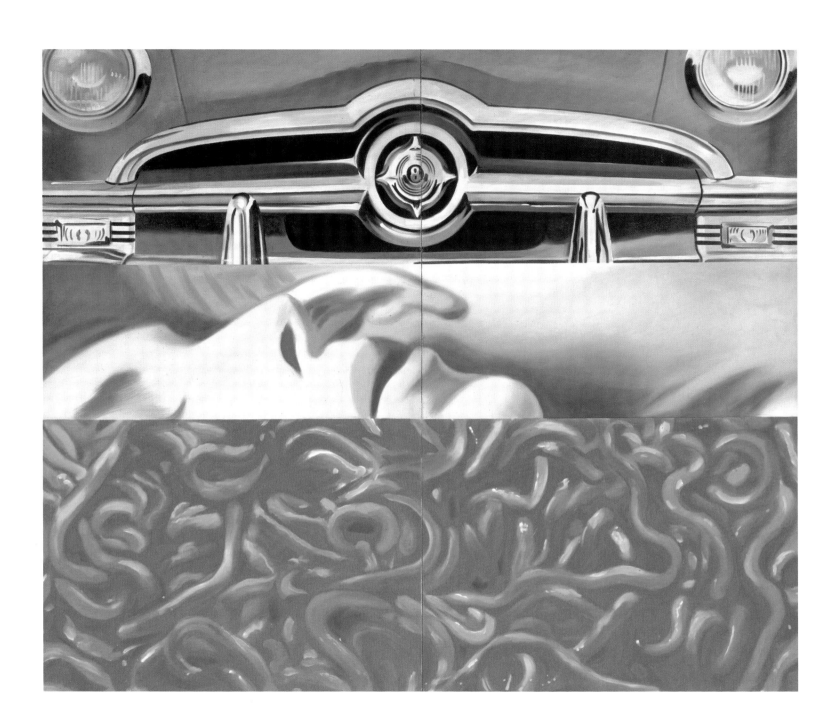

Jim Dine
Five Feet of Colorful Tools, 1962
Oil on unprimed canvas, with mounted
wooden strip and 32 tools hung on hooks,
141.2 x 152.9 x 11 cm
Collection, The Museum of Modern Art,
New York, Sidney and Harriet Janis
Collection

dancer. Later, Robert Morris and Öyvind Fahlström included their fellow
painters in performances and street actions. In his performance *Site* in 1964,
Morris wore a mask by Jasper Johns, and in *Kisses Sweeter than Wine* (1966),
which took nine evenings to perform, Robert Rauschenberg made an appear-
ance as an "idiot savant".

It was obvious that the light-hearted methods of presentation favoured by
the Happening would have an effect on the paintings of these artists, and
indeed they (especially Rauschenberg in the sixties) began to incorporate
rubbish and organic waste into their collages and assemblages. The exhibition
"Art of Assemblage," organized by William C. Seitz in autumn 1961 for the
Museum of Modern Art in New York, was also influential in this respect. Seitz

Richard Artschwager
Long Table with Two Pictures; 1964
Table: formica on wood, 86 x 244 x 56 cm
Pictures: Acrylic on celotex with formica,
each 107 x 82 cm
Saatchi Collection, London

Claes Oldenburg
Bedroom Ensemble I, 1963
Ensemble with various objects,
304.8 x 518.2 x 609.6 cm

PAGE 98:
Richard Lindner
Couple, 1961
Oil on canvas, 94 x 63 cm
Galerie Claude Bernard, Paris

PAGE 99:
Red Grooms
Hollywood (Jean Harlow), 1965
Acrylic on wood, 78.4 x 89 x 30.5 cm
Smithsonian Institution, Hirshhorn Museum
and Sculpture Garden, Washington D.C.,
Gift of Joseph H. Hirshhorn

had brought together work by Abstract Expressionists, assemblages, so-called "junk culture" and environments. Both Americans and Europeans were represented here, especially those whose work stood close to Pierre Restany's "Nouveau Réalisme" in Paris: Raymond Hains, Arman, Pierre de la Villeglé, Martial Raysse, Daniel Spoerri, Niki de Saint-Phalle, Christo, Jean Tinguely, the Italians Enrico Baj and Mimmo Rotella, and also American artists whose work at that time was only marginally (if at all) associated with Pop – such as George Brecht, Edward Kienholz, Marisol, Robert Watts and Lucas Samaras.

One of the first galleries to show American Pop artists was the Reuben Gallery in downtown New York; the artists – and later the galleries, too – had moved "downtown", the province of trade, small industry and the proletariat.

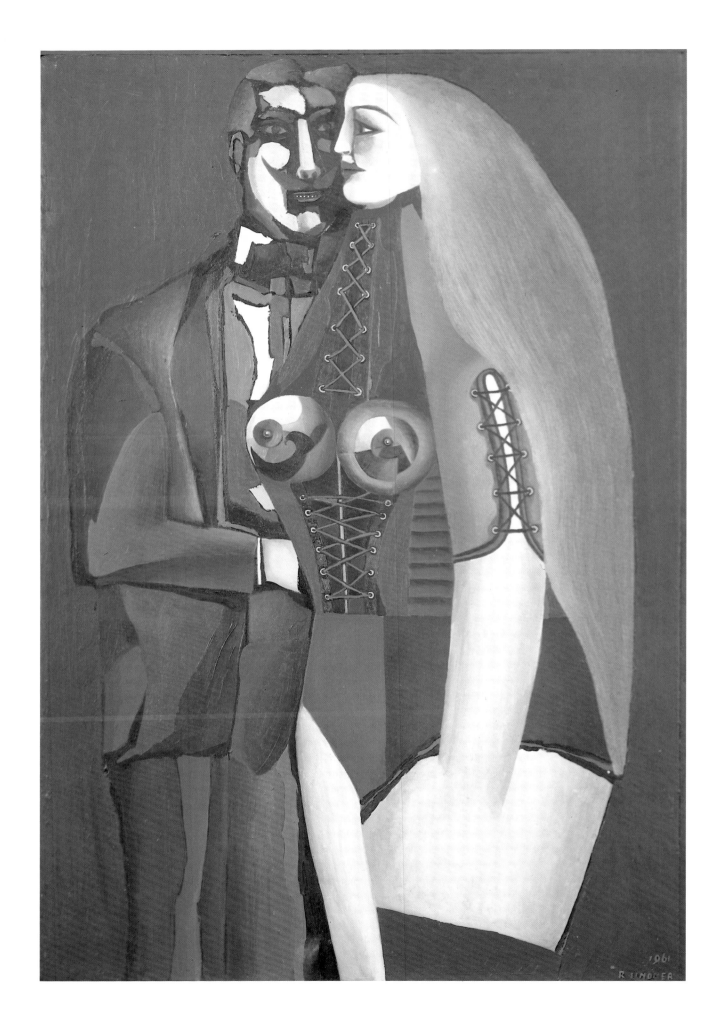

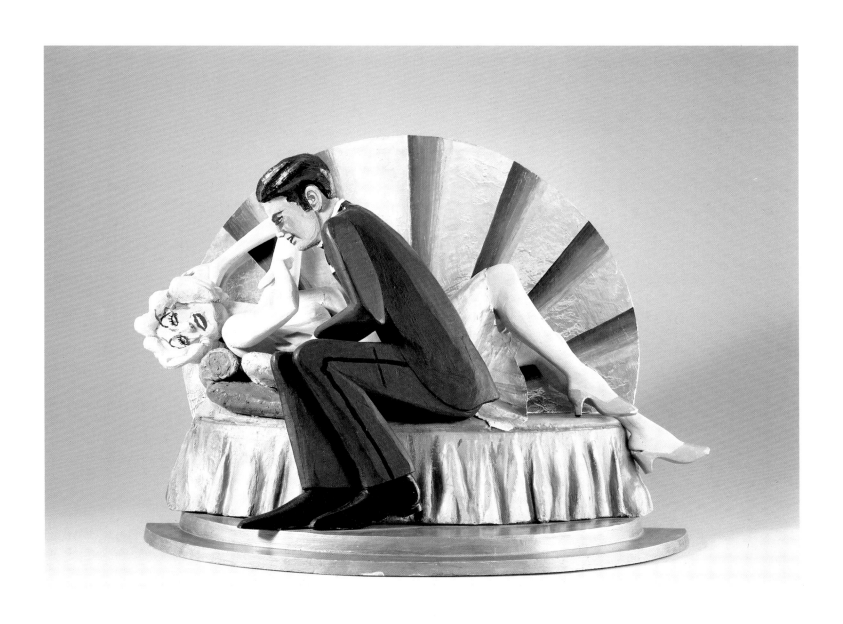

Wayne Thiebaud
Cake Counter, 1963
Oil on canvas, 93 x 183 cm
Museum Ludwig, Cologne

Downtown corresponded more closely to the artists' sense of life and art, and to their subject matter, than New York's finer uptown-side with its luxurious, well-to-do society, its art buyers and established galleries. Other artists who lived on Long Island, in the outlying parts of New York or in other towns, Claes Oldenburg and George Segal, for example, now also moved to downtown New York. The Reuben Gallery organized Happenings and both one-man and group exhibitions with Oldenburg, Grooms, Dine, Rosalyn Drexler and Whitman – in collaboration with Kaprow, and also with Watts, Segal and Lichtenstein, artists who were teaching at Rutgers University. Until 1959 several of these artists were united in a kind of co-operative based in the Hansa Gallery. Richard Bellamy's downtown Green Gallery, Martha Jackson's Uptown Gallery and Leo Castelli and Ivan Karp's Judson Gallery sponsored these new tendencies in art, also showing environments and putting on Happenings and thematic exhibitions ("New Forms, New Media" (1960), "Environments, Situations, Spaces" (1961) at Martha Jackson's; Oldenburg's *The Street* (p. 90) and Jim Dine's *The House* (p. 91) (1959) at the Judson Gallery).

Between 1960 and 1962 the work of the later Pop Art stars Andy Warhol and Roy Lichtenstein went through an important stage of its development; a meticulousness learned from the mass media and their intransigent pictorial vocabulary were characteristics these artists shared. During the following years of the sixties, Claes Oldenburg, Tom Wesselmann and James Rosenquist laid the conceptual foundations for later directions taken by Pop Art. It was during this period, too, that Jasper Johns made his frivolous metal sculptures, Larry Rivers painted pictures with bank notes and Camel cigarette-packets (p. 87), Robert Indiana produced his object-sculpture *Cuba* (p. 88) and George Brecht his cupboard object *Repository* (p. 89). The year 1961 is generally seen as a watershed. By that year, certain formal techniques had been so consistently and uncompromisingly employed, had attained such a degree of rigour, clarity and precision that Pop Art was able to establish itself for the first time in

New York as a new direction in art — from now on it was discussed, written about and collected. Pop Art's first collectors were Robert Scull, the proprietor of a taxi-business, the architect Philip Johnson and the publisher Harry Abrams. "Pop Art", which the British art critic Lawrence Alloway had originally coined to allude to the trivial, commonplace and secondhand realities artists were incorporating into their work, now became the accepted term for the new American art. The first important public discussion on the new art was held in New York in 1962 at an event entitled "A Symposium on Pop Art" during the exhibition "Recent Painting in the USA: The Figure". As for as the artists themselves, if they articulated their interests at all during the early years, then these were directed more towards the themes of their work than towards the way in which they had interpreted these.

Though its detractors were vociferous, Pop soon became the object of a euphoric enthusiasm of cult dimensions among the American population. The ludic qualities of these paintings and sculptures, their irony and entertainment value easily lent themselves to a kind of affirmative consumer misinterpretation: "Some of the worst things about Pop Art have come from its admirers," as Tom Wesselmann put it in 1963, referring to the superficial manner in which even those paintings were consumed which attempted to reflect and undermine the consumer mentality. This phenomenon derived from the matter-of-factness of Pop Art, which was intended to stimulate the viewer's own capacity for self-

"My approach is fantastic from the beginning . . . reality does not exist very much for me . . . I am a very interior person . . . reality serves my imagination . . . though of course I keep in touch with it." CLAES OLDENBURG

Claes Oldenburg
Pastry Case I, 1961-62
Enamel on nine plaster sculptures in a glass showcase, 52.7 x 76.5 x 37.3 cm
Collection, The Museum of Modern Art, New York, Sidney and Harriet Janis Collection

Allan d'Arcangelo
Road Series No. 13, 1965
Oil on canvas, 200 x 253 cm
Museum Ludwig, Cologne

analysis. As a side-effect, it is understandable, for the artists themselves had a kind of "love-hate" (Lichtenstein) relationship with the things they were portraying and were themselves fascinated by the triteness of their subject matter. Yet another reason was the artists' command of commercial imagery and use of this prowess in their work: Warhol had designed shoes; Rosenquist had painted billboards; Rauschenberg had been a commercial artist; Lichtenstein, educated in design, had arranged window displays; Oldenburg had worked as an illustrator and designer; Wesselmann had drawn cartoons. In this respect, these artists were trained professionals. Their professionalism led viewers to read their pictorial vocabulary as if it were the language of advertising. This was also taken up by commercial Pop, the Pop bric-a-brac industry. The influence of Pop on advertising, which itself had been a formative influence on Pop, grew accordingly — and can still be detected today. The distance between the works of art and their trite subject matter was too small for the viewer to see through their triviality, too small to create the tensions necessary for the viewer to catch himself taking pleasure in superficiality, gloss and extravagance. The subsequent commercial exploitation of Pop Art was therefore the logical

consequence of the fact that this art was now serving precisely those commercial interests which it had initially repudiated.

Pop Art went from success to success, and its artists modified and redefined their project as they went along, reacting (Warhol signing Campbell's Soup Cans) to the artistic devaluation of their work by a market intent on exploiting the new Pop industry. Lichtenstein showed the consequences of this development for art and the art scene in a series of identical portraits with different titles (Ivan Karp, Allan Kaprow and others), and in his comic texts: "I'm supposed to report to a Mr. Bellamy, " says the soldier (p. 92); "Why, Brad darling, that painting is a masterpiece! My, soon you'll have all of New York clamoring for your work!" (p. 93).

The artists proceeded to make statements explaining their latest points of view. Claes Oldenburg described his intentions and methods of production, the levels of meaning in his work and new ideas for future projects both in his sketches themselves and in accompanying texts and explanatory statements. Lichtenstein held lectures interpreting time, society, fashion, art, art history and himself. Johns analysed, philosophized and theorized. Warhol irritated his

Mel Ramos
Hippopotamus, 1967
Oil on canvas, 180 x 247 cm
Saarland Museum, Saarbrücken, Ludwig
Collection

audiences by refusing to adopt any position which was not ambivalent. His tone was sarcastic and he persistently repeated himself, interviewing the interviewer and hiding behind various guises. He remained the sphinx of Pop Art. The concepts of media transparency, of the anonymity and depersonalization of the artist, though also propagated by other artists, found in Warhol their staunchest, most extreme advocate. Warhol was the incarnation of the idea of the artist and Pop star prevalent in the art world at that time.

Both market success and openness to misunderstanding are themselves elements of artistic strategy. The viewer may, of course, ask the artist to explain the meaning which his pictures and statements refuse to provide. But what artist will admit to a socially critical attitude to defend himself against the accusation that his work is affirmative or politically indifferent, if this means that he is merely conforming to a certain role expected of art in society? An example of the insignificance of artists' motives in the final analysis is the standard answer referring to artists' social and political engagement. Asked who the real "author" of this answer was, John Cage gave me the following answer: "Rauschenberg did the same."

Jim Dine's work is not so much concerned with the tragic side of American everyday life as with its euphoria, its promiscuous diversity of hopes and visions

Alex Katz
The Red Smile, 1963
Oil on canvas, 200 x 291.5 cm
Collection of Whitney Museum of American
Art, New York, purchased through the
Painting and Sculpture Committee Fund

of life. His themes are symbols, like the heart or the rainbow; he experiments with the human figure, with its private yearnings for love, peace and joy. He shows us the neo-romantic clichés, set pieces, solutions, colours and signs – paintings which fondly parody the apparent serenity of everyday life, purposefully bordering on Kitsch and flirting with the images of the entertainment industry. Robert Indiana confronts these "soft" subjects with his brash stereotypes and hard, "cool" colour planes – *God is a Lily of the Valley* (1961). He juxtaposes emotional texts with an abstract aesthetics of blatant signals borrowed from pinball machines. Compared to Jim Dine's soft, gushy, blood-red toy heart, Robert Indiana's *LOVE* is typographically cool and crisp.

The anti-Pop developed by the "No" group rejected the tendency of some Pop artists to cultivate standard images and stereotypes. Formed in 1958 by Boris Lurie, Sam Goodman and Stanley Fisher, this group was supported by the March Gallery, and later by the Gallery Gertrude Stein. Aggressive, chaotic, critical, political and angry, they used shock and horror tactics, environments incorporating handbills, statements, events, street actions and Happenings against what they saw as affirmative tendencies in Pop Art.

Pop Art gained such momentum that ever more artists from all over America were drawn into its wake. The Californian John Wesley came to New

Edward Ruscha
Large Trademark with Eight Spotlights, 1962
Oil on canvas, 169.5 x 338.5 cm
Collection of Whitney Museum of American
Art, New York, Percy Uris Fund

Jim Eller
Scrabble Board, 1962
Scrabble board with glued-on letters,
35.6 x 35.6 cm
Collection of the artist

York in 1960 and painted infantilistic, satirical, comic-like, bizzare pictures in which he analysed human behaviour and social norms. Allan D'Arcangelo found his inspiration in billboards and street-signs. Using perspective to emphasize focal depth, his pictures captured the notion of progress associated with our standardized culture of road communications: his symbolic "road" leads the eye to infinity and disappears into a void – as if sucked into the maelstrom of progress. Robert Watts, Alex Hay and other New York artists took commonplace objects and consumer goods as the theme of their paintings and sculptures, while Rosalyn Drexler and Red Grooms concentrated on entertainment, "dancing" – the glamorous life.

Among the highly original artists of the time was Richard Lindner, an artist of the older generation who had emigrated to America from Germany and was an obsessive painter and draughtsman of garish, razor-sharp and very direct, sado-masochistic figures (p. 98). An artist of considerable subtlety was Richard Artschwager. His purist furniture and interiors maintain a vague balance in form and material between abstraction and naturalistic illusion (p. 97). His pictures are conceptually interesting parallels to Oldenburg's *Bedrooms;* their crisp forms seem almost formalistic, but are put to vivid use in portraying the "American way of life", with its domesticity and narrow-minded interior decorations.

Outside New York, the earliest exponents of American Pop Art were from California – Billy Al Bengston, Edward Ruscha, Joe Goode, Wayne Thiebaud and Mel Ramos. These had already developed their own version of Pop by the beginning of the sixties. The lightness, ease and sensuality of their subject matter, their fluidity and use of bright colours in paintings and sculptures expressed something of the West Coast mentality. The centre of this art was Los Angeles, a city whose sub-culture not only had an enduring influence on this variant of Pop, but which was later to conquer the world in the form of the hippie culture and "alternative" lifestyle. The sugary-sweet components of these

Edward Ruscha
The Los Angeles County Museum of Art on
Fire, 1965-68
Oil on canvas, 135 x 339.1 cm
Smithsonian Institution, Hirshhorn Museum
and Sculpture Garden, Washington D.C.,
Gift of Joseph H. Hirshhorn

PAGE 107:
Edward Ruscha
Actual Size, 1962
Oil on canvas, 182.9 x 170.2 cm
County Museum of Art, Los Angeles,
donated anonymously through the Contem-
porary Art Council

colourful pictures reflected that Californian cornucopia which had so attracted David Hockney in 1964. Their compositions and themes were built around images of motorbikes, sex, sensual pleasure, food and glamour.

The exception here was Edward Ruscha, who championed an intellectual, conceptual style which exploited levels of feeling, period styles such as Romanticism and Classicism, technology, domestic culture, cinematic images and realism (pp. 106, 107). Ruscha had a decisive influence on Concept Art in the seventies. Jim Eller's *Scrabble Board* (1962; p. 106) provides a key to understanding West Coast Pop. The only word on this intellectual boardgame is "rat" – a word, which even according to the points system, is the lowest word in the game; the culture of luxury and lustre had been turned on its head and was sliding into disaster – into the garbage – within a cartographic grid of numbers and statistics.

Contacts between West Coast and New York artists can be traced back as far as 1960. New York Pop Art was first shown in Los Angeles in 1962. Warhol's *Campbell Soup Cans* and the work of other New York and West Coast Pop artists was exhibited in private galleries. The group exhibition "The New Painting of Common Objects" organized by Walter Hopps at the Pasadena Art Museum, with work by Lichtenstein, Dine, Warhol, Ruscha, Goode, Thiebaud and others, was intended as a combined exposition of the New York and Los Angeles art scenes. In 1963, the Los Angeles County Museum included West Coast painters in the exhibition "Six Painters and the Object", which Lawrence Alloway had originally devised for the Guggenheim Museum in New York. The first general survey of West Coast Pop Art was the "Pop Art, USA" exhibition shown by John Coplans at the Oakland Museum near Los Angeles.

In 1960 H.C. Westermann was constructing bizarre, alienatingly surreal and totally unwieldy (mainly wooden) contraptions which were vaguely reminiscent of commonplace objects. The Canadian universal artist Michael Snow was working out a conceptual response to the cultivation of images in the media. The Canadian Greg Curnoe was translating the privatisation of technical achievement, especially in the form of objects like the car or bicycle, into brightly coloured, portrait-like paintings.

The second half of the sixties saw an intensification of realistic tendencies

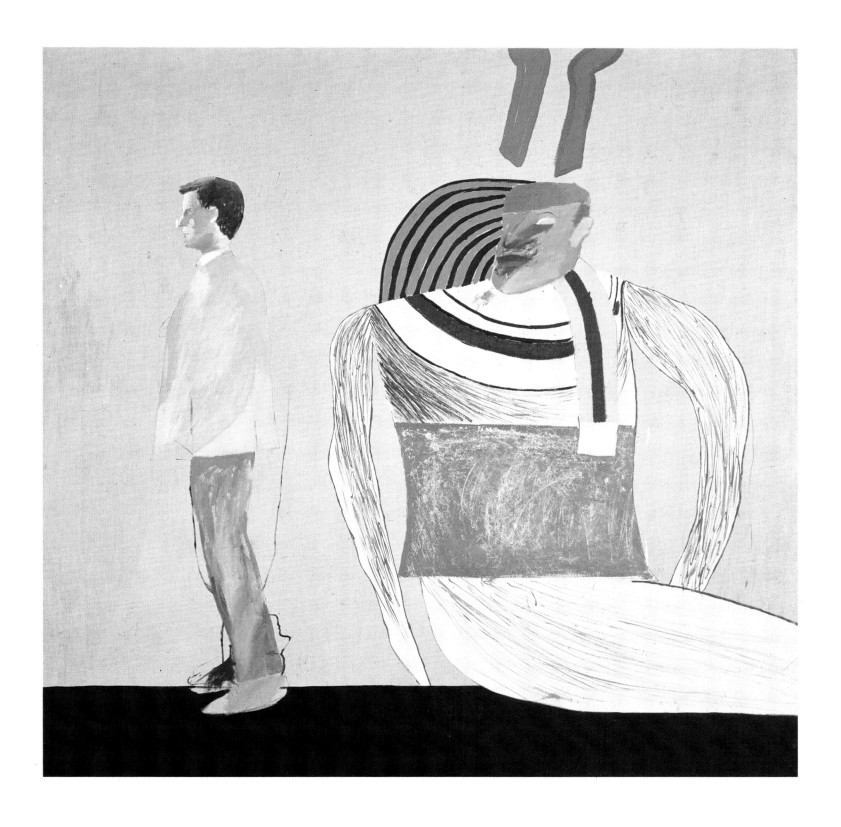

David Hockney
Man in a Museum (or you are in the wrong movie), 1962
Oil on canvas, 147.3 x 52.4 cm
The Arts Council of Great Britain, London

Howard Kanovitz
The People, 1968
Acrylic on canvas, mounted on plastic
ground, 172 x 175 x 10 cm
Wilhelm-Lehmbruck-Museum, Duisburg

in American Pop Art, especially in New York and on the West Coast. This tendency was expressed particulary in traditional representational techniques in painting and drawing. This new aspect of the dichotomy of representation and reality was not provoked by the inclusion of common objects or media imagery, but by the extreme exaggeration of received formal techniques – a stylistic development which has entered art history's catalogue of realisms as "New Realism". As "hyperrealism" this tendency exposes over-naturalistic figuration and illusionistic devices which are deeply rooted in art history. The term "radical realism" points to the artist's awareness of the representational limits of his own medium. In "photorealism" painting competes with photography and explores the process and effects of photomechanical reproduction. Howard Kanovitz (p. 110), Richard Estes and Chuck Close are the exponents of this method of painting. Malcolm Morley is more of an outsider. His apparently arbitrary "impressionistic" manner renders the formal organization and colour structure of images transparent, but, at the same time, the exuberance of his style intentionally causes the imagery to degenerate into cliché. What is meant here by "impressionistic" is a routine painterly brushwork which reveals nothing of the personal condition or emotions of the artist.

The sculptor Duane Hanson casts figures in polyester, painting and dressing them as they are in real life, but isolating them from their social context and

thus exposing their stereotyped behaviour, their loneliness, their unintentional humour and tragedy. They face the spectator in full life size, engaging with him in a silent dialogue. These very ordinary figures, socially conventional "types", seem to be implicated in something darker, something ominous. John de Andrea and Robert Graham take up the theme of the body in Wesselmann's *Nudes:* sexual clichés veiling the fragility and emptiness of human relationships. The radical realists take the open confrontation between art and life to absurdity.

As Pop Art spread, various perspectives began to emerge in American art, especially in figural sculpture and the environment, which had little in common with Pop Art. Marisol uses traditional forms in her figural sculptures (p. 111): abstraction and Cubist forms are combined with folk art, media images and parodies of the influence of the media upon toys. Edward Kienholz consciously exaggerates the sense of alienation and ruin of the figures he portrays in philistine homes and conventional surroundings. His expressive, surreal language conveys the existential disintegration and crisis-prone frailty of a human being defenceless against his own boredom and loneliness, trapped within the mechanisms of a world beyond his control. His stage-like environments remind one of George Segal's neutralized, static figures. Segal's white plaster casts of people in real environments – streets, in front of window displays or store fronts

Marisol
La Visita, 1964
Painted wood, plaster, textiles, leather and photograph, 152 x 226 cm
Museum Ludwig, Cologne

Edward Kienholz
The Wait, 1964–65
Assemblage: Varnish, glass, wood and
found objects; 203.2 x 375.9 x 198.1 cm
Collection of Whitney Museum of American
Art, New York, bequest of the Howard and
Jean Lipman Foundation

– express isolation, loneliness, melancholy, silence and a feeling of captivity (p. 113). He takes up traditional pictorial motifs from early twentieth century American realism and uses the environment to translate them back into objects whose dimensions and criteria are human and commonplace – our own. Segal's work laid the foundations for John de Andrea's and Duane Hanson's radical hyperrealism at the end of the sixties.

George Segal
Picasso's Chair, 1973
Plaster, wood, cloth, rubber and string,
198.1 x 152.4 x 81.9 cm
The Solomon R. Guggenheim Museum, New
York, Gift of Dr. Milton D. Ratner

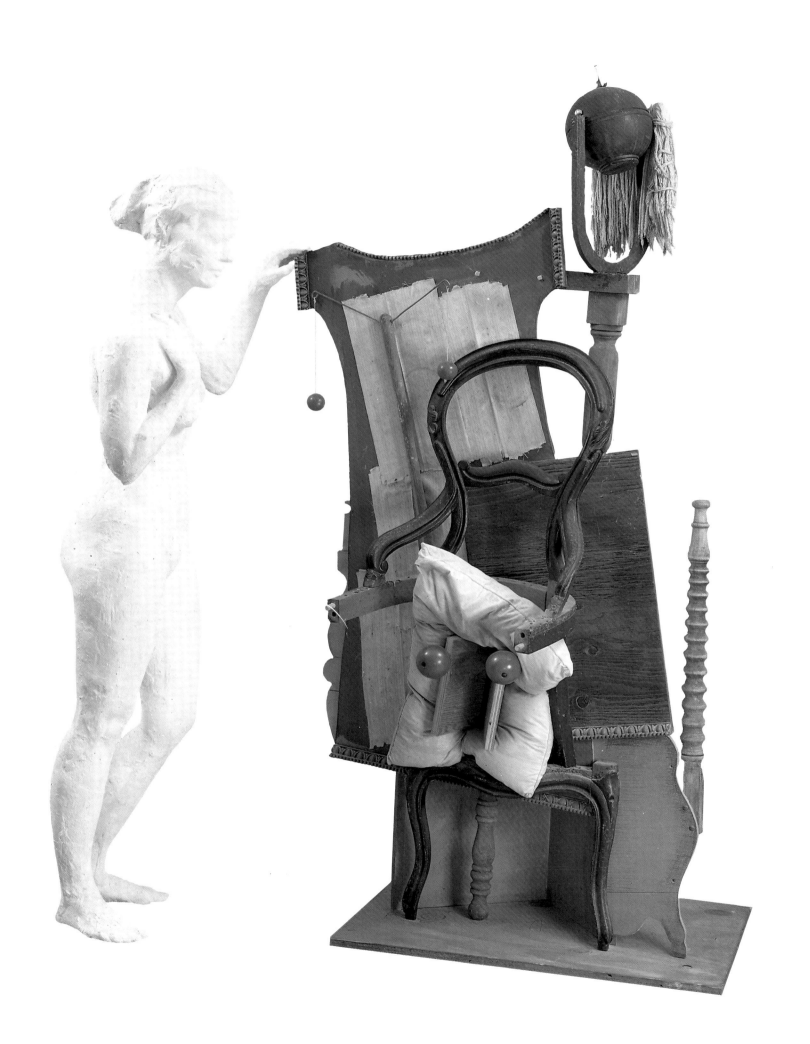

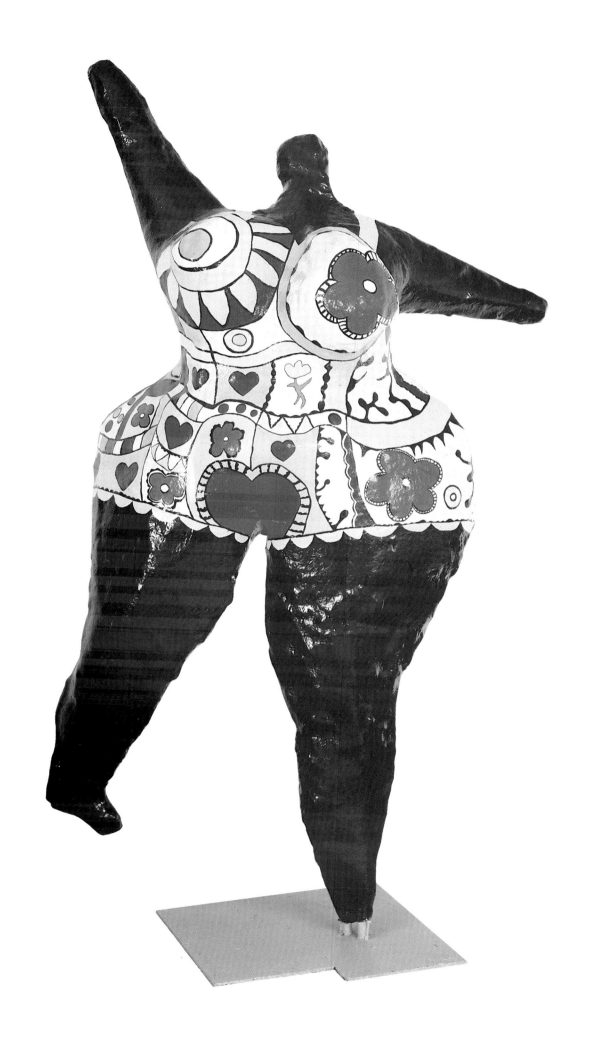

European Aspects of Pop Art

As certain phenomena of the Anglo-American Pop Art movement became increasingly internationalized during the course of the sixties, parallel movements began to emerge on the European continent. The conflict between these and indigenous European cultural traditions often proved to be less intense than it had been in America and Britain. In North America, the mass media and popular culture had begun to stimulate a new art in the early fifties which soon outgrew its (art-)historical background. And in London, the Independent Group and the Institute of Contemporary Art had linked the development of English Pop Art in the fifties to an interdisciplinary critical debate on subjects of contemporary relevance, such as the theory of progress, the interpretation of technology and the science of communications.

In England and America, Pop had been articulated with great vitality by a whole generation; fine art, music, literature and popular and mass culture had become intermeshed. Elvis Presley, the Rolling Stones and the Beatles, the hippies and the beatniks had started a "cultural revolution". The European mainland stretched out its cultural antennae as far as possible to pick up these new signals. In 1962, the Beatles gave their first big concert at the Hamburg Star Club; English Pop artists were invited as visiting professors to the College of Fine Arts in Hamburg: Eduardo Paolozzi from 1960 to 1962; Allen Jones 1968/69; Peter Phillips 1968/69 and Joe Tilson 1971/72. The trend towards Americanization gained ground in advertising and sales strategy, in the mass media and the modernization of marketing and social theory. In the sixties, activity by European Pop artists was generated mainly within youth culture, but this was invariably a reaction to American models. This Pop art was less radical, but it also showed greater formal complexity. It was original, up-to-date and carried the stamp of a new generation.

European Pop Art tended to be a heterogeneous and intractable affair. Its iconographical aspects, its formal techniques and, more especially, the quality of the latter, varied quite considerably. As a result, the struggle of the artists to impose their own originality upon the (art-)historical traditions within which they were working also varied in intensity. By the end of the sixties, pluralism in Europe had led to a fashionable Pop internationalism whose reflections of commonplace subject matter and styles had degenerated into formalistic attitudinizing. In what follows, I wish to subsume various aspects of European Pop Art under certain categories: the iconography of Americanism, topography, outstanding artistic personalities, inflationary tendencies in art, the political critique of current affairs and of society in general and interrelations between American, British and European artists as a result of travel, exhibitions and teaching fellowships.

"Everybody has called Pop Art 'American' painting but it's actually industrial painting. America was hit by industrialism and Capitalism harder and sooner and its values seem more askew." ROY LICHTENSTEIN

Niki de Saint-Phalle
Black Nana, 1968-69
Painted polyester, 293 x 200 x 120 cm
Museum Ludwig, Cologne

Arman
Torse aux Gants, 1967
Torso with gloves and plastic hands,
polyester, 88 x 37.5 x 29 cm
Museum Ludwig, Cologne

The Marilyn Monroe motif is a typical example of European Americanism and can be found on everything from posters to works of art. (Mention of this in the works of the English artists Peter Blake and Richard Hamilton follows below.) An object created by the "empaquetage" or "packaging" artist Christo in Paris in 1962 shows the imported film idol in the title role of a wrapped magazine. A painted over décollage by the later Cologne Action artist Wolf Vostell in 1963 alienates her image by repeating it in rows; in 1961 Vostell also did décollages of the Beatles and the Coca-Cola trademark (p.34). Yet another example is the incorporation of Coca-Cola cans and bottle-tops into Arman's box objects from 1961 on; Arman, a leading representative of Nouveau Réalisme, also filled a polyester torso with dollar-bills. Mimmo Rotella, an Italian Nouveau Réaliste, produced a décollage of a Democrazia Cristiana poster which had used images of John F. Kennedy and the American flag.

Nouveau Réalisme brought together artists of quite different backgrounds and direction. The theoretical foundations of this movement were formulated by the Frenchman Pierre Restany, who had also initiated the group's first exhibition in Milan in 1962 and further activities concentrated on Paris. During the "New Realists" exhibition in New York in 1962 Restany grouped European and American artists together and subsumed the most important American artists along with the Italians Enrico Baj and Gianfranco Baruchello, the Swede Öyvind Fahlström and the English artists Blake and Phillips under the term "popartistes"; he drew a clear line between these, however, and the Nouveaux Réalistes. Nouveau Réalisme can therefore be seen as a parallel development to Pop Art in as far as it also included popular culture, junk, technology, the world of advertising and consumer goods and the notion of the object in its general concept of art.

Yves Klein died in 1962 when this movement was still at its zenith. His Action Art had been close to the American Happenings enacted by Claes

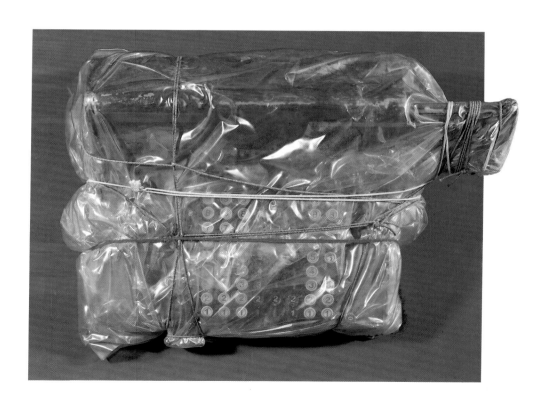

Christo
Wrapped Adding Machine, 1963
Adding machine, polyethylene, string and bast, 46.5 x 57 x 15 cm
Neue Galerie, Aachen, Ludwig Collection

Oldenburg, Jim Dine, Robert Rauschenberg, Öyvind Fahlström and others. His monochromatic paintings, object assemblages and body painting, his preference for blues and golds, are expressions of his extended concept of art and renewal of the European tradition in Dadaism. His idea of the monochrome also linked him with the "Zero" group who concentrated their artistic expression on the clarity of the colour white. Jean Tinguely's macabre and partly self-destructive fantasy-machines ironize the age of technology and the absurdity of an overstrained tachism in a manner both playful and cynical. Décollage artists like the French "affichistes" Jacques de la Villéglé and Raymond Hains (p. 120) and the Italian Mimmo Rotella were interested in continuing the spontaneous and formless modes of presentation of "art informel". Their provocative actions were conceived as interventions in the thematic material of consumer goods advertising. Niki de Saint-Phalle's grotesque, doll-like and, in some cases, even enterable giantesses, the so-called Nanas, look at isolation, stereotyped images and vulgar sexual aesthetics from a woman's point of view – work which bears a striking affinity to Pop Art (p. 114). Average images and stereotypical female physionogmy – as found in the world of leisure and holiday advertising – are treated in the pictures of Martial Raysse in a manner directly appropriate to Pop Art (pp. 122, 123).

The Bulgarian artist Christo had been associated with the Nouveaux Réalistes before coming to New York. In packaging both everyday objects, consumer goods for instance, and more unusual things such as buildings and landscapes, he situates his work outside traditional notions of art; there is a clear reference here to the concept of the alienated object as propagated by the Dadaists. His packaged objects draw a veil around the products of a throw-

Arman
Accumulation de Brocs, 1961
Enamel cans in plexiglass showcase,
83 x 142 x 42 cm
Museum Ludwig, Cologne

PAGE 118:
Öyvind Fahlström
Roulette, Variable Painting, 1966
Oil on photographs, paper, vinyl, pasteboard and magnets, 152.5 x 166 cm
Museum Ludwig, Cologne

PAGE 119:
Wolf Vostell
Miss America, 1968
Screen photography, transparent paint and silkscreen on canvas, 200 x 120 cm
Museum Ludwig, Cologne

Dancing lights, near right golden
sequins sparkled over gol...
lace—a delicious li...
dress skimm...
scalloped...
r...mb...
(...
All...
...
H...
On...
stre...
sq...
bow...
silk and...
earrings...
Carnegie...
Julian...
...e's Houston.

Raymond Hains
Affiche Déchirée, 1961
Coloured paper on zinc, 200 x 100 cm
Museum Ludwig, Cologne

away culture; they stimulate the viewer's curiosity to know what the wrappings contain. The familiar thus becomes an unknown quantity demanding to be seen and rediscovered (p. 116).

Arman achieves a similar effect by accumulating everyday objects, relics of the affluent society and objects of art culture (eg. painting utensils and musical instruments). Squeezed together and enclosed in plexiglass containers or embedded in plastic, everyday consumer objects both assume dimensions of monumentality and express a melancholy sense of destitution. Showing quite ordinary things in apparently random fashion in a museum showcase or in some container gives them exhibition value. Arman renders the banal aesthetic, and renders aesthetics banal. He lets the trivial appear in all its penetrating ugliness and beauty, giving his objects a state of finality and disintegration. His artistic production, forms and subject matter are derived directly from contemporary notions of utility value. This understanding of art and objects laid the foundations for new strategies in perception and for a changing approach to the problems of art and reality.

In the early sixties, Paris attracted many foreign artists who were interested in neo-realistic tendencies in art: Mimmo Rotella, Eduardo Paolozzi, Arthur Köpcke, Öyvind Fahlström and Daniel Spoerri. The Swiss artist Daniel Spoerri produced absurd object-assemblages inspired by Dadaism and Surrealism. His "snare pictures" are constellations of objets trouvés removed from their contexts and fixed unaltered to the surfaces on which they were "found"; they show Spoerri's proximity to the Nouveaux Réalistes, the New York Pop Art movement and West German Action Art scene. Spoerri's combinatory method is an indication of the dubiousness of drawing borderlines between different styles in this period. Pop Art may therefore be understood as a synonym for certain phenomena of the period, but not as a period style; for the art of the period thrived precisely on its subversion of consensus and stylistic consistency. The subsequent explosive fashionability of the international Pop movement, especially in Western Europe, seemed itself to justify its having embraced trivial culture and the mass media.

The Swedish painter Öyvind Fahlström is generally considered to be the most important Pop artist outside America and Britain. He came to New York via Paris in 1961 and was soon firmly integrated into the New York Pop scene. He took part in Robert Rauschenberg's actions and in various performance events. By alienating the pictorial clichés of the comic, bric-a-brac and souvenir industries and giving them topical relevance, he turned them into the annals of his time, into politically challenging counterparts to patterns of taste in popular culture (p. 118). His compositions give the impression of an ornamental latticework whose banal components are unpredictable, suddenly becoming moments of criticism, while boredom turns into drama and catastrophe is a playful, vulgar gesture. Fahlström uses typical contemporary material freely and naturally in his often variable collages. The pictures which emerge are like panoramic encyclopedias of the trivial.

Following the first big exhibitions in the middle of the sixties, American and British Pop Art continued to make its influence felt in Europe, especially in Paris, Berlin, Düsseldorf, Cologne, Hamburg and Munich. The West German artists developed a particularly demonstrative aesthetics influenced by industry and technology (B 1 in the Ruhr, Op Art and, from 1961, Co-Op in Hamburg). Their Art held up a mirror to consumer culture, linking trivial symbols with American iconography (Beuys' reaction to this in 1970: "Cleanse the world of Americanism!"). Reproducible objects such as multiples and silkscreen prints catered for

Erró
Interieur Américain No.7, 1968
Acrylic on canvas, 115 x 90 cm
Neue Galerie, Aachen, Ludwig Collection

an increasingly wide public interest – a reaction to the effect of the mass media. The importance to these artists of the material world led them to explore ever more dimensions of the object.

An important aspect of Hans Peter Alvermann's work is its intended political effect. His object collages and assemblages betray the influence of Surrealism and are similar to works of Pop Art, which they also ironize; they are perhaps especially reminiscent of Robert Indiana's sculptures of 1960/1961. Alvermann overstresses the principles of order, cleanliness and morality in his work to characterize a consumer society both patronizing and aggressive. There are many striking examples of "political Pop" in painting, object art, film, photography, performance and video. At the end of the sixties and beginning of the seventies, the effect of political images, the control of images by the mass media and the obtrusive, manipulative aesthetics of the latter were reflected in the work of artists from all over Europe. Among these were the Germans

Konrad Klaphek, Thomas Bayrle, Gerd Winner, Dieter Rot and many others, the Swiss artist Peter Stämpfli and the Austrian Curt Stenvert. In the late sixties, certain tendencies in Pop Art and Radical Realism developed into a new political realism which – partly inspired by the art of the Russian Revolution – expressed a desire for social change and saw itself as a parallel to the students' movement of those years.

One of the most striking European personalities of the international Pop Art movement was Arthur Köpcke. Born in Hamburg, Köpcke lived mainly in Copenhagen during the sixties, where he built up a committed art movement which also organized its own actions. In 1967 he went to Paris. He died at the age of 49. Even his early collages of around 1952 took their subject matter from contemporary popular culture. In the sixties he inserted trivial images into his collages; their loud colours, stylization and banal subject matter are reminiscent of the aesthetics of the neon advertisement. Köpcke's work reveals an intensely personal relationship with the "myths" of everyday life and the media; it exposes the subliminal mechanisms used by the media to influence the subconscious mind. His pictures seem emotionally fraught, disturbed, excited. Their vulgar expressionism pauses on the borderlines between abstract-expressionistic gesture, triviality and sensuality.

In the early sixties, the young Sigmar Polke and Gerhard Richter were closely associated with Pop Art. Polke's images and grid and dot patterns give the impression of reproductions – subjective painting seems to have been eliminated (p. 124). The motifs of these pictures are like enlarged newspaper repros or poster collages with dreams and clichéd fantasies woven into them. His themes are the commonplace trifles of private and social life, typical uses of the visual image and unoriginal patterns of behaviour and taste. In arranging these in pictorial form, the cliché remains a cliché; the superficial "sticks" to the surface of the picture; the composition is unconventional, like an undramatic poster. Polke's grid patterns and faux-naif sign-language bring trivial mass information into the foreground; at the same time they are like lattices or picture puzzles, like foils through which there is the vague suggestion of various things, events or signs which are usually perceived in their totality. This opaqueness and blurring effect allows moments of banality an unlimited degree of abstraction. Things are subordinated to the power of the artist, an arbitrary author – a person who "receives commands" as Polke puts it; they are the counters on a boardgame where reality and our perception of it are put through their paces.

In the early sixties, Gerhard Richter developed a direction in painting – and in other art genres – which he called "capitalist realism". Richter, who had "immigrated" to Düsseldorf from Dresden in 1961, focused in his work on the everyday phenomena of capitalist society: on stereotyped behaviour, snapshot poses, consumer habits, pornography, advertising (*Collapsible Clothes-Horse;* 1962; p. 125), tourism, the exotic, "types" (nurses, celebrities), and on landscapes, the city and the painting as a painting.

Photography functions as a gearwheel in Richter's pictures, as a lens between subject, painting and object. As a vehicle of information the photograph brings the world closer, but as a mere copy, it pushes reality into the distance. Photography shapes both the object of perception and perception itself, and thus also influences the process of painting. Photography, like the screen of a television, filters what it shows, manipulates, simplifies, blurs and makes a mystery of the image. Richter's photo-painting, produced with the help of slides projected to scale, "corrects" the colour-form-space structure of the photograph by making various "false" adjustments of focus. It thus reverses the

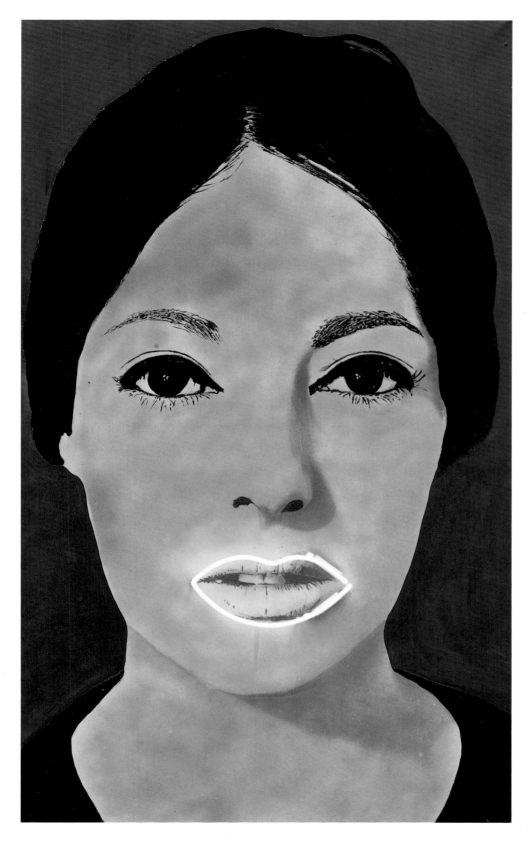

process by which its effect is usually achieved: sensations, events and apparently illustrious subjects are rendered banal in the photographic painting process (Jackie Kennedy), while the banal swells in significance (corrugated iron). His painting is both style and its lack; it is simultaneously anonymous and personal.

Martial Raysse
High Voltage Picture, 1965
Oil, fluorescent paint, powder, collage
construction, 162.5 x 97.5 cm
Stedelijk Museum, Amsterdam

PAGE 124:
Sigmar Polke
Freundinnen, 1965
Girlfriends
Oil on canvas, 150 x 190 cm
J.W. Fröhlich Collection, Stuttgart

PAGE 125:
Gerhard Richter
Faltbarer Trockner, 1962
Collapsible clothes-drying rack
Oil on canvas, 105 x 70 cm
J.W. Fröhlich Collection, Stuttgart

OPPOSITE PAGE:
Martial Raysse
Bel Été Concentré, 1967
Silkscreen on synthetic ground, 198 x 50 cm
Suermondt-Ludwig-Museum, Aachen,
Ludwig Collection

FALTBARER TROCKNER

5,60 m nutzbare Trockenlängen!

DM 8.70

Richter frees the objects from feelings, and liberates the structure of the painting from its subjective aura. He traces the latter back to the artificial elements of production and creates a code for them by alienating their definition or by the physiological sensitization of focal adjustment. Colour becomes a grey hue draping, neutralizing and depersonalizing everything. The intricate all-encompassing structure of the brushwork causes things to radiate a new, cool tension: a "beautiful" landscape becomes cold, tired and flat; the ordered structures of buildings in a city look chaotic and smooth. Richter's painting is simultaneously open and obscure; it gives us a direct view of things, but is also an illusion; it is enigmatic – like a sphinx. Author, figures and meaning remain concealed behind painted veils which have their own independent lives.

Parallel to paintings which focused on particualr motifs, abstract compositions emerged in the latter half of the sixties whose theme was the structure of painting itself (cf. Lichtenstein's "brush-paintings"; p. 60). Whether painted in bright colours or in mixtures of browns and greens, these canvases show every structure of the brushwork, of colour, line and space. And yet the eye is guided through these gyrating compositions as if into an infinite and indefinable flying enclosure whose contents appear to be sealed from view; absurd as it sounds, it is as if the painting is creating the illusion of being a painting.

Like the American Pop artists Johns and Lichtenstein, Richter breaks with Abstract Expressionism, with "informal" tachism as the expression of personal emotion, by simulating formless gesture as if it were something gratuitous, turning his attention to the "objective", to the object itself. He objectivizes the brushstroke into a concept in painting, in aesthetics.

Bronze portraits of Richter and his friend Palermo face each other in an environment with colour surfaces – the latter a mural by Palermo. The portraits show clearly defined faces of prosaic character whose "personalities" carry the signature of Richter's "anonymous" craft – their presence is that of a sameness in value attributed to a sameness in kind. Their suggested anonymity leaves their background, whether intellectual or any other, as undefined as their authorship.

Richter's intentions also came out clearly in a collaboration with the painter Konrad Lueg: in their "Demonstration for a Capitalist Realism" in a Düsseldorf furniture store in 1963 they played the role of "consumers". They integrated the whole furniture store into their artistic act and sat about in a banal environment with armchairs, tables, crockery, glassware and a television. These objects were raised on pedestals; they seemed to be caricaturing the Neo-Dadaist gesture. This act also had its counterpart. In 1967 Richter and Polke posed for the invitation card to an exhibition, blithely lying on unmade beds in the Hotel Diana, surrounded by bare walls and crumpled up newspapers. This was personal euphoria radiant among a heap of media garbage; the "wealth" of the individual surrounded by bare, uniform anonymity.

Richter's subject matter includes ordered living habits (consumerism), stability in visual habits (the photographic media), behavioural constraints (poses), compulsive patterns of feeling (the family) – an exemplary way of life as pre-figured by models and media imagery. His highly original realism is an attempt to analyse and diagnose this sham reality wherever authentic perception of it is possible. For whereas in previous centuries art provided a lens through which to perceive – or perhaps to interpret – the human being and nature, history and contemporary life, the mass media have the function of manipulating our reality.

»... dé-coll/age ist dein unfall –
dé-coll/age ist dein analysieren –
dé-coll/age ist dein leben –
dé-coll/age ist dein reduzieren –
dé-coll/age ist dein tv-trouble –
dé-coll/age ist dein fieber –
dé-coll/age ist dein verwischtsein – ...«
WOLF VOSTELL

Mimmo Rotella
Cinemascope, 1962
Décollage, 173 x 133 cm
Museum Ludwig, Cologne

Retrospective – The Sources of Pop Art

Historically, Pop Art can be said to react from a contemporary culture in which reality was subordinated to the interests of art. The subsequent de-individualization of art, its mechanical, anonymous quality, stood at the end of a long process of development in art history. Pop Art holds up a mirror to industrial, mass society with its technological progress, its expansion of mechanically reproducible media and its commercialization of popular culture. Since this development does not appear to be reversible, Pop Art is, for the time being, sited at the end of a process which has trivialized reality and reduced it to the status of a consumer product. This decadent stage in cultural history is comparable, to cite an example, to the "late Roman culture industry": the stereotyping of historical models in art, the consumption of ideals of beauty, the inflation of religious symbols, the mass accumulation of luxurious status symbols in the form of mechanically produced consumer articles, a sense of identity derived from an imperialist world power which held all the political and economic reins in its hand and whose attempt to improve the living standards of a consumer society turned progress and affluence into nothing short of an ideology. Bearing these characteristics in mind, it would hardly be surprising if one were to think of America. But one might also be reminded of the neo-classical historicism of the Victorian Age in England and its offshoots on the European mainland between the *Gründerzeit* at the end of the nineteenth century and the First World War.

America at the outset of this century was characterized by the growth of the cities and of a mass society in which the dramatic development of industry and trade were accompanied by increasing social problems, the expansion of the media and a powerful leap forward in internationalization through immigration and tourism, leisure and sport. The new catchwords were "skyscraper", "self-made man" and "business". Lifestyle in the American upper social strata was still very much modelled on Europe. In 1890, one eighth of American families owned seven eighths of the national wealth. Diverse positions were voiced in art. The representative art of the period attempted to meet the demands of the upper strata for portraits, landscapes, pioneering themes, mythological subjects and neo-romantic or symbolist tendencies. Opposed to this was an art which looked to Europe for its models, which was influenced by French Impressionism and whose aim was to constitute an American avant-garde and to keep abreast of developments on the Parisian art scene.

In relation to the historical background of Pop Art, it is interesting to note the development during this period of a strain of realism whose themes were everyday life, industrialization and social problems. The protagonists of this politically engaged and programmatic art included John Sloan (who also

Marcel Duchamp
Fontaine, 1917 (3rd version, 1964)
Upright urinal, height: 61 cm
Galleria Schwarz, Milan

Andy Warhol
Brillo, Del Monte and Heinz boxes piled on top of one another, 1964
Silkscreen on wood, 44 x 43 x 35.5 cm;
33 x 41 x 30 cm; 21 x 40 x 26 cm
Private collection, Brussels

worked as a newspaper illustrator), George Bellows, Thomas Anshutz, Robert
Henri, George Luks (the son of a Pittsburgh miner) and William Glackens,
some of whom were avowed socialists. They became known as the "Ash Can
School" — and as the "apostles of ugliness", "the black gang" or "the rev-
olutionary gang". The "Ash Can School" wanted no truck with an inter-
nationalized art which subordinated reality to the dictates of the avantgarde.
They were interested in a regional art, in a politically committed art, capable of

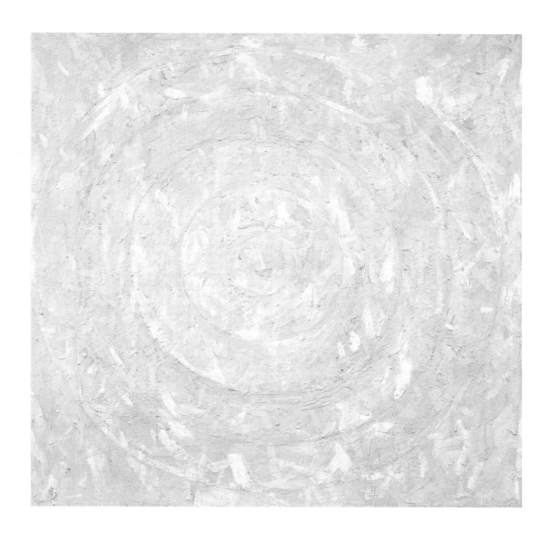

Jasper Johns
White Target, 1957
Oil and wax on canvas, 76.2 x 76.2 cm
Collection of Whitney Museum of American
Art, New York

reflecting American life critically and realistically. They were the first artists to integrate advertising slogans, shop-windows and newspapers into their work.

Parallel to this painting, photography was developing into an independent artistic medium in America. One of its protagonists was Alfred Stieglitz whose "Gallery 291" in New York championed the new American and European avantgarde in painting, sculpture and photography. Along with the symbolist painter Arthur B. Davis, and with help at the planning stage from Robert Henri, Stieglitz was one of the initiators of the legendary "Armory Show" of 1913, an "International Exhibition of Modern Art" which showed a representative selection of work from recent currents in American and European art in the former armory of the 69th Infantery Regiment in New York. This first big international exhibition of contemporary art was a key factor in setting the guidelines for the future development of American art. It was also the acid test in facing a growing public interest in art which was increasingly inclined to reject critical appraisals of American reality in favour of fashionable trends of European provenance.

The search for an American identity proved to be the most significant historical determinant of Pop Art. Writing in "The Globe" under the title "Art and Unrest" in 1913, Hutchins Hapgood triumphantly proclaimed that America hat reached the most interesting moment of its historical development. It was, he continued, no coincidence that this was also the most interesting moment of its political, industrial and social development. What was meant by "unrest"

Jess Collins
Tricky Cad (Case VII), 1959
Newsprint collage, 48.3 x 17.8 cm
County Museum of Art, Los Angeles, Gift of
Mr. and Mrs. Bruce Conner

was a state of vigorous expansion – a condition reflected in art and in the women's movement, in politics and in industry, in the form of a kind benevolent restlessness.

A work which created a considerable stir at the "Armory Show" was Marcel Duchamp's *Nude Descending a Staircase* of 1912. The Frenchman Duchamp later remained in New York where he met the Parisian painter Francis Picabia and the American painter and photographer Man Ray. These three artists were the founders of the New York Dada movement. From 1915 Dada questioned traditional notions of art and took as its theme the idea of the affront, or shock. This was one of the roots of the later Pop Art movement. To throw doubt on art was also to throw doubt on its forms and subject matter, on the traditional modes of its reception and on its concepts of beauty and truth. In 1917 Duchamp presented a urinal (*Fountain;* p. 129) for the "Independents" exhibition and signed it Richard Mutt. Duchamp stated that it did not matter whether or nor Mutt had made this "fountain" with his own hands. The important thing was that he had selected it. Mutt had taken a normal household article and displayed it so that its intended purpose had disappeared behind a new title and a new way of looking at it. He had thus given this object a new meaning. To speak of plumbing here was, according to Duchamp, absurd. After all, America's only real art works to date were its sanitary arrangements and bridges! The idea of abolishing the contradiction between reality and representation and of presenting reality directly and dubbing it art was highly radical at the time and later influenced Andy Warhol.

What was it which made Dada so inspiring for the development of Pop Art? Dada combined advertising images and texts, slogans, revolutionary pamphlets, folk art and popular culture in collages, pictures with texts, photos, films, assemblages, theatre and performances. The unorthodox, and in some ways surreal, manner in which it combined these, integrating both the rational ordering principle and elements of chance, influenced Pop Art and the Happening towards the end of the fifties. The work of art as an object, as an objet trouvé or Ready-made, the everyday consumer product as an object of artistic interest – this recipe shocked the art scene and insulted its sense of aesthetics. The Ready-made, as a forerunner of Pop Art, shows how art became part of the everyday world (like Lichtenstein's Mondrian pictures), and how the everyday world became art (like Warhol's Brillo boxes, p. 128). Duchamp was not interested in the aesthetic attraction of the products themselves, or in analysing the banality of their aesthetics. His objects were a means to an end, a means of demonstrating, rather than illustrating, the cultural rift between explosive social problems in society and its artistically saturated establishment. This intervention in the structured hierarchy of the world of art and the world of things paved the way for a route which led from "Duchamp", as a synonym for confrontation, to a principle in Pop Art which handed over artistic direction to the world of everyday commoditiy articles and integrated the machine into its artistic vocabulary.

Another important precursor of Pop Art was the American Marsden Hartley, who had exhibited his work at the "Armory Show" in 1913 and who, in 1917, had become acquainted with a group of artists known as *Der Blaue Reiter* in Berlin. It was Hartley who, for the first time, had incorporated trivial signs and symbols from the world around him into his pictures (p. 134). He and Man Ray were the first American artists actually to understand Duchamp and Dada. He nevertheless invented playfully ironic, abstract figurative compositions in his own work. Like Man Ray, Hartley was a pupil of Robert Henri. Under

Reginald Marsh
Tattoo and Haircut, 1932
Egg tempera on fibreboard, 118 x 121.6 cm
The Art Institute of Chicago, Chicago, Gift of
Mr. and Mrs. Earle Ludgin

the heading "The Importance of being Dada" in his essay "Adventures in the Arts", he described Dadaism as the final phase of Modernism in painting and literature, a movement incorporating that enthusiasm for freedom of expression which Marinetti had defended so volubly in his Futurist manifestos. He also detected a new, and entertaining, nihilistic streak in Dadaism, which he traced back to Nietzsche. Hartley saw the essential idea – and charm – of Dadaism as residing in its attempt to reduce everything in our minds to the level of everyday reality. For Dada, nothing was greater than anything else. A typical Dadaist, therefore, was someone who attributed no more meaning to one thing than to any other. Hartley saw Dadaism as offering a shimmer of hope to the artist in a world where art had become overburdened with meaningless "significance". Dada was a joyful doctrine, conceived to liberate art and to defend its true freedom. On the 1st of April 1914, the Societé Anonyme organized a symposium on the question "What is Dadaism?" – with Hartley as its chairman. One of its participants was Stuart Davis, also a pupil of Henri. His paintings greatly influenced the development of Pop Art. They showed a typically American conglomerate of abstracted objects from everyday life, signs and commodity and advertising imagery arranged in compositions with bright colour surfaces. During the symposium, Davis professed chaos as a principle of composition.

The isolation of the human being in the public places of big cities – also the subject of George Segal's sculptures (p. 143) – was Edward Hopper's theme.

Marsden Hartley
Painting Number 5, 1914/15
Oil on canvas, 100.3 x 80.7 cm
Collection of Whitney Museum of American
Art, New York, anonymous donation

Hopper, who had also studied under Henri, had exhibited an early work at the "Armory Show". His later pictures throw a penetrating light on an alienated world, on deserted outposts on the land and in the town, on the loneliness of the individual in the crowd, recording these with an almost mechanical intensity: aging people, lovers, people in a café, office workers, villas, streets, stores and gas stations (p. 142). Hopper rejected European traditions and committed himself to the creation of a truly American art. "The question of the value of nationality in art is perhaps unsolvable. In general it can be said that a nation's art is greatest when it most reflects the character of its people," he wrote in the preface of a catalogue published in 1933 for a retrospective of his work at the Museum of Modern Art in New York. Hopper set out to reflect American public life in all its small-minded sterility, to capture relations in American society uncompromisingly in his painting; the means of expression he chose for this were anonymous and austere.

The so-called Precisionists, among them Charles Demuth, were inspired by Dada's unconventional stance and translated Duchamp's assertion that the

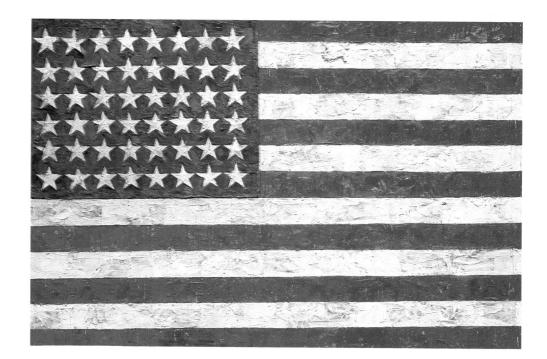

only art New York possessed was its bridges and sanitations, into painting. They attempted to express the nature of the times by means of realistic representation, and, at the same time, to wed abstraction and realism into a kind of unity. Charles Sheeler, on the other hand, translated industrial reality directly into pictorial form. This reality seemed cleansed, sterile, frozen – alienated and therefore almost too realistic. Sheeler worked as a photographer, like the important genre painter Ben Shahn. American photography in the twenties and thirties was interested in similar themes: life in American cities and on the land, views of industrialism, the changed appearance of American streets as a result of billboard advertising, the effect of the mass media on everyday life, bleak social milieu. Realism in photography and the cinema rose to unique levels of artistic achievement during these years. The interpenetration of art and everyday life was a characteristic feature of the thirties. The period was marked by economic and political crises; the "American Dream" was succeeded by the Depresssion. This explained the trend towards social criticism, and also the artists' preoccupation with the myth of "America".

Various developments in Europe which influenced art, especially in the period between the two wars, are also important for the history of Pop Art. It was a period of great advances in civilization, technology and mass culture, a period of luxury and decadence in lifestyle, of enormous growth in the entertainment industry (musical hits, the cinema, cheap novels and illustrated magazines). Critical intellectuals, writers, artists and film directors reacted to these phenomena and attempted to interpret this new cultural situation and make people aware of it. The work of Walter Benjamin and Siegfried Kracauer deserves special mention here. A number of Bauhaus publications also reflect this new *Zeitgeist*, as do the Hungarian Bauhaus teacher, László Moholy-Nagy's experiments in photography, the cinema, multi-media and machine art. "The Ornament of Mass", the title of an essay published by Kracauer in the "Frankfurter Zeitung" in 1927, suggests what, today, might be called a "network": the adaptation of new technologies to mass demands for information. In his essay of 1936, "The Work of Art in the Age of Mechanical Reproduction",

Walter Benjamin analysed changes which were occurring in habitual patterns of viewing and behaving and in the production and reception of works of art, and also showed the emergence of a mass supply of cultural products. He was describing the first stage in a development which would later flow into the era of Pop Art, and which led in the fifties to Marshall McLuhan's theory of the externally controlled human being, of the power and influence of the mass media as "the message". In the twenties, qualities and devices developed by the photographic media, and the new technologies of photographic and mechanical reproduction, changed notions of art and culture. On the one hand a mass culture developed in the form of a commercially produced popular (*Volkskunst*) or amateur art (hobby photography), and on the other, a reflective, critical "high" culture which exploited the possibilities of mass reproducibility. Andy Warhol's use of amateur cinefilm in the sixties can also be explained in this context; his intention was to achieve an inexorably realistic, "amateur" documentation of the monotony of everyday life by incorporating all the imperfections, tedium and distributive restrictions of non-professional film direction.

In 1947 the Hanoverian Dada artist Kurt Schwitters created one of the most well-known prototypes of Pop Art, the collage *For Käthe,* a composition which included the first use of the comic — a novel variety of popular literature at the time. In the same year, Eduardo Paolozzi was creating similar, Pop collages. Schwitters, who had begun experimenting with collages and assemblages before 1920, combined tickets, advertising slogans, photographs, letters and magazine and newspaper cuttings in pictures and reliefs which resituated these obtrusive, "found" objects within the intimacy of a Cubist composition.

Collage and assemblage are essential formal principles in Pop Art. In using secondhand images and objects, the intention was to give them a new

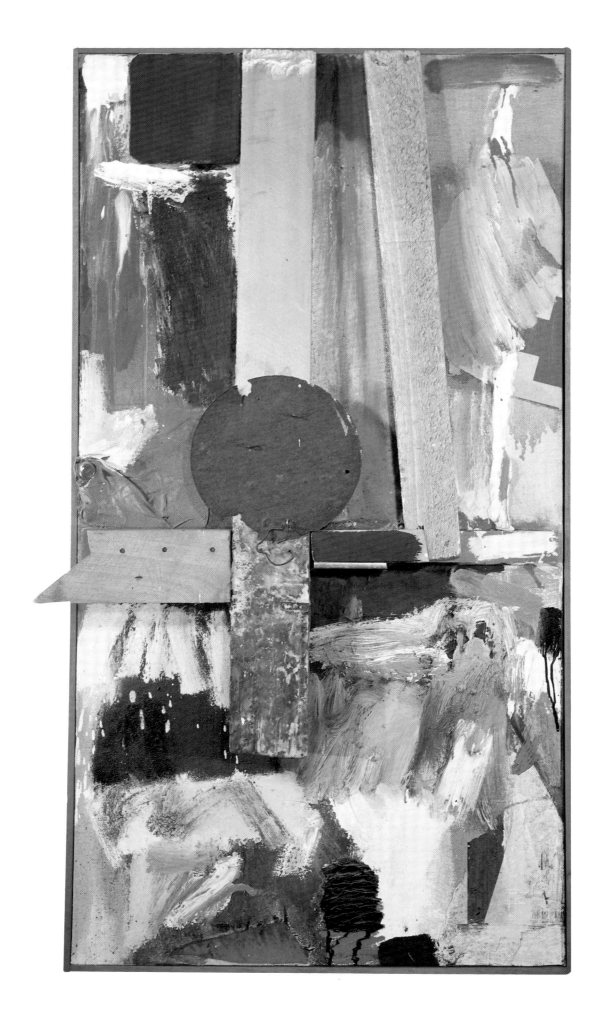

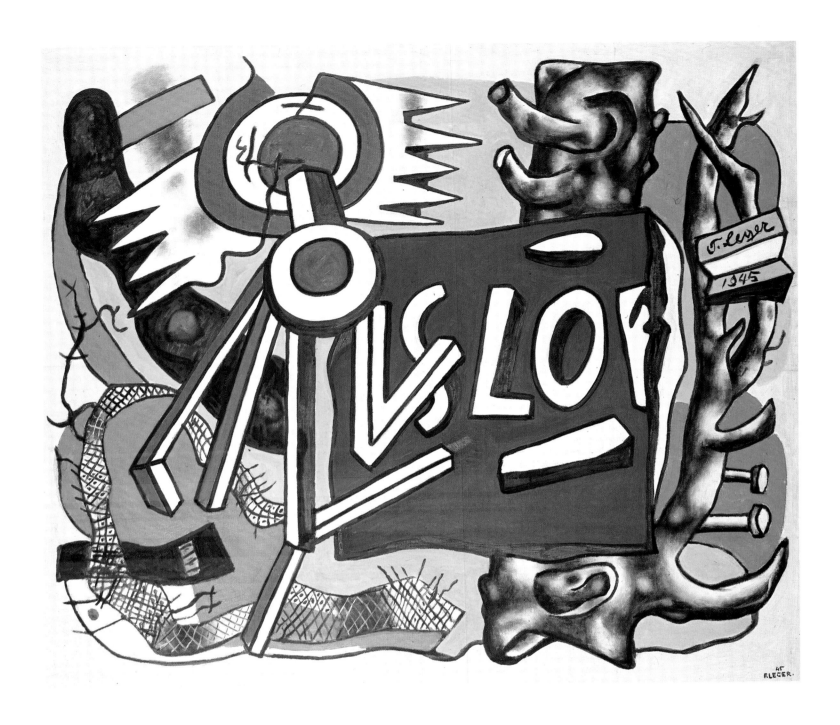

Fernand Léger
Le Tronc d'Arbre sur Fond Jaune, 1945
Oil on canvas, 112 x 127 cm
National Galleries of Scotland, Edinburgh

meaning and, in some senses, to subjectivize the objective. Objects, fragments and traces are combined with painting, drawing and sculpture in such a way as to transcend the borderlines between heterogeneous subjects. There is an evident proximity here to the combinatory effects achieved by Surrealist artists; the latter, however, focused primarily on the subconscious impulses of the human mind, rather than on externally controlled human behaviour – a concern of Pop Art. In this context, it is worth mentioning the torn posters, or "affiches lacérées", produced by European, and especially French artists – the so-called décollages – which also influenced Pop Art (Jacques de la Villéglé, Raymond Hains, p. 120, Mimmo Rotella; Wolf Vostell, p. 34). In both their subject matter and systematic enactment of a "mechanism" apparently controlled by chance, these pictures express human presence in a preformed, externally determined environment.

Yet another germ cell of Pop Art lies in the European painting of the

THE EXHAUSTED SOLDIERS, SLEEP-
LESS FOR FIVE AND SIX DAYS AT A
TIME, ALWAYS HUNGRY FOR DECENT
CHOW, SUFFERING FROM THE TROPICAL
FUNGUS INFECTIONS, KEPT FIGHTING!

Roy Lichtenstein
Takka Takka, 1962
Magna on canvas, 173 x 143 cm
Museum Ludwig, Cologne

twenties and thirties. This art had repudiated Cubist styles in favour of a realistic vocabulary capable of depicting the effects of social and environmental factors on the individual in objective terms and without emotional interference. Although the motivations behind the various realisms which gained widespread currency in the twenties may have differed considerably, their common aim was the criticism and transformation of mass industrial society. These changes – seen initially as a step backwards after the abstract avantgarde – culminated, in German painting especially, in the style known as *Neue Sachlichkeit*. Its leading representatives were Otto Dix, George Grosz and Christian Schad. The work of these artists experienced a kind of renaissance during Pop Art and the social realism of the sixties.

In England, the motherland of European Pop, William Roberts painted formulaic faces and uniform, angular body movements to reflect the dynamic compression exercised by a mass society flooded by the products of the

entertainment industry and new media. In his picture *The Cinema* (1920), an aggressive, oversized canvas painted in blacks, whites, greys and browns smothers the colourful bustle of the human figures in a stifling, hellish atmosphere. Human figures are depicted in the Underground as nameless, tired beings lacking in any sense of individual direction, forcibly made to conform to a system of strictly defined movements, driven along by hieroglyphic signals and sucked – as if in a maelstrom – into the gullet of an underground chasm. These pictures reflect the age of industry and the media as an unforeseen phenomenon penetrating individuality and invading the sphere of human privacy. Peter Blake's work can be said to owe much to this realist tradition in English painting, which – quite apart from its influence on Pop Art – found highly original followers in Lucien Freud and Francis Bacon, and, in the USA, in Warhol's friend Philip Pearlstein.

Raoul Haussmann
Tatlin at Home, 1920
Collage and gouache, 41 x 28 cm
Whereabouts unknown

"The orientation of reality to the masses and of the masses to it is a process of infinite consequence for both thought and intuition."
WALTER BENJAMIN

The great representatives of classical Modernism had a particularly strong influence on Pop Art. Besides the Surrealists Max Ernst and René Magritte, these included Henri Matisse, Pablo Picasso, Paul Klee and Fernand Léger. The most striking characteristic of the Surrealists' work in relation to Pop Art is its unrestrained capacity for combination, its subtle suggestion of patterns in behaviour, taste and objects. Klee had a penchant for the trivial, for Kitsch and for the habits of bourgeois life, for playfulness and for folk art; he tended both to flirt with and ironize fashions, trends and superficiality. Picasso's playfulness and artistic volatility constantly led him to trace associations to different stylistic trends, to integrate "found" objects into his compositions and to fuse these with abstract elements (sculptures and bronzes). His work also stands for the eclectic accessibility of different cultures, for the vulgar, the euphoric and the catastrophic. Léger's work depicts a dialogue between human beings and

Edward Hopper
Nighthawks, 1942
Oil on canvas, 76.2 x 144 cm
The Art Institute of Chicago, Chicago, Collection of the Friends of American Art

machines ("Ballet méchanique", an experimental film made in 1924); his paintings portray the feeling of living in a world where the sense of self has been replaced by the anonymous, mechanical qualities of the contemporary human being. In his compositions, space, colour and line conspire to form severe, meticulously constructed mechanical frameworks; living conditions are expressed in terms of rigidly interlocking shapes. Lichtenstein consistently refers to Léger's style of representation, even, on occasion, building his compositions around motifs transferred directly from Léger's paintings. Indeed, the theme of "art after art" is altogether helpful in establishing Pop artists' attitudes to art history. Matisse shows an inclination for the decorative, for folk art and a bold, frontal vocabulary; but more importantly, he expresses a sensual optimism in the everyday domestic world of his paintings.

One of the main sources of American Pop Art was the tradition of folk art. This tradition expresses the Americans' positive attitude towards life, their realistic mentality and desire for adventure and discovery; it also decorated their homes and gave form to their commodity articles. In its simplicity and self-assurance, in its vitality and narrative joy, early American folk art — and especially that of the nineteenth century — was a unique and formally compressed tableau in which the Americans had recorded their personal seals, their status symbols and national symbols, their historical myths and their legends, their everyday environments, ways of life and familial domesticity. Its products were an expression of cultural change and self-determination, a mirror capturing individuals (portraits), types, fashions and signs of national, historical identity.

Warhol's work in the fifties demonstrates a particular sympathy for the lightness and playfulness, the self-assurance and directness of American folk art.

The fact that folk art is one of its chief sources shows that American Pop Art grew out of the vital consciousness and way of life of the people, that it stands firmly planted in the American civil tradition. It is this tradition which explains the link between its venerable and unique folk tradition and the relentless insistence of Pop Art on remaining a "popular" art, a contemporary folk art. Entertainment, show, optimism, wit and the amusingly critical punch-line can also be found in caricatures, running commentaries, illustrations, picture stories and other genres. The thin dividing line between caricature, folk art and Pop Art is illustrated in the graphic work of Saul Steinberg, and in paintings by William Copley.

Pragmatism, realism, objectivity, optimism and entertainment are typical characteristics both of the American people and of American art. Both the fascination for advertisements, for poster and movie painting and for consumer goods packaging, and the delight in the trivial and simple, in apparently meaningless, banal and trite things are deeply rooted in the history of American art. They can be traced back even to the painted *objets trouvés* and news pictures of the nineteenth century.

Pop Art can be seen in conjunction with any other realism in the history of art whose aim was to give a routine, harmonious appearance to the contradictions and absurdities of the material world. For Pop Art, the realism of a world of things in which hierarchies are absent, symbolizes the social emancipation of art and the artist.

George Segal
The Butcher Shop, 1965
Plaster, wood, metal, vinyl and plexiglass,
238 x 252.1 x 124.5 cm
Art Gallery of Ontario, Toronto, Gift of the Women's Committee Foundation

Robert Rauschenberg

There are several basic characteristics of Robert Rauschenberg's work which must be attributed to his biography. No other American artist of his generation can be said to combine such extremes of artistic influence in his work: both traditional painting and the universality of modern means of expression.

In 1947/48 Rauschenberg studied art and related subjects – art history, design and composition, sculpture, music, anatomy and fashion design – at the Kansas City Art Institute. He did window displays, designed film sets and decorated photographic studios. In 1949 he went to Black Mountain College in North Carolina and added photography to his other subjects. The breadth of his education was a prerequisite for the open-mindedness with which he later approached his craft. He also gained inspiration from his encounter at Black Mountain College with the composer John Cage, who was a few years his senior, and with the dancer Merce Cunningham. From 1952 on, he collaborated with both of them in music, dance and theatre performances. From 1953 to 1965 Rauschenberg designed stage sets, scenes, costumes and décor for Cunningham's ballet group.

By 1948 he had come to the conclusion – though he was "at least 15 years too late" – that as an artist, he had to "study in Paris". While he was there, he painted landscapes and urban scenes in traditional style. He returned to America after reading about the German Bauhaus artist Josef Albers, who became his teacher at Black Mountain College. Albers, who reduced form and colour to their basic structures, influenced Rauschenberg's early concrete, philosophically conceived paintings. But Rauschenberg also grappled with the opposite extreme in painting – with Abstract Expressionism and Action Painting. His encounter with Willem de Kooning was decisive for his development; de Kooning was an abstract-expressionist painter whose motifs tended toward the trivial and commonplace.

In rubbing out a drawing by Willem de Kooning in 1953 (*Erased de Kooning Drawing;* p 83.), Rauschenberg's intention was to create artistic language out of the void, as it were, out of an entirely open and liberated space. During this period he also made car-tyre prints and collages with themes relating to natural history. The clear white, black and red paintings partly inspired by Cage's Zen Buddhism, and which in turn inspired Cage to new compositions, are pregnant with a latent exuberance of expressive energy. This feature, characteristic of Rauschenberg's artistic project at the time, is in keeping with John Cage's principles of composition.

In New York, the urban and cultural metropolis of America, Rauschenberg had every opportunity to further develop his artistic plans. In 1950 he took a studio on the Upper West Side; in 1953 he moved downtown, and from 1955

"The logical or illogical relationship between one thing and another is no longer a gratifying subject to the artist as the awareness grows that even in his most devastating or heroic moment he is part of the density of an uncensored continuum that neither begins with nor ends with any decision or action of his."

ROBERT RAUSCHENBERG

Robert Rauschenberg
Black Market, 1961
Combine Painting: canvas, wood, metal, oil, 152 x 127 cm
Museum Ludwig, Cologne

Robert Rauschenberg
Yoicks, 1953
Oil, cloth, and paper on canvas,
243.8 x 182.9 cm
Collection of Whitney Museum of American
Art, New York, Gift of the artist

Robert Rauschenberg
Red Painting, 1953
Oil, cloth and newspaper on canvas with
wood, 73.7 x 84.7 cm
The Solomon R. Guggenheim Museum,
New York, Gift of Walter K. Gutman

on, shared a studio neighbourhood with Jasper Johns. Rauschenberg's collages and assemblages of the late fifties and early sixties seemed to give the initial boost for the development of Pop Art. These works were much indebted, both in subject matter and form, to the Dada movement, to Kurt Schwitters and Marcel Duchamp, the letter of whom had been living in New York since 1915 and had become Rauschenberg's friend in 1960.

Rauschenberg's intention was to confront the trivial, mechanical reproductions of the media industry with his freely conceived graphic, painterly and plastic elements: the polarity of the objective and the subjective, the personal in dialogue with the general, the functional and preformed in combination with the creative. This unusual, unorthodox method of mixing heterogeneous elements appeared to violate the most sacred criteria governing the principles of artistic composition. These principles prescribed a consciously devised, trans-

parent conception from which logical steps could be deduced for the ordered arrangement of the canvas – even if the artist's intentions were highly expressive or activistic, and could therefore not be contained within the existing framework. Rauschenberg's pictures do not fulfil these criteria since they combine both freely conceived and extraneous elements in an apparently chance and meaningless manner, and therefore seem devoid of inner sense or interpretation. As far as the element of chance in his painting is concerned, his technique can undoubtedly be compared with that of Action Painting. However, Rauschenberg also reverses Action Painting's most important means of expression. By "depersonalizing" the components of the painting process which are expressive and dependent upon his mood, he creates a force with which to counter the unpredictable, or accidental elements within a sequence of movements. His mechanical and anonymous process of production enables

Kurt Schwitters
Merzbild 1 A (Irrenarzt), 1919
Merz Picture 1 A (psychiatrist)
Montage, mixed media on canvas,
48.5 x 38.5 cm
Marlborough Fine Art Ltd., London

Robert Rauschenberg
Canyon, 1959
Combine Painting, 219.7 x 179.1 x 57.8 cm
Sonnabend Gallery, New York

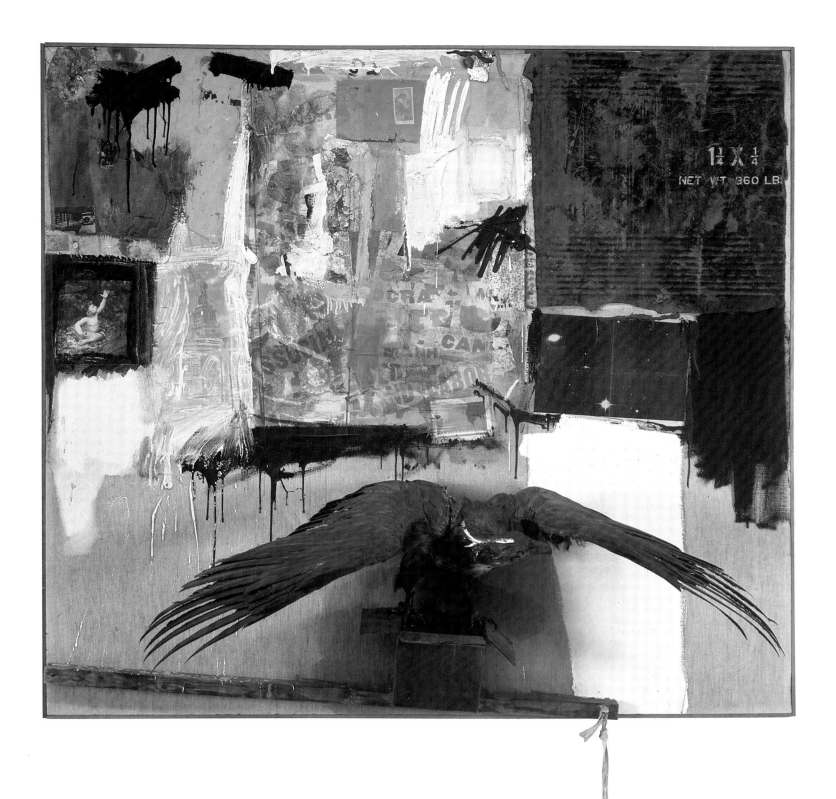

him to de-individualize, to generalize and objectivize artistic statement; by distancing himself from the creative process in this way, he is able to give form and content a binding communicative value.

When we speak of universality as a thread running throughout Rauschenberg's work, we are referring to his treatment of philosophical subject matter, to images from the mass media in his work and to his use of different artistic techniques. These techniques include tracing, his "transfer-drawing" (compare Warhol's "blotted line", developed in the fifties), frottage (a "kid's game"), colour filtering and all kinds of printing techniques such as the silkscreen method and the reversed print. They also include "objets trouvés", photographs, newspaper clippings, comics, letters and textss as well as non-representational painting and drawing, either as an integrated structure or seemingly haphazard and accidental.

The great density of mass-media images in Rauschenberg's pictures creates a sense of space and gives the impression of things appearing from just below the surface or from a great depth and then sinking again. His "combine paintings" (pp.144, 149, 151) are montages within which figurative elements and their meanings are interwoven with undefined, non-representational planes. The value and identity of the figurative elements remain unaltered in themselves, but are exposed to multiple refraction by presenting them in a new and unrestricted light. The domain of personal experience is linked with signs and objects taken from the throw-away, consumer society. One might describe them as the icons of the day, or as visual mnemonics. The symbols he uses are derived from layers of reality which are normally very distant from one another, but which he combines through association and suggestion. Waste products, dirt and bones are connected with vital, "positive" symbols; the "highlights" of art history combined with the present, with everyday life, politics, machines and workers; bright colours encounter black (*Black Market,* 1961; p. 144). The new combinations lift their contents to new levels of meaning.

Rauschenberg's many collaborations with other artists show that he understood universality as a communicative project. In 1962 he acted with Niki de Saint-Phalle, Frank Stella, Jean Tinguely and others in Kenneth Koch's play "The Construction of Boston", which was put on by Merce Cunningham, for whose dance company Rauschenberg designed stage, lighting and costumes. He staged his own first dance production "Pelican" in a roller-skating rink in 1963. He liked to include his fellow artists in his own performances, and sought contact with the many different artistic and intellectual figures of his time. He met Martin Luther King in 1967 when he was awarded an honorary doctorate in literature at Grinnell College, Iowa. Rauschenberg endeavoured to unite art, culture and science in a single philosophy of life. It was this project which led to his founding the "Experiments in Art and Technology" (E. A. T) with Billy Klüver in 1966, an organization to help creative artists and technical and industrial engineers to work together. In 1969 NASA invited him to the Kennedy Space Center to witness the launch of Apollo 11 on its flight to the moon. This complied both with Rauschenberg's artistic and intellectual, scientific interests. His reaction to this experience was the series of lithographs, *Stoned Moon.*

Rauschenberg's only *Self-Portrait* (1965) – one of the very few self-portraits of the Pop era – reveals the complexity and universality of both his subject matter and means of expression, and also the way in which internal and external experience meet in his work. It is as if he is confronting his own face with technology, with the philosophical perspectives of a belief in progress, and with utopian civilisations. Rauschenberg's compositions make full use of a

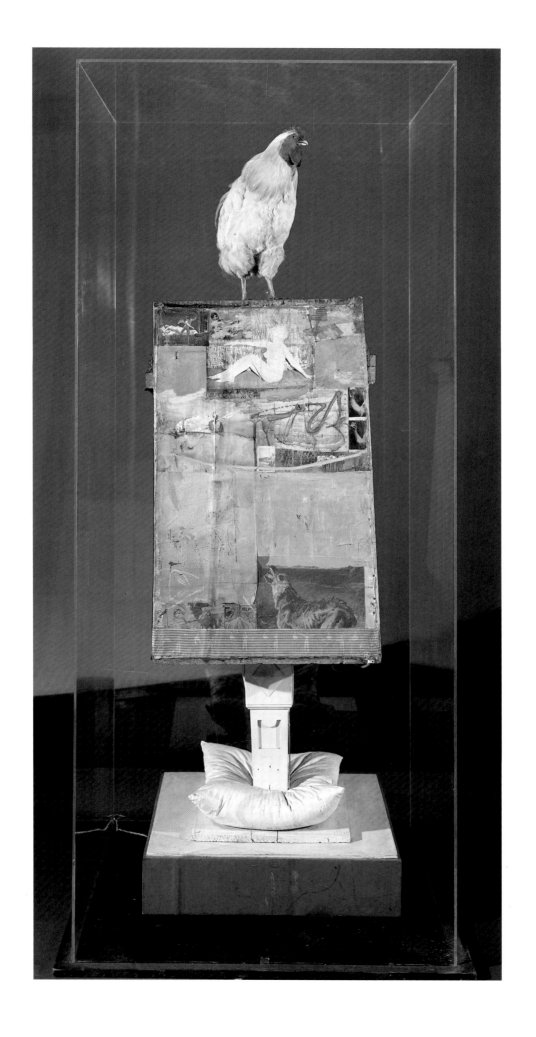

Robert Rauschenberg
Kite, 1963
Oil and silkscreen on canvas,
213.4 x 152.4 cm
Sonnabend Gallery, New York

given space, seemingly projected through the four cardinal points. The things in it appear to be arranged within an ornamental net. The self-portrait shows him with the tools of the artist. The photograph stands for the modern method of representation and shows the artist himself; paint and pencil are his traditional working materials, and his signature, a mirror inversion of the first letter of his name, has been the "hallmark" of the artist since the early Renaissance. The ear can listen to the world, and is perhaps a symbol for alertness, communication, musicality and sensuality. The material is confronted with the spiritual, and matter with the immaterial.

Robert Rauschenberg
Hedge, 1964
Oil and silkscreen on canvas, 60 x 48 cm
Ludwig Collection, Aachen
(On loan to the Museum Nationalgalerie
Altes Museum, Berlin)

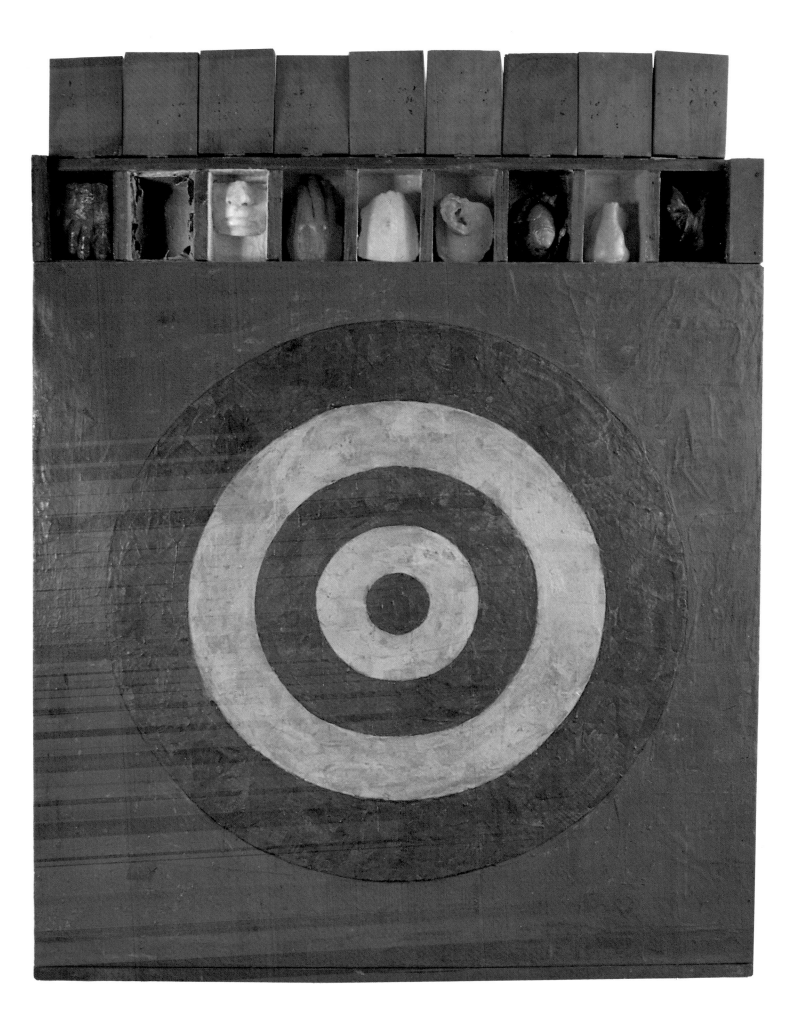

Jasper Johns

Subject – object – perception – painting – picture: Jasper Johns' intention is to reduce the artistic logic of this far-reaching and comprehensive process to its most simple and concrete mode of presentation. Johns defines the phases through which a painting passes as factual, conceptual processes of equal importance. The subject (painting) does not override the object (picture); perception is not coloured by emotional or idealistic prejudice, and the picture itself is not an illustration of any kind of idea. Painting simply exists in its own right. The modelling process proceeds from "perception" – a central concept in Johns' theory – via the act to the picture itself. In looking at a picture we perceive both its material and non-material layers of meaning. "One can say that the physique of the painting embodies the thought, allowing the mind to perceive both at once; or the two can split, allowing one to sense them at different times."

Johns' resolute clarity at every stage derives from self-reflection; that is to say, he is aware of himself both during the act of perception, and while observing the steps he takes to realize his idea. He investigates what he is doing and how he is doing it while he is doing it. "And the process of my working involves indirect unanchored way of looking at what I am doing." His utterly plain explanation of his painting method is evidently also a product of self-questioning and artistic self-determination. In his notes, statements and inter-view responses, Johns locates the indissoluble planes of reference and stance of his work in what can only be described as a philosphical system. The subtlety and precision of his language equip him with the tools to undertake an exact dissection of his every step, of the stages through which his work passes and of the result itself, but they are also the tools of his "Socratically wise" irony: "It (the statement) has to be what you can't avoid saying, not what you set out to say." "I think that most art which begins to make a statement fails to make a statement because the methods used are too schematic or too artificial. ... The final suggestion, the final statement, has to be a deliberate statement but a helpless statement."

Perception is the central criterion in the genesis and effect of Johns' paintings. "...the perception of the object is through looking and through thinking." "Meaning" is a product of unmediated "looking" and should there-fore not be distorted by expectations, prejudices, knowledge, feelings or ideas. What Johns calls recreation arises during the process of working, through visual and intellectual activity. "I have attempted to develop my thinking in such a way that the work I've done is not me – not to confuse my feelings with what I produced. I didn't want my work to be exposure of my feelings." By reducing the meaning of an object in a painting to the function of perception and

Jasper Johns
Souvenir, 1964
Encaustic on canvas with objects,
73 x 53.3 cm

Jasper Johns
Target with Plaster Casts, 1955
Encaustic on canvas with plaster casts,
129.5 x 111.8 x 8.9 cm
Leo Castelli Gallery, New York

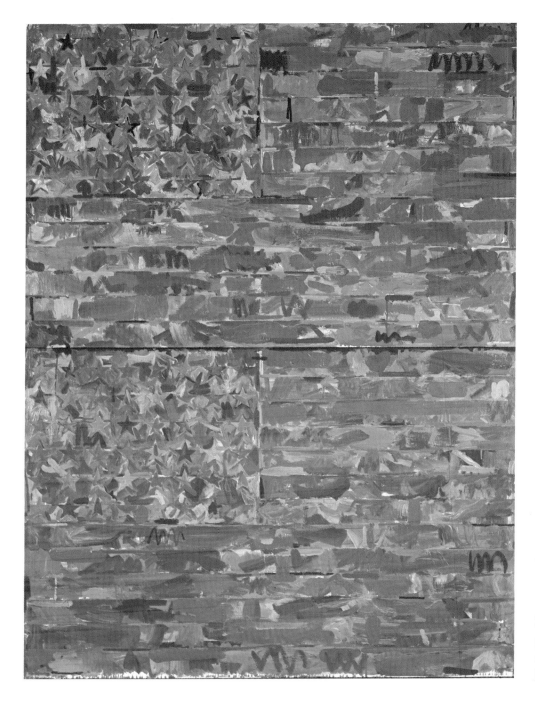

purifying it of emotions, he liberates both the image and its representation from interpretations which are not integral to the act of seeing, and from individualistic bias.

Johns started painting his first important objects and symbols with this method in 1954. They include his *Flags* (pp. 39, 135, 158, 159), his *Targets* (pp. 40, 131, 156) and also numbers, letters, the "canvas" and words. Johns locates these, characteristically enough, at the outset of his artistic project, having destroyed – as far as was possible – everything which predated them. His perception of a thing proceeds from the "physical form of whatever I'm doing". In order to execute a painting, he prefers to adhere to what already exists (the tiles in his later work, for instance, with their anonymous ornamental quality), rather than inventing his own composition. He reverses the usual process: "Invent a function. Find an object." Johns confessed that he was no longer

"Say, the painting of a flag is always less about a flag than it is about a brush-stoke or about a color or about the physicality of the paint, I think." JASPER JOHNS

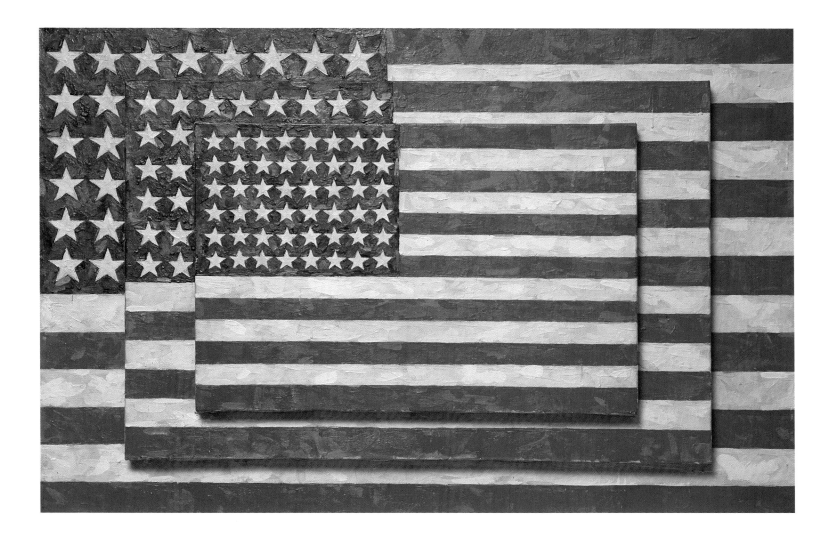

interested in the image of the U.S. flag when the real thing received its additional stars (51 altogether). The pictorial variations of this theme show that, for Johns, perception is not static, but constantly changing. The flag is exposed to frequently "changing focus"; Johns paints it in different states: "But I was interested in the kind of nuance, modulation, play between thinking, seeing, saying and nothing."

Johns concentrates the whole variety of life, objects and art into a few central motifs which he selects subjectively. Their integration into an expression of the conditions of perception is a matter of his own, personal. Just as Johns sees procedure and statement as equals, his paintings allow the parts and the whole to be perceived as equal in value. The painterly structure, composition and colours combine to make of the original objects a unity which precludes hierarchical divisions and gives equal weight not only to the parts in relation to one another, but also to each part in relation to the whole. In his sketchbooks he writes: "Whether to see two parts as one thing or as two things." And in deciding how to apportion the space within a canvas, he sees two "things" and the space between them as three "things".

The absence of interpretation, whether in the painting or the object, and the anonymity of the pictures and their style, are a result of the withdrawal of the artist's personality, and show that the act of perceiving a picture or depicted object is a variable process. In one text Johns quotes his friend John Cage: "At every point in nature there is something to see. My work contains similar

Jasper Johns
Three Flags, 1958
Encaustic on canvas, 78.4 x 115.6 x 12.7 cm
Collection of Whitney Museum of American Art, New York,
Gift of the Gilman Foundation, the Lauder Foundation, and A. Alfred Taubman,
donated anonymously on 50th Anniversary

PAGE 160:
Jasper Johns
4 the News, 1962
Wax painting and collage on canvas, 165.1 x 127.6 cm
Kunstsammlung Nordrhein-Westfalen, Düsseldorf

PAGE 161:
Jasper Johns
Device, 1961-62
Oil on canvas, 182.88 x 121.92 x 11.43 cm
Dallas Museum of Art, Dallas, Gift of the Art Museum League

Jasper Johns
Studio, 1964
Oil on canvas, 186.7 x 369.6 cm
Collection of Whitney Museum of American
Art, New York, acquired through the Fund of
the Friends of the Whitney Museum of Ameri-
can Art

PAGE 162/163:
Jasper Johns
Untitled, 1972
Acrylic and wax paint on canvas, board, wax
moulds and various materials, 4 parts,
183 x 490 cm
Museum Ludwig, Cologne

possibilities for the changing focus of the eye." His non-representational symbols draw the strands of the picture together into what appears to be an indissoluble and (usually) finely-woven mesh, from whose abstract structure the object can be distilled. Colour, too, determines the way in which an object is perceived. The flag may shine out in reds and blues, or it may be abstracted into white-ish tones, into the material disintegration of a bronze – as if receding into nothingness. In his drawings, the structure of the flag is minimized. One is reminded of Impressionist brushwork, that is of a kind of painting which went out to discover the actual mechanisms of perception, the natural tensions and movements of the human eye.

Johns' work does not pander to expectations created by the media. He sees the media as a strategy for the decoding of different layers of thought and vision. Which is the object, and which the picture? How does one depict the weight of a beer can behind its painted façade? How does one go about giving two beer cans "individual" identity while giving them identical form and making them equally beautiful?

Besides his work in encaustic, oil and collage Johns uses complex graphic techniques such as lithograph and etching. But it is above all his drawings whose conception, structure and intricately interwoven detail illustrate the extreme precision of his artistic system. Painted bronzes (1960) and assemblages with plaster-cast masks, with spoons, chairs, plaster-casts of faces and bodies (he combined plaster-casts of parts of the body with his target in 1955; p. 156) are among the constantly changing ways Johns depicts different levels of perception.

In 1959 Johns turned away from his hitherto strictly reductive technique. He

began to paint objects from the everyday world with generous, gestural brush-strokes. He added the map of America to his central themes. In the paintings with stencilled colour-words, colour is either simply pure colour, unrestricted energy, or else it adheres to objects.

In 1960, Johns worked on minimalist, concrete studies of flags and targets in white paint (p. 131) and bronze. Like Rauschenberg, Johns had painted colour surfaces in his early work from 1950, but he had destroyed most of these. In 1964 he began to give clearer, more direct expression to the complexity of possible relations between subject and object, between the act of painting and the painting itself. His anonymous ornaments (from tiles to the drawings of trees by the hairdresser who "invented" the anonymous pictorial structures of Johns' compositions at the beginning of the seventies), the symbols, words and also the flags and targets he took up again in the mid-sixties and of the seventies concentrate Johns' "visual and intellectual activities" in varying perspectives. Johns attempts over and over again to turn the borderland between the material and non-material worlds into an object of perception.

The distinguishing feature of both Johns' and Rauschenberg's work is their universality within the field of tension between the totality of things and nothing-ness, between the whole and the part, between the banal and the philosophical. Johns and Rauschenberg were studio neighbours in Pearl Street, downtown New York, from 1955 to 1958 during a crucial stage of their development. Johns' compositions reduced his pictures to essentials, while Rauschenberg expressed the full range of his sweeping ideas with the help of dislocation, stratification and combination. A connecting link – especially as far as John's philosophical side is concerned – was their friendship with the composer John Cage. Johns had met Cage through Rauschenberg in 1954. Cage has de-scribed Johns' ability to give almost magical effect to precise perceptions while placing these within the context of lived, everyday meanings. The thing about the "target," according to Cage, was its need of something else. Indeed, there was nothing which could not function as its opposite. Not even the rectangular space in whose centre the target was placed. And it was precisely this undi-vided, and apparently residual, zone of the painting which engendered – miraculously, as it seemed – its own organization. Into "faces", as Cage put it.

"Two meanings have been ascribed to these American Flag paintings of mine. One opposition is: 'He's painted a flag so you don't have to think of it as a flag but only as a painting.' The other is: 'You are enabled by the way he has painted it to see it as a flag and not as a painting.'" JASPER JOHNS

Jasper Johns
Untitled, 1964-65
Oil on canvas, 183 x 492 cm
Stedelijk Museum, Amsterdam

Campbell's

CONDENSED

TOMATO

SOUP

Andy Warhol

"It was fabulous: an art opening with no art." This was Warhol's comment on the opening of his exhibition at the Institute of Contemporary Art in Philadelphia in 1965. The organizers of the exhibition had removed Warhol's pictures to protect them from the expected crowds. This situation fascinated Warhol ("We were the art exhibit."); he saw it as giving an ironic twist to his artistic project. "Nobody had even cared that the paintings were all off the walls. I was reallly glad I was making movies instead."

Warhol's working method is a constant process of action and reaction; he leaves the borders open between production, product and reproduction, between the image, the depiction and the depicted. His art is informed by the knowledge that it is the appearance given to a thing or an event, the manner in which it is mediated or presented, which gives it its meaning. The medium is itself the content of the message.

A characteristic feature of Warhol's work is that he takes the shortest possible route from reality to the picture. In 1968 he published his novel "a", "a novel by Andy Warhol", in the "Evergreen Black Cat Book" paperback series of the Grove Press, a publisher associated with the Beat movement (Price: $1.75, 451 pages; the favourite pages of the book's reviewers were listed on the back cover). The novel consisted of nothing but day by day recordings of the telephone calls of the people who visited Warhol's New York factory.

Warhol not only wanted to turn the trivial and commonplace into art, but also to make art itself trivial and commonplace. He not only transforms mass-produced objects and information from the mass media into art, but turns his own art into mass produced objects. Whatever is lowest comes out on top in Warhol's work, and vice versa: he knocks elitist "high" art off its pedestal and drags it down into the slough of everyday life; sub-cultural phenomena, on the other hand, become socially acceptable. American art had already begun to approach the themes of everyday life and social habit in the work of the Ash Can School (around 1900), for which Warhol had great respect, or in the socially critical and realistic painting of the twenties, which had influenced Roy Lichtenstein. Warhol felt that in the media age of the sixties, everyday life with all its trivia was the challenge art had to meet.

In a book he published with Pat Hackett in 1980 called "POPism, the Warhol 60s", Warhol tells the story of Pop Art as seen by Warhol in the style of a cheap paperback thriller. He turns it into something trite, relativizing a revolutionary process in the history of art whose momentous significance has become the object of countless theories by artists and academics from all over the world. But Warhol's account of the events of those years hits the keynote and real mentality of the movement more than any other – especially as far as

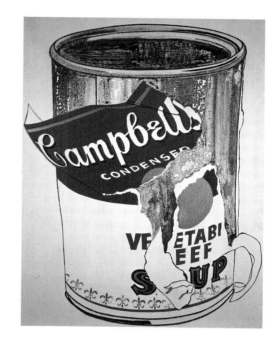

Andy Warhol
Big Torn Campbell's Soup Can (Vegetable Beef), 1962
Oil on canvas, 274.3 x 152.4 cm
By courtesy of the Galerie Bruno Bischofberger, Zurich

Andy Warhol
Campbell's Soup Can I, 1968
Acrylic and liquitex, silkscreen on canvas, 91.5 x 61 cm
Neue Galerie, Aachen, Ludwig Collection

Window Display by Andy Warhol at Bonwit-Teller, New York, April 1961
In the background: pictures by Andy Warhol: "Advertisement", 1960; "Little King", 1960; "Superman", 1960; "Saturday's Popeye", 1960

his own art is concerned. He reduces the notion of style to absurdity – POPism – countering a prevailing tendency which subordinated the novelty and otherness of Pop Art in its relation to the media to the traditional terms and value judgements of art history. The aim of this tendency was to portray the depersonalized, mass media aspects of Pop in terms of the kind of subjective image of the artist which had been so typical in the historical development of style. "By 1960, when Pop Art first came out in New York, the art scene here had so much going for it that even all the stiff European types had to finally admit we were a part of world culture. Abstract Expressionism had already become an institution, and then, in the last part of the fifties, Jasper Johns and Bob Rauschenberg and others had begun to bring art back from the abstraction and introspective stuff. Then Pop Art took the inside and put it outside, took the outside and put it inside. The Pop artists did images that anybody walking down Broadway could recognize in a split second – comics, picnic tables, men's trousers, shower curtains, refrigerators, Coke bottles – all the great modern things that Abstract Expressionists tried so hard not to notice at all. One of the phenomenal things about the Pop painters is that they were already painting alike when they met. My friend Henry Geldzahler, curator of twentieth-century art at the Metropolitan Museum before he was appointed official culture czar of New York, once described the beginning of Pop this way: 'It was like a science fiction movie – you Pop artists in different parts of the city, unknown to each other, rising up out of the muck and staggering forward with your paintings in front of you.'"

In many respects, Warhol himself had emerged from the "muck". The son of Czech immigrants – his father was a miner – he had a lower middle-class upbringing in Pittsburgh, Pensylvania. His father's early death meant that Warhol had to take occasional jobs while still at school. From 1945 to 1949 he studied technical drawing and design under Richard Lepper at the Carnegie Institute of Technology in Pittsburgh. Lepper had studied at the New Bauhaus in Chicago under former Bauhaus master and multi-media artist László Moholy-Nagy. In his "Pictorial Design" course, Lepper taught his students to approach reality as a social organism in their drawings and pictures. It was important to proceed from an unbiased analysis of the facts and to give careful consideration to the criteria by which one arrived at an appropriate style. The aim of this method was to use individual objects to illustrate the dominant structures in society, and to make these easily intelligible by way of graphic representation.

Andy Warhol
Peach Halves, 1962
Oil on canvas, 177.5 x 137 cm
Staatsgalerie Stuttgart, Stuttgart

Andy Warhol
Tunafish Disaster, 1963
Synthetic polymer painting and silkscreen on canvas, 316 x 211 cm
Saatchi Collection, London

During this period, Warhol painted several very simple, almost childlike pictures with a psycholgical background. There were also drawings of a social or political nature in which he used physiognomy as an index of different levels of self-expression. In Pittsburgh, Warhol got to know the painter Philip Pearlstein, who was also studying under Lepper at the time. Pearlstein gained his reputation in the sixties as a psychological realist whose most common theme was human, and often erotic, relationships.

In 1949 Warhol moved to New York and, for a short time, shared an apartment-cum-studio with Pearlstein. Warhol worked as an illustrator and commercial artist, and published his designs of ladies shoes in the magazine

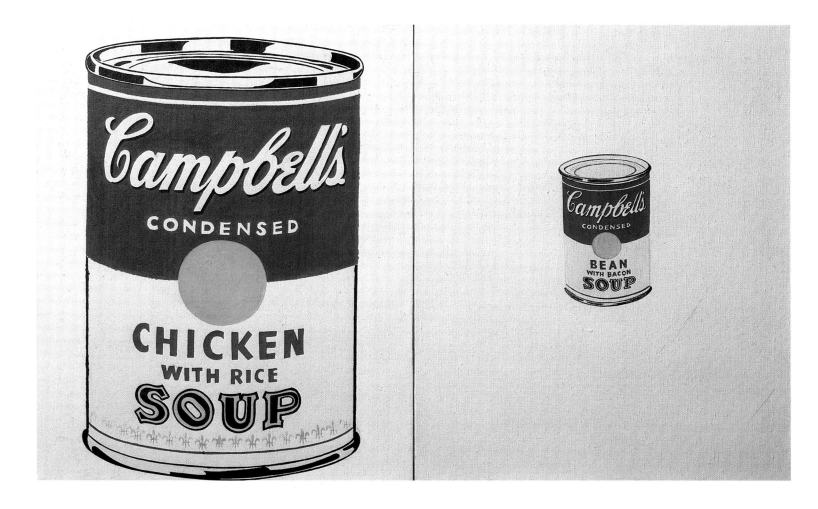

Andy Warhol
Campbell's Soup Cans (Chicken with Rice,
Bean with Bacon), 1962
Acrylic on canvas, 2 panels,
each 51 x 40.5 cm
Museum Abteiberg, Möchengladbach

"Glamour". In the fifties – he was now living with his mother – he illustrated Truman Capote's short stories. Capote's writing, like Pop Art, fed on colloquial American speech and mundane reality. By the fifties, the style and subject matter of Warhol's work was already concerned with those images culled from mass trivial culture which were to fascinate him in the sixties. In addition to many individual pieces of work – portraits, "shoe" pictures, caricatures, everyday subjects –, and besides his shoe-portfolio, he also produced and published extensive series of drawings with texts by his friend Ralph T. Ward: "Love Is a Pink Cake" (1953), "A Is an Alphabet" (1953), "A House That Went To Town" (1953), "There Was Rain in the Street, Snow of the Day" (1953), "25 Cats Named Sam and One Blue Pussy" (1954), "A la Recherche du Shoe Perdu" (1955), "In the Bottom of My Garden" (1955), "A Gold Book" (1957) and "Wild Rasp-berries " (1959).

Warhol's own work and his commissioned work developed in parallel. He had a predilection for showing his visitors both, as he was fully aware of their proximity. Indeed, he saw the trivialization of his own work as a challenge. At the same time, he could not be sure that the viewer's own expectations of art might not prevent him from understanding his intentions. His graphic technique was the "blotted line" – a kind of traced copy, a printing process comparable to the frottage technique developed by Rauschenberg in the late fifties. The line was only drawn indirectly, in fact almost mechanically, on the paper. His evenly-proportioned outlines and brightly coloured surfaces give Warhol's work a lively and stylized effect. His drawings take their energy from contemporary images produced by the star and fashion cultures; his graphic series

include allusions to traditional cookery books, books of fairy tales, pictorial broadsheets, series of illustrations and picture stories, freely interpreted in a playful manner and in such a way as to irritate the viewer. Warhol's early graphic work is rooted in folk art as well as in popular literature and the mass media.

Without breaking in any way with his graphic activities of the fifties, Warhol painted his first pictures in 1960 using graphic motifs taken from advertising and comics: *Advertisement, Peach Halves* (p. 169), *$ 199 Television, Coca Cola, Dick Tracy, Saturday's Popeye, Superman* and *Batman.* By translating the small format illustration into the format of a painting, Warhol de-professionalizes the routine design of the reproduction. Warhol's diffuse painting scatters the sensationalistic, secondhand product images and insistent poses and faces of the comic stars into a seemingly unsystematic and arbitrary disorder. He distorts the relations between the figures, between texts and images, and dislocates the layout of his pictures. Colour and line become dribbling relics – ironic quotations from the remote world of Abstract Expressionism and its tachist painting techniques. In 1961 Warhol exhibited some of these works in the window displays of the Bonwit Teller department store (p. 168).

Wahrhol's first pictures using material from comics tended to soften the hard professional gestures and aggressive vocabulary of the texts and images. By contrast, Roy Lichtenstein's work – neither of the artists had heard of the other at this stage – strained the harsh language of the comic strip to its utmost limits of perfection and artificiality. Warhol countered the scrupulous accuracy of the original genre with imprecision and deliberate error. In doing so, he soiled the comic strip's narrow-minded ideological and decorative purity.

It is not without intention that Wahrhol alludes to "muck" and "trash" – the title of a film he made in 1970 – and to "rising up out of the muck" in his book about the origins of Pop Art ("POPism"). Dirt and trash are recurrent and profound aspects of Warhol's artistic experience. They extend from the grime of his social background in the mining town of Pittsburgh to the creative soiling of perfectly arranged, but trivial objects. This was to remain an essential compositional device in his work. The stencilled grimy blacks of his silkscreen transfers in *Suicide, Crash, Electric Chair* and *Thirteen Most Wanted Men* (cf. pp. 54, 175-177) are intended to evoke the problematics of reproduction and mass distribution, but they are also clearly intended to soil the perfectionism of mass media models, and thus to provoke a confrontation with mass viewing habits. A striking example of this is Warhol's overprint of Elvis Presley and the Campbell's soup can: *Campbell's Elvis,* 1962. Both the person and the object are examples of the commodity fetishism attached to clichéd images of stars and brand names.

The euphoric picture of progress which the images of stars and consumer goods attempt to suggest in Warhol's silkscreen prints on canvas become saturated with personal, social, political and environmental dirt. He shows the personal tragedies behind the masks of political and Hollywood stars such as John F. Kennedy and Marilyn Monroe. During the course of the sixties, themes such as the "scum" of the crime world, murder, and the death of the individual as symptoms of mass society became more and more prominent in Warhol's work. His pictures illustrate the fact that tragedy, in as far as it is picked up by the sensation-hungry media, may make a person famous for fifteen minutes of his life, but that his personal fate is immediately forgotten again. Life is cheapened by a repetitive stream of banal Hollywood clichés. For a person to

"Some people, even intelligent people, say that violence can be beautiful. I can't understand that, because beautiful is some moments and for me those moments are never violent." ANDY WARHOL

Andy Warhol
129 DIE IN JET (Plane Crash), 1962
Acrylic on canvas, 254.5 x 182.5 cm
Museum Ludwig, Cologne

FINAL ★★ 5¢ **New York Mirror**

WEATHER: Fair with little change in temperature.

Vol. 37, No 296

MONDAY, JUNE 4, 1962

C

129 DIE

(UPI RADIOTELEphoto)

IN JET!

become famous as a result of a personal tragedy is a rare enough event, and yet our society expects such events as part of its daily diet.

Wahrhol himself was confronted with criminal aggression in 1968 when Valerie Solanis, the founder and only member of S.C.U.M. (The Society for Cutting Up Men), shot him down in his factory.

In his texts and interview statements, Andy Warhol has frequently pointed out the link between personal fate and social destiny in his work. "It was Henry who gave me the idea to start the Death and Disaster series. We were having lunch one day in the summer at Serendipity on East 60th Street and he laid the Daily News out on the table. The headline was '129 DIE IN JET'. And that's what started me on the death series – the Car Crashes, the Disasters, the Electric Chairs... Whenever I look back at that front page, I'm struck by the date – June 4, 1962. Six years – to the date – later, my own disaster was the front-page headline: 'ARTIST SHOT'." LIFE magazine linked the anonymity of disaster with individual fate by giving the pictures of the disaster a quality which allowed the "victim" to "triumph" over his death, as the magazine put it. The aestheticization of the wreckage (like an "abstract sculpture", according to the magazine) conforms with the aestheticization of the fate of the individual who has won fame as a result of his death.

"Did a leak kill ... Mrs. McCarthy and Mrs. Brown?" In a newspaper caption the picture of the anonymous "murderer" – the can with a handwritten number marking it as a piece of evidence – is linked with the portraits of the happily smiling victims. This subject inspired Warhol to produce various versions of the *Tunafish Disaster* (p. 170), conceived in 1963 as an antidote to the Campbell's Soup Can euphoria. Clichéd ideals of progress and the disasters which occur in mass society are not portrayed by Warhol as contradictions, but as necessarily contingent realities – although he does not himself provide the viewer with this interpretation. Warhol has always combined his casual manner of speaking about these things, his apparently random and indifferent way of producing pictures and the stylization of his own outward appearance with the intellectual clarity of his analysis of contemporary phenomena, artistic matters, and his own personality as an artist. His analytical, diagnostic abilities can already be seen in his preference for social and political subjects in his drawings between 1945 and 1949, but also in his critique of Bertolt Brecht while working as a stagehand for a theatre company from 1953 to 1955. Warhol liked to compensate for his social pessimism by glamourizing his own appearance – by dyeing his hair silver, for instance. Gold and silver are favourite colours of Warhol; take, for example, his *Golden Book* and *Golden Shoes* in the fifties, his cushion and balloon action (1966), and especially his aggressive subjects in silver, his *Car Crash* and *Electric Chair,* his silver versions of *Elvis,* his *Gold Marilyn* (1962) and the *Thirteen Most Wanted Men* painted over in silver at the New York State Pavilion in 1964.

Governor Nelson Aldrich Rockefeller had ordered the removal of his *Thirteen Most Wanted Men* from the New York State Pavilion of the World Fair as soon as the pictures had been hung. In a portrait commissioned in 1967, Warhol shows Rockefeller as the prototype of a politician who exercises his power and influence via the media. His public image as a billionaire and Governor makes him appear the guarantor of American progress, striving to create harmonious relations between artists and politicians. This cliché of the successful American politician and representative of progressive management is conveyed to perfection in mass distribution by the media, but the real person behind the image is glossed over. Warhol sabotages this mechanism; in spite of

"Warhol's auto-death transfixes us: DIE is equal to EAT." ROBERT INDIANA

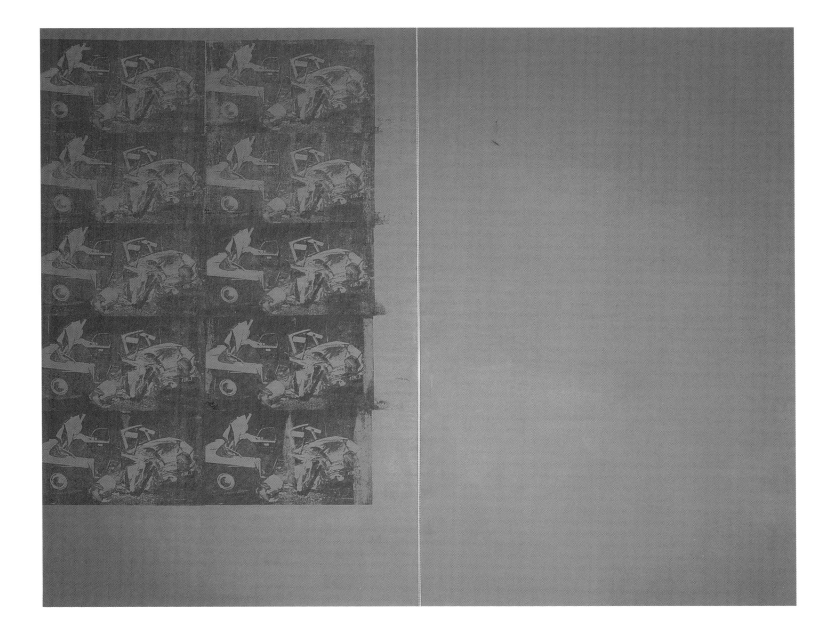

Andy Warhol
Orange Car Crash 10 Times, 1963
Acrylic and liquitex on canvas, 2 panels,
each 332 x 206 cm
Museum moderner Kunst, Vienna,
Ludwig Collection

— or because of — their repetition, the politician's features are reduced to silence and petrified in a mask of impotence: a monumental snapshot whose "grandeur" (190.5 x 142 cm) allows the viewer an opportunity to elicit the qualities which lie behind it. These are revealed behind the politician's sweat-covered mask: insecurity, aggression and the tensions of irrational reaction. Warhol's objective and, equally, cynical portrayal can be seen in connection with Rockefeller's political rejection of his picture series at the New York State Pavilion.

In 1964 John Chamberlain, Robert Indiana, Roy Lichtenstein, Robert Rauschenberg and Andy Warhol were all commissioned to produce works for the New York State Pavilion, which was designed for the World Fair by the architect Philip Johnson. It was the biggest public contract Warhol ever had. It was a unique opportunity, putting him at the centre of the political project advancing all things American. By contrast, with his fellow artists from New York, Warhol chose to show the explosive reality of everyday life in American society. He used some old FBI arrest warrants with frontal and profile views of wanted criminals to produce a series of screenprints of the *Thirteen Most*

Andy Warhol
Most Wanted Man No. 10, Louis M., 1963
Serigraphy on canvas, each 122 x 100 cm
Museum Abteiberg, Mönchengladbach

Wanted Men. He exhibited the 25 panels – three unprinted panels completed the 36 sq. metre block – on the outside of the pavilion. A few days later the order went out to remove the panels on the grounds that the mafiosi shown in the pictures had already been tried, and some of them found innocent. "In one way I was glad the mural was gone: now I wouldn't have to feel responsible if one of the criminals ever got turned in to the FBI because someone had recognized him from the picture."

This was Warhol's typically mundane, and slightly cynical, reaction many years later. Warhol wanted to replace the *Thirteen Most Wanted Men* with the picture of the World Fair boss, Robert Moses. Warhol did in fact complete Moses' portrait on commission during the same year, and in identical format. But instead, he painted over the *Thirteen Most Wanted Men* in silver on the spot, where they continued to hang for about four weeks, before being removed to a warehouse and, later, destroyed.

"I was really glad I was making movies instead," was Warhol's reaction when his exhibition at the Institute of Contemporary Art was opened without any of his pictures. He could now indulge in his favourite pursuit of observing, photographing and filming everything which was going on around him. As an artist, he felt passive – as he himself has frequently said – and not creative, because he put himself on the same level as the objects of his observation. Warhol's contentions that everything is beautiful, that everything influences everything, and that everything is boring are mere commonplaces; but they reflect his feeling that the world is a commonplace affair, and full of repetitions.

Quantity becomes a quality in an era of mass communication and mass production. Consumerism, too, is a passive form of acquisition, an uncreative

approach to the world, a substitute for the creative potential in human self-expression. Standardized production and conformity in behaviour give rise to the acceptance of uniform objects and images. Among Warhol's many films, there are two which document the theme of "beauty" as a reproductive cliché: the *13 Most Beautiful Women* and *13 Most Beautiful Boys,* made in 1964/65, are macabre versions of the motif of *Thirteen Most Wanted Men.* Warhol's themes here are disinterested observation and voyeurism, presented in the automatic, mechanically reproductive form of the pure copy of reality. Beauty emerges out of unmanipulated self-portrayal, out of the original qualities of a person, and does not transmit any kind of value in itself. That everything is beautiful is a contention which, by implying the absence of unique values, also includes its opposite, "nothing is beautiful", or to extend the rhetorical game: "Beauty? What is that?" – "Beauty in itself is nothing".

Warhol applies the criterion of "quantity as quality" to people as well as to consumer articles. Faced with a mass of factual material, Warhol selects what is typical, symbols of the age which have acquired mythical status and become the common property of the society in which he lives. Between 1962, the year of his first silkscreen prints on canvas, and 1970, the following "types" appear in

Andy Warhol
Double Silver Disaster, 1963
Acrylic and liquitex silkscreen on canvas,
106.5 x 132 cm
J.W. Fröhlich Collection, Stuttgart

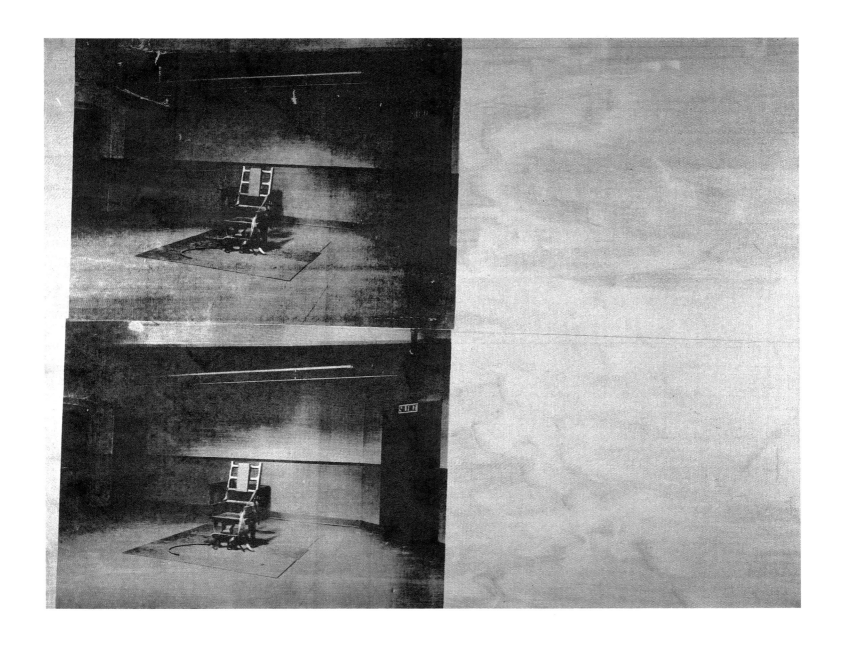

Warhol's iconography: film stars (Marilyn Monroe, Lız Taylor, Elvis Presley, Marlon Brando and others); stars of the art world (Mona Lisa, Robert Rauschenberg, Leo Castelli, Merce Cunningham, Andy Warhol and others); political stars (Jackie Kennedy, Nelson Rockefeller and others), commissioned portraits; the gangster milieu (*Gangster Funeral, Thirteen Most Wanted Men*, p. 176; electric chair, p. 177); patterns and symbols of feeling and behaviour ("Happy" as the title of a portrait, flowers, kisses, *Tunafish Disaster,* p. 170); political action (*Race Riot,* atomic bomb); news and information; stamps, etc. (postage stamps, discount stamps, company labels, trademarks, transport tickets and bank notes); consumer goods (Campbell's cans, Coca-Cola, Pepsi Cola, packaging); and monuments (the Statue of Liberty and the Empire State Building).

His silkscreen prints on canvas – a technique whereby an illustration is transferred onto the canvas mechanically – were preceded by two periods of object painting: one in which he painted motifs from the comic genre and from advertising (1960/61), and the other the *Do-It-Yourself pictures* (1962; p. 179), which simulated techniques of mechanical reproduction. There are five versions of this theme. Warhol paints as perfect a likeness of the subject as he can, but leaves it incomplete. As a result, the trivial forms take on their own, partly individual, existence. The leftover numbers have the effect of a restless, disturbing grid, and only make sense if the viewer is acquainted with the subject. Each number stands for a colour, and yet what is intended as a nuance becomes an unexpectedly sharp contrast in Warhol's pictures, making the composition appear strangely off balance and full of tensions. Warhol paints his subject in a routine manner, but confuses and alienates it at the same time. By transferring his subject to the canvas in this way, Warhol brings out the contradiction between the triviality of the original, a run-of-the-mill, trashy cliché, and his mechanical, and yet entirely freehand transposition of it onto formats of considerable size (from 137 x 183 cm to 183 x 254 cm). Within the context of art, the banal content of these pictures gives them a strikingly innovative quality. They are unfamiliar paintings; one feels they must be something new, although their subject is utterly commonplace. Here, too, beauty and horror lie in close proximity to one another, for Warhol's *Do-It-Yourself* paintings reveal the inhumanity of a meaningless aesthetic. Their effect is that of aesthetic rape; in their patronizing manner they suppress all creativity. Their transformation at Warhol's hand lends them a new and sensational pictorial quality: the artist both exhibits and proves the range of his art while identifying with a base and trivial culture. He rescues the latter from the "muck" of its empty and boring existence and adds his own corrective to its powerful omnipresence.

Andy Warhol
Do-It-Yourself (Flowers), 1962
Acrylic and silkscreen on canvas,
175 x 150 cm
By courtesy of Thomas Ammann, Zurich

PAGES 180/181:
Andy Warhol
Flowers, 1970
8 Leaves from the portfolio with
10 serigraphic prints, each 91.5 x 91.5 cm
Edition: 250 artist's proofs, signed with ball
point pen and numbered with stamp on rear
Published: Factory Additions
Museum moderner Kunst, Vienna,
Gift of Ludwig

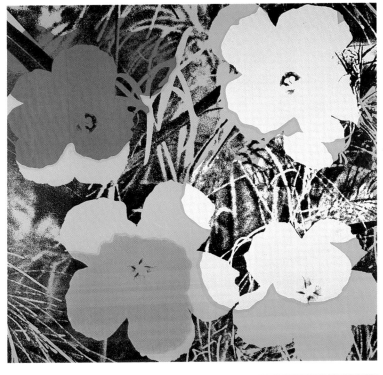

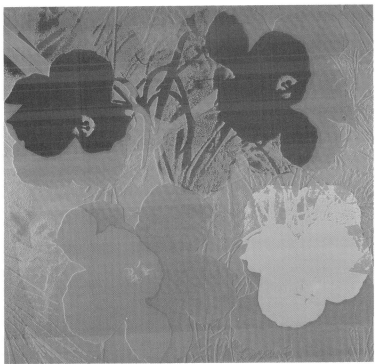
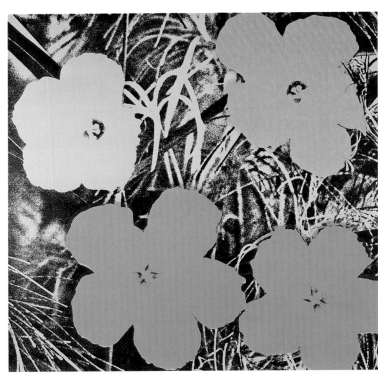

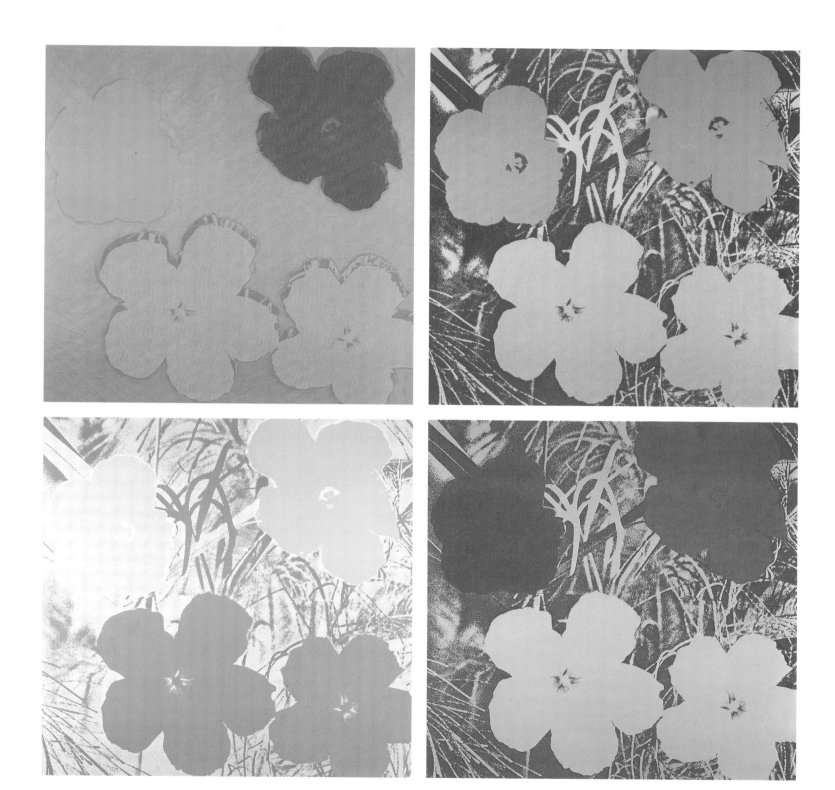

Roy Lichtenstein

Lichtenstein has said that he owes his style to comics, but not his themes. His statement to this effect – during an interview with Raphael Sorin (1967) tells us something of the intention behind Roy Lichtenstein's art.

Both the form and content of the commercial comic derive from its function of trivializing and generalizing emotions, actions, people and objects so as to make these conform to popular opinion. The opinions of their authors, however, remain concealed. The fabrication of comics by production teams in which each specialist is responsible for only one stage of the comic's production and is therefore unlikely to think of the final result only serves to reinforce this state of affairs. The comic's professional and one-dimensional ingenuity enables it to activate the human senses, to exercise control over action and movement, to create a certain atmosphere, to generate a bodily, animal presence, to suggest things paused at a subliminal level, things thought but not said. The graphic explosive power of the machine-gun enables the viewer to visualize a fictional or factual explosion (p. 139). It is like that sun setting over the sea, caught as if in a moment of frozen tranquility; a natural phenomenon, whose naturalness has been worn out by the cinema, by television and advertising, and which therefore alienates the observer from its equivalent in the real world.

The pictorial vocabulary, typography and arrangement of texts and images in the comic are borrowed from the aggressive language of advertising, from the slogans used by the packaging industry, for example. These mechanisms of production helped Lichtenstein to exploit to the full certain moods calculated to suggest the existence of something real. He was thus able to track down contemporary stereotypes of reality while simultaneously keeping his distance as an artist, both from his subjects and from himself.

Lichtenstein's pictures aim to de-individualize and objectivize emotions and gestures. His paintings look as if they have been produced mechanically. They appear to be perfect and quite anonymous, as if made by a graphic designer. He likes to clean away the "the record of my hand" – errors, imprecisions, alterations, for instance – or to "erase" them with ground paint: by doing this he is able to "remove any stain marks". This is the prosaic tone in which Lichtenstein describes his perfectionism in an interview with John Coplans in 1967 (in 1961 he was still leaving his corrections undisguised). Lichtenstein develops his artistic strategy in parallel with his artistic technique. He depicts the content of his pictures in the same manner as a comic or commercial artist whose composition begins with both a preconceived notion of average perceptive powers and a special purpose in mind. But Lichtenstein's point of

Roy Lichtenstein
Magnifying Glass, 1963
Oil on canvas, 40.6 x 40.6 cm
Private collection

Roy Lichtenstein
Explosion No. 1, 1965
Enamel on steel, 251 x 160 cm
Museum Ludwig, Cologne

Detail from a "New York Times" Sunday supplement

Roy Lichtenstein
Girl with Ball, 1961
Oil on canvas, 153.7 x 92.7 cm
Collection, The Museum of Modern Art, New York

PAGE 186:
Roy Lichtenstein
I know … Brad, 1963
Oil and magna on canvas, 168 x 96 cm
Neue Galerie, Aachen, Ludwig Collection

PAGE 187:
Roy Lichtenstein
M-Maybe (A Girl's Picture), 1965
Magna on canvas, 152 x 152 cm
Museum Ludwig, Cologne

departure is quite a different one, so that he changes the functional context of the comic and of the other media he uses. He redeems their superficial effects and coherence from their unequivocal nature. What was hitherto vacuous, suddenly becomes suggestive and meaningful.

In an interview with David Pascal in 1966, Lichtenstein described his preference for comic motifs which were typical, and thus expressed nothing out of the ordinary. He pointed out that the motifs he chose were those which seemed to him to be merely classical archetypes of the genre, rather than meaningful in any way. He used these motifs as a means of reaching an almost classical form, emphasizing their timeless, impersonal and "mechanical" qualities. He described comics themselves as an area in which to experiment with the stimulation of the imagination. By removing his subject from the sequence of pictures in which it occurs in the original and thus depriving it of its narrative logic, Lichtenstein gives the scene he is depicting a new and quite unfamiliar meaning. The picture now confronts our viewing habits, our structured patterns of perceiving and reading, as if it were something foreign. At the same time, the new, large format of the pictures heightens the commonplace triviality of the original. The comic strip is also exposed to a number of other artistic processing techniques. Lichtenstein reduces his medium to its most basic elements of expression, tightens their pictorial coherence and further simplifies the standardized production process of the cartoon drawings. The composition – the relations of the figures to one another and to their environment – is made even plainer, while the delineation and colouring, which concentrates on blue, red, yellow, sometimes green, and black and white, becomes more trenchant. Lichtenstein thus gradually changes the original comic illustration by revising the typography of the texts and standardizing the colours with a prestructured foil. "I use color in the same line. I want it oversimplified – anything that could be vaguely red becomes red. Actual color adjustment is achieved through manipulation of size, shape, and juxtapositions. … Also, I wanted the subject matter to be opposite to the removed and deliberate painting techniques." (Lichtenstein in an interview with John Coplans in 1967).

Lichtenstein's approach is analytical. He wants to show painting as it really is, or can be: the art of transforming something real into a deliberately artificial and yet trivial language. Painting is not a means to an end in the sense of realistic representation, nor an end in itself in the sense of constructivist or abstract art. It is not a mirror of the self in the sense of Abstract Expressionism or the various forms of romanticism. It is, in fact, the exact opposite: different levels of reality themselves form the material of a painting, purged of subjective emotion and idealistic intention. One such level of reality is art itself, which Lichtenstein consistently quotes, alienates and alters in his pictures. Paintings by Paul Cézanne, Fernand Léger, Claude Monet, Piet Mondrian and Pablo Picasso serve as points of departure in this process. In an interview with Alan Solomon in 1966, he expresses the crux of his strategy: "I'm using these aspects of our environment which I talked about as subject matter, but I'm really interested in doing a painting". This attitude, which counters interpretations of his work as "social commentary", is comparable to certain classical, or classicist, periods in art history in which reality, subject matter and idealist stances are all made to serve an impersonal and topical style. In an interview with Raphael Sorin in 1967, Lichtenstein pointed out that it was only our critical intelligence which separated the classical picture of the past from those of the present. His interest in the modern cliché, for instance, had been an attempt to show the mythological status, or classicism, of the "hot dog".

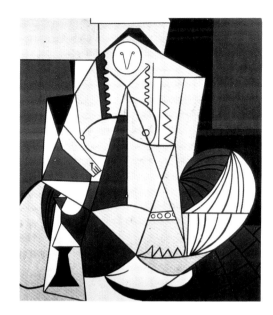

Roy Lichtenstein
Femme d'Algier, 1963
Oil on canvas, 203.3 x 172.7 cm
Collection of Mr. and Mrs. Peter Brant,
New York

PAGES 188/189:
Roy Lichtenstein
As I Opened Fire, 1964
Magna on canvas, three panels,
each 172.7 x 142.2 cm
Stedelijk Museum, Amsterdam

Roy Lichtenstein
Trompe-l'œil with Léger Head and Paint-
brush, 1973
Magna on canvas, 116 x 91.4 cm
Private collection

The sobriety and severity of his systematic approach lead to the levelling of all content. His subjects are stereotyped through abstraction so that they conform to popular taste, but, at the same time, the heightened drama of the trivial reinstates them within the context of a tensely open painting. In building a picture, Lichtenstein transcends the restraints of secondhand contents, much as Cézanne transcends nature.

His persistence in this project, which he has continued to refine, is a consequence of his intensive artistic and intellectual development. Lichtenstein was brought up and educated in a middle-class milieu and became acquainted with the problems of contemporary art at a relatively early age. He studied natural science, the humanities and art history and worked on the side as a designer. During the late thirties, in an atmosphere still influenced by the "New Deal", he was introduced to the socially engaged and critically ironic trend in realism by the painter Reginald Marsh. Marsh's position was in line with an entirely American tradition orientated towards regionalism and the expression of the artist's own experience of contemporary life. In the forties Lichtenstein studied under Hoyt L. Sherman. She was influenced by Gestalt psychology, whose structural approach took into account the totality of a picture's production and included various levels of perceptual psychology, putting universal expression at the centre of its theory. Here, Lichtenstein was confronted with a discipline just as rigorous as that which Andy Warhol experienced under Robert Lepper in Pittsburgh. Lichtenstein's wide-ranging early work is characterized by its persistent attempts to determine a new relationship between the playful and the serious, between emotion and intellect, between reality and abstraction. He translates the highlights and idols of American history, motifs from Westerns, important examples from art history and heroes from classical mythology into his own language. In doing so, he alludes quite plainly to the classical, rococo and romantic periods, and also to the art of primitive cultures. Lichtenstein studied the work of Cézanne, Picasso, Klee, Miró, Léger and Stuart Davis in great depth. Initially, his reactions to these models were very direct. His work was traditional in character, with a surrealist style influenced by Abstract Expressionism. Later, in 1958, Lichtenstein reduced Abstract Expressionism to absurdity when comic figures like Bugs Bunny, Donald Duck and Mickey Mouse began to spring from the chaotic, abstract lines of his drawings and paintings.

During his development as an artist, Lichtenstein returned again and again to investigate new ways of determining the relationship between the subject matter and techniques of painting, of finding a balance between intuition and ideas; he thus enabled his own style to stand out all the more clearly against the background of art history. In the sixties Lichtenstein pursued the idea of a universal painting, best compared with the ornamental contexts in which he found his subjects – ornaments from Indian cultures and Greek architecture, for example. He produced pictorial ornaments which organized different levels of content in complex abstract ways, allowing scope for the viewer's associations and giving equal weight to each section of the whole.

Lichtenstein gives back to mass society its own standardized and superficial structures of experience and perception in the form of challenging and inquiring paintings which say nothing, and which in doing so, say everything. In an interview with Alan Solomon in 1966, he puts it this way: "Pop deals with using commercial subject matter, and sensitivity usually . . . It's that sort of anti-sensibility and conceptual appearance of the work that interests me and is my subject matter."

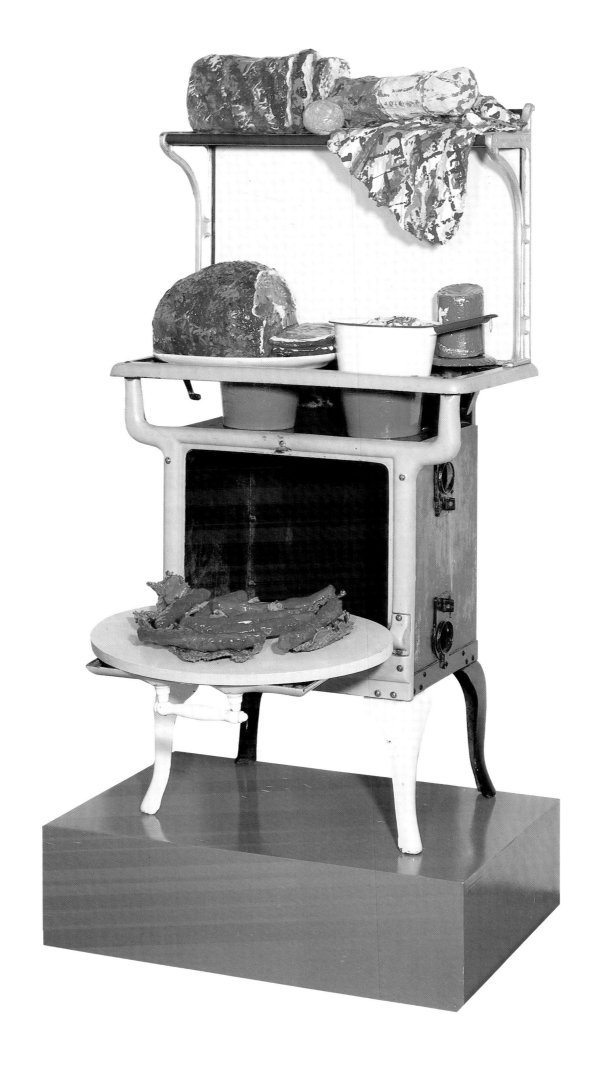

Claes Oldenburg

Claes Oldenburg's highly individual figurations make him one of the leading protagonists of Pop Art. His sculptures stand in the Surrealist and Dadaist traditions and are remarkable for their wealth of forms and themes. He takes up typical Pop subjects, but translates them into his own unmistakable artistic language. "I am for art that takes its form from the lines of life itself, that twists and extends ... and is heavy and coarse and blunt and sweet and stupid as life itself." (Oldenburg).

Claes Oldenburg's sculptures are often set in public areas in towns or landscapes where they take on the appearance of a kind of architecture. In his rough drafts, sketches and technical drawings he has outlined their architectonic structures and their spatial effect. He bases his sculptures on everyday objects but modifies their function and meaning by giving them extremely large dimensions, making them out of different materials — hard becomes soft and soft becomes hard — and giving them new colours. A clothes-peg, for example, became a cathedral reaching toward the skies. (*Late Submission to the Chicago Tribune Architectural Competition of 1922: Clothespin (Version Two)*, 1967). With its new, colossal dimensions, this otherwise inconspicuous little object ascended zestfully in an upward sweep and became the conveyor of a dynamic design, opening up the ornamentality of its inner form like a façade. In his "submission" for the Tribune Tower competition, Oldenburg ironized a dispute between neo-Gothic, classicist and functionalist styles in architecture.

In a similar project, he turned a pair of scissors into an obelisk. His *Proposed Colossal Monument to Replace the Washington Obelisk, Washington D.C.: Scissors in Motion* (1967) was like a cynical allusion to fetishism, and to the distance between contemporary life and its own history. The decisive factor here was the power of motion to suggest the dynamics of an intervention in time and cultural reality which, for all its banality, may have serious consequences. Oldenburg makes "symbols of my time" out of commodity articles, furniture, luxury goods and media clichés. Civilization is metaphorically and literally overflowing with the spirits which it once conjured up, and of which it can no longer rid itself: toothpaste flows from its tube and smothers town and country beneath it like a torrent of lava. Telephones and typewriters, our vehicles of communication, and lollies and ice-cream cones, symbols of our affluence, become soft, grey and rotten, collapsing into a grotesque mass. They hang feebly from the wall, or lie limply on the ground. To Oldenburg, making something means transforming "symbols" and giving them back to the public in the form of new and challenging obstacles; or it means erecting architectural devices which act as question marks and point to exhaustion, decadence and cynicism in society. "The artist is a machine, yes, but a human machine most

Claes Oldenburg as a living sculpture on an unused column near Grosvenor Square, London

Claes Oldenburg
The Stove with Meats, 1962
Muslin and burlap soaked in plaster, painted with enamel; stove and objects,
147.3 x 71.1 x 69.9 cm
By courtesy of the Neue Galerie, Aachen, Ludwig Collection

193

Claes Oldenburg
The Street, 1960
Environment in the Judson Gallery, Judson
Memorial Church, New York

Claes Oldenburg
Lingerie Counter, 1962
Muslin and burlap soaked in plaster, painted
with enamel, metal stand, glass base, height:
210 cm
Ungarisches-Ludwig-Museum, Budapest
(Gift)

sensitive, his profession is balance and he reacts to his surroundings by affirming what is missing. In hard times he becomes soft, in soft times hard."

The Street (p. 194) has a concoction put together from everything the artist could lay his hands on (according to Oldenburg, there was nothing which could not be used). It was an uncanny environment consisting of various things which have been painted over, alienated and softened, and allowing the viewer scope for a wide range of associations. It was followed by works like *Snapshot from the City* and the environment *Environment Situation Spaces.* In 1960 Oldenburg produced the series *Flags,* followed in 1961 by *Fotodeath,* and in 1963 by *Autobodies,* a mixed media project which extended over a number of years and consisted of photographs, objects, toys, *objets trouvés,* texts, environments, performances and happenings – this was to become a leitmotif in Oldenburg's work during the years to come. In 1960/61, he made *The Store* (p. 196) with all kinds of grimy replicas of foods and drinks. He repeatedly added new variations to his large scale environments with furniture and ensembles with household articles. "Objects shattering or altered by collision, Objects altered by gravity or in trajectory." Then came his *Soft Machines.* These were like defective machines in some American science-fiction film, where houses, people, streets, cars, furniture and all kinds of solid objects were melted by some strangely unpredictable force. Formal metamorphosis is Oldenburg's catchword, and his art is intended to surprise the "public sphere" and its public locations.

Products look like "objects impregnated with humanity". Machines and technology produce things which are designed for use by (and therefore also for the exploitation of) human beings. Objects are tailored to human requirements, and so they also reflect – in their designs, function and purpose – human features: physiologically, sociologically and culturally. The nature of human beings is revealed in their relation to their environment. Objects and consumer goods are designed to have a subliminal effect on the subconscious mechanisms of the human mind: weapons (the "Ray Gun"), for example, as an expression of aggressive, sexual stimulation. Associations of this kind are exploited by advertisements for foods, sweets and luxury goods. Lipsticks, for instance, are portrayed as phallic symbols. Oldenburg transforms these objects into hard or soft materials and shows them in varying sizes: from miniatures to colossal columns and monuments. These are the "historical monuments" of his day – the fetishes of the epoch.

In 1969 Oldenburg erected the free-standing sculpture *Lipstick, Ascending on Caterpillar Tracks* (p. 196) on the Yale University campus. The combination of lipstick and a tank is typical for Oldenburg. He shows them acting together as a symbol, or as a mirror reflecting the human physiognomy; they are given equal status – the lipstick is adapted in size to the original dimensions of the caterpillar. Our normal picture of lipstick as a means of enhancing beauty is quite remote from images of war machinery, such as the tank. Their combination, however, clearly shows that they are linked by the power of aggression, including sexual aggression. (We are reminded of the legendary Helen whose beauty was the cause of the Trojan War.) An impersonal machine in concert with a private luxury article – together, they look like a lethal weapon. The intention behind Oldenburg's architectonic geometry was clearly expressed in this project. His sculpture used projections on the vertical and horizontal planes to suggest the dynamics of human movement: an upright posture, and expansion within upper and lower limits.

Oldenburg concentrates on the "elementary idea" and transforms its materials, functions and forms, and, more especially, its ideas, "into a surpris-

Claes Oldenburg
The Store, 1962
Environment in the Green Gallery, New York

Claes Oldenburg
Lipstick Monument, Ascending on Caterpillar Tracks, 1969
Yale University

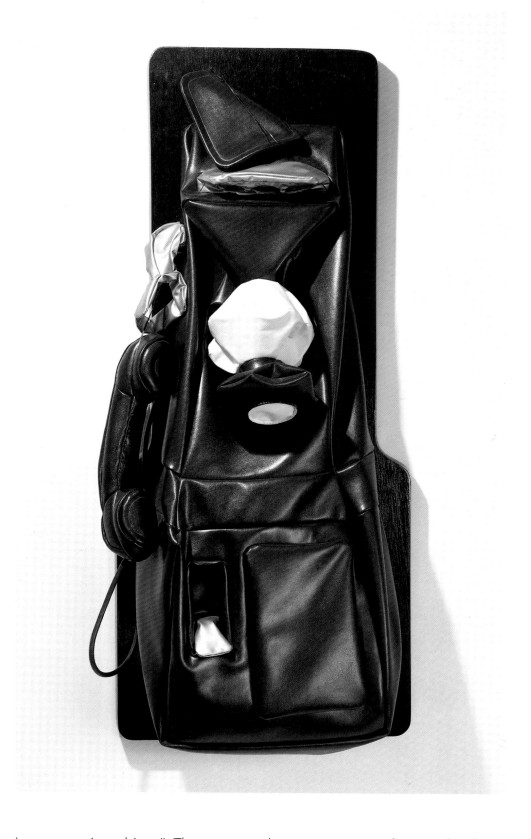

Claes Oldenburg
Soft Pay-Telephone, 1963
Vinyl filled with kapok, mounted on painted
wood, 118.11 x 48.26 x 22.9 cm
The Solomon R. Guggenheim Museum, New
York, Gift of Ruth and Philip Zierler

ing suggestive object." The commonplace now seems alien, and only its external, formal characteristics are recognizable, as if through the haze of distant memory. Confronted with the atmosphere of a public location, its commonplace character retreats, leaving behind it a weird, insane creature – a monstrous, unknown and challenging being. There are many sketches by Oldenburg containing notes on the "elementary idea"; the metamorphosis of

Claes Oldenburg
Toilet (Hard Model), 1966
Varnish and felt-pen on corrugated card-
board and wooden construction,
111.8 x 71.1 x 83.8 cm
Museum für Moderne Kunst, Frankfurt/M.

things reveals the surreal, expressive powers hidden within their structures. The
process of transformation into different materials, contents and dimensions has
the effect of a force taking possession of things. So extreme is the artist's
manipulation of objects, that the viewer feels visually and spatially crushed by
them, by Oldenburg's projected cityscape of ryvita skyscrapers, for example
(*Row of Buildings in the Form of Bitten Knäckebröd,* Stockholm 1966-71).

Oldenburg's sculptures descend like bolts from the blue, in the form of
gigantic tongues or genitalia; or they reach for the skies in the shape of
lipsticks, scissors or clothes-pegs; in both cases they block one's view and
hinder one's passage. His collossal "chocolate ice-cream" obstructed Park

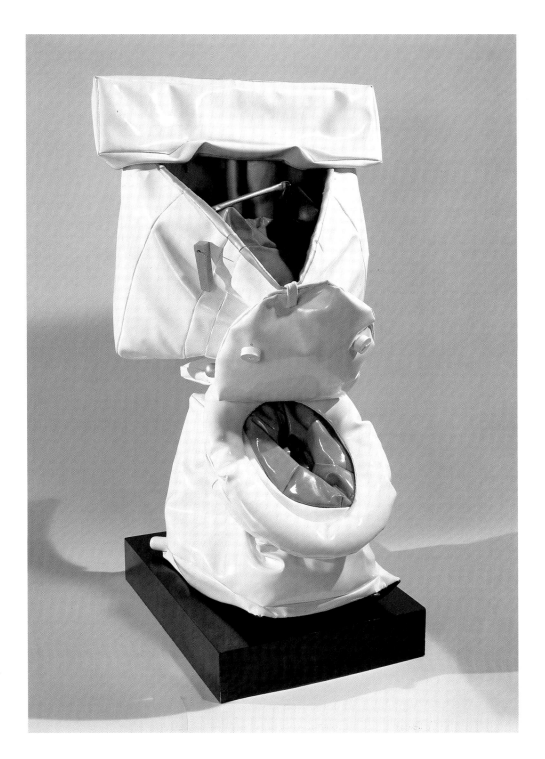

Claes Oldenburg
Soft Toilet, 1966
Vinyl filled with kapok, painted with liquitex, and wood, 132.08 x 81.28 x 76.2 cm
Collection of Whitney Museum of American Art, New York, Gift of Mr. and Mrs. Victor W. Gane on 50th Anniversary

Avenue in New York, for example; it was only possible to pass at the bottom right, where a "bite" had been taken out of it (*Proposed Collossal Monument for Park Avenue New York, Good Humour Bar,* 1965). His giant objects are usually placed in cityscapes, only rarely in landscapes. Their enormous weight makes these everyday objects look out of place and changes one's habitual view of them. The inconspicuous worlds outlined in Oldenburg's sketchbooks begin to take on dimensions which, through their realization within the public sphere, represent a public challenge. Oldenburg's imaginative approach, both to his objects and to his art, does not follow the dictates of the everyday, media world, but serves his own artistic requirements.

Claes Oldenburg
Soft Typewriter – "Ghost" – Version, 1963
Liquitex on canvas over kapok-filling and
wooden construction, wooden parts tied
with cord, 22.9 x 69.9 x 66 cm
Museum für Moderne Kunst, Frankfurt/M.

The ambivalence of the positions Oldenburg adopts can be traced back to the early stages of his work. His method is to start out from his own perceptions and insights into relations within society, and to react to these with his theoretical and artistic activities. Of Swedish nationality, Oldenburg was the son of the Swedish Consul General in Chicago, studied at Yale and started a profession in journalism. In 1952 he began his studies at the Chicago Art Institute and finally moved to New York in 1956. His first pictures were influenced by Abstract Expressionism. His drawings in the late fifties were close to graffiti and anti-political slogans. In 1958 he met Alan Kaprow, Red Grooms and other artists. Grooms ran a gallery in his studio. Here, Oldenburg saw exhibitions of "Art Brut" with folk art, primitive art, art by the mentally disturbed and sub-cultural art, and exhibited his own pictures there during the same year. He also took part in Red Grooms' environment and performance *The Burning Building* (p. 91). During this period he was also reading Sigmund Freud and studying psychological association in gestural drawings. Through Kaprow, he developed a closer relationship to the Happening, a form of expression with which he had already experimented. His first confrontation with the theoretical and ideological aspects of Pop came through John Cage and his "New School for Social Research". Oldenburg's first environment, *The Street* (p. 194), had the character of a performance. It showed the individual buried by objects of his own making. The general chaos and the objects' unwieldiness alienated the latter and gave them the appearance of props on the stage of a declining civilisation.

From 1959/60 onwards, Oldenburg's *Ray Gun* stood at the centre of his artistic output (for example, *Ray Gun Spex, Schizo Ray Gun, Ray Gun Theatre* with Jim Dine, Al Hansen, Alan Kaprow and Robert Whitman, and in 1977, the *Ray Gun Wing*, an exhibition room in the shape of a pistol in the Museum of Contemporary Art, Chicago). In 1962, the Ray Gun Theatre put on performances of "Nekropolis". Oldenburg's early environments turned the euphoric designer and consumer language of the media inside out. His crumpled up newspapers, trash and dripping paint threw the preformed everyday world into disarray, turned the quality and meaning of objects on their heads, subverting the way we have come to see and handle them. Things which otherwise seemed so important were deprived of their function. But in the midst of the chaos,

"I am for art that is smoked, like a cigarette ... I am for art that flaps like a flag ... "
CLAES OLDENBURG

Oldenburg was able to perfect his own designs, their spatial impact and the effect of the materials he used. At the same time he transformed things into their soft state, into a state of decay, thus turning the human environment into something which could be very uncomfortable. His *Mouse Museum,* based on a geometric plan of Mickey Mouse and shown in 1972 at the "documenta" in Kassel, was conceived as an encyclopedia of "found" and deformed everyday objects collected by Oldenburg since the beginning of the sixties. It locked the "cosmos" of the trivial and banal into an infernal museum, packed with commonplace miniatures. The cornucopia of our affluence was, it seemed, empty, and whoever had permitted themselves to be fooled to the contrary, came away shocked. "I wish to reflect things as they are now and always without sentimentality. To face facts and learn their beauty." (Notes, New York 1961).

Claes Oldenburg
Giant Fagends, 1969
Canvas, urathene foam and wood,
243.84 x 243.84 x 101.6 cm
Collection of Whitney Museum of American
Art, New York, purchased through
the Fund of the Friends of the Whitney
Museum of American Art

Peter Blake

It is through his use of conventional forms and pictorial means that Peter Blake shows us the reflection of inner and outer worlds in the mirror of the individual. The conservative form of his pictures owes a debt to ethical and cultural tradition. His simplicity appears naive and folksy, helpless and clumsy. He shows us figures who have an apparently intact sense of their own lives, and taken by surprise, are woken out of their stupor by some outside intervention. It is as if two worlds existed side by side. We become witness to a conflict between the destructive force of the outside world and the individual, who is caught in almost childlike captivity within the protective shell of his own personality. A world of fantasies and wishful thinking propagated by the mass media has replaced the real world. The human senses are exposed to an unprecedented onslaught of clichés, images and information. Blake's highly detailed paintings do not show this "new world" as a foreign world. Modern images in his work look "put on", like extra things pinned to an old pattern, as if the canon of dreams, hopes, longings, fairy tales and even works of art has simply been extended by the various new phenomena produced by civilisation. In his portrayal of the interaction between the individual and the crowd, fashion and convention, modernity and tradition, Blake paints in a figurative manner which avoids all recourse to period styles or to the pictorial language of the mass media.

On the basis of a portrait of his sister, Blake was admitted in 1950 to the Royal College where he began studying painting in 1953, following his National Service. The Royal College at that time was a centre of education for a new generation of abstract and realist artists, all of whom felt equally at home there. Blake, however, remained an outsider. He was not a member of the Independent Group, which, in 1952, had started bringing together artists, architects and others, and had coined the new concept of Pop in art and in culture through its theories and its events. Like many of his American contemporaries, Blake was intensely interested in folk art. With the help of a research award, he was able to study abroad; this experience gave rise to his so-called *Postcards.*

Blake expresses his view of the times above all through the use of the portrait. In an early self-portrait (p. 203) which he began in 1952 before going to the Royal College, we find him wearing Harlequin trousers and standing in front of a wall with posters; in 1954 he painted children reading comics. From the outset, Blake integrated elements of trivial or "trashy" literature into his work to illustrate the fantasies and way of life of the younger generation, although his style did not yet express that sense of belonging to a generation which later became so characteristic of Pop Art. In 1955 Blake began to mix

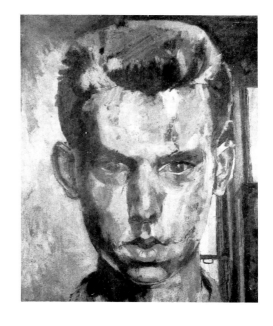

Peter Blake
Self-Portrait, 1949
Oil on wood
By courtesy of the Waddington Galleries
Ltd., London

Peter Blake
Bo Diddley, 1963
Acrylic and scotch-tape on hard-board,
122 x 76 cm
Museum Ludwig, Cologne

Peter Blake
ABC Minors, 1955
Oil on hard-board, 76 x 49 cm
Museum Ludwig, Cologne,
Ludwig Collection

drawing, collage and assemblage and to incorporate different layers of banal reality directly into his work, which, in turn, took on the character of reliefs or sculptures. His themes were circus figures, wrestlers, strip-tease dancers, pin-up girls, tatooed figures and stars from the rock world and subculture. Although he belonged to a younger generation of London artists than Paolozzi or Hamilton, he had completed his key works long before 1960.

Like his *Self-Portrait with Badges* (p. 52), *On the Balcony* (1955/57; p. 67), which Blake handed in for his final examination at Royal College, is a key to understanding Blake's subject matter. Well-behaved children sitting, or stand-ing, submissively on a kind of stage (of life) are shown hemmed in, and yet

Peter Blake
Assemblage Nudina, 1961-64
Oil on wood, 33 x 17.7 cm
Badischer Kunstverein, Karlsruhe

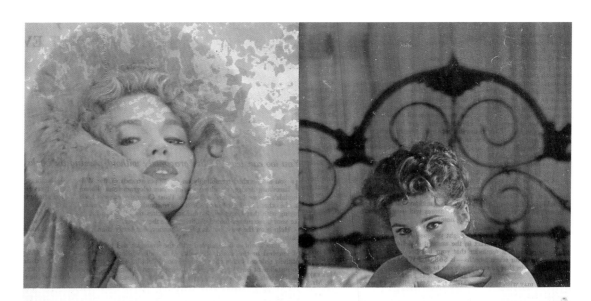

unmoved, by a vast accumulation of images from traditional art and popular subculture: Manet's *Balcony*; pictures of the balcony of the royal palace; toys; newspapers; modern idols; souvenirs; wrappings; English painting (by Robyn Denny, Dick Smith and Leon Kossoff) and a work by the artist's brother. He unites both new and older, more well-known symbols of the modern era in a "collage composition" which, in an academic style, imitates reproductions.

In 1959 Blake began to use posters and photographs as models for paintings, collages and assemblages showing the idols of the new era: rock and film stars such as Elvis Presley, Cliff Richards, Frank Sinatra, Bo Diddley (p. 202), the Beatles, Marilyn Monroe and Jean Harlow. His paintings became more insistent, more like posters, and more perfectionist in the sense that they simulated flaws. Blake dedicated his portrait of the Beatles, begun in 1963 and finished in 1968, to the year in which the group was founded. The date "1962" stands at the centre of the painting. In 1967 Blake "staged" the record cover for "Sergeant Pepper's Lonely Hearts Club Band" with his wife Jann Haworth. He arranged the group as if for a poster and then stylized the image into an icon of the new generation. The naive facial expressions and clear, genuine gaze contrast with the fashion-conscious costumes. A reserved individuality is re-

Peter Blake
Toy Shop, 1962
Relief in mixed media, 156.8 x 194 x 34 cm
Tate Gallery, London

Peter Blake
Tuesday, 1961
Oil and mixed media on wood,
47.6 x 26.7 x 3.8 cm
Tate Gallery, London

763 Bedouin

Peter Blake
Bedouin, 1964/65
Acrylic on wood, 77.5 x 47.5 cm
Thyssen-Bornemisza Foundation, Lugano

Peter Blake
Tarzan, Jane, Boy and Cheeta, 1966-75
Oil on canvas, 122 x 92 cm
Galerie Claude Bernard, Paris

vealed behind the flashy colours and challenging effect of this picture. Entertainment and art have become inseparable here. The levels of expression inherent in Pop music, in the new folk-music of the Beatles, for example, reflected both "high" culture and subculture, both the trivial and the remarkable.In 1963 Blake married Jann Haworth, the important American Pop artist, with whom he travelled the USA in 1963. In 1969 he moved with his family to the country, where he founded "The Brotherhood of Ruralists" in 1975. Since then, Blake's work has gradually returned to pure painting.

Richard Hamilton

Richard Hamilton "portrays" highly stylized interiors with human figures who hide their rear identities behind a "waxwork" exterior image to match the style of their surroundings. Functional and atmospheric qualities such as romanticism, practicality and taste are linked with furniture and household accessories, televisions and telephones. Perfectly designed worlds reflect a desire for enduring stability and security. But they also veil the vulnerability of these apparently intact, clean zones to the unexpected incursions of the real world. In Hamilton's picture collages (pp. 212, 213), obscure painterly elements, distortions of perspective, reworked passages, alienation and surreal exaggeration point to deformations of this ordered, hidebound picture of the world. The engagingly disconcerting effect of his pictures derives from their combination of trivial themes and subtle ideas, using techniques reminiscent of poster montage and commercial design. Hamilton mixes the gloss of the clichéd image with levels of ironic artistic expression.

Hamilton's confident handling of formal techniques and his predilection for furnished interiors derive from his professional background and from his work as a teacher. In 1936, when he was fourteen, he began work in the publicity department of an electrical firm. He studied painting at the Royal Academy Schools in London from 1938 to 1940, and again in 1946. He was a founder member of the Independent Group in 1952, in which artists, academics and architects held lectures, discussions and interdisciplinary exhibitions on the arts and mass media, and on culture and progress. From 1941 he worked as a draughtsman, having completed the training in 1940. From 1952 he taught design at the Central School of Arts and Crafts – where he met Eduardo Paolozzi – and at King's College in the University of Durham. From 1957 to 1961 he taught interior design at the Royal College of Art, where many of the younger generation of Pop artists were studying. He held no teaching post in creative art as such. It is, in fact, his professionalism in the use of applied design and modern, commercial images which gives his pictures their ambiguity, pictures in which the viewer will find the conformity of his own views reflected.

During his artistic development, Hamilton became interested in Cubism and Futurism, and in the work of Paul Cézanne, the photographer Eadweard Muybridge, Paul Klee, and especially Marcel Duchamp. Among the various abstract tendencies in classical Modernism, he discovered, and appropriated, the use of kinetic motifs. His abstractions and jumbled perspectives create the impression that the things in his pictures are moving. He plays with light effects, with the "lighting" of interiors, with colour rhythms. Painterly passages also appear able to move freely and non-objectively in his mixtures of abstraction and realism. This explains why his pictures sometimes look like still lifes: he

"The restriction of his area of relevance has been confirmed by the artist with smug enthusiasm so that decoration, one of art's few remaining functions, has assumed a ridiculously inflated importance."

RICHARD HAMILTON

Richard Hamilton
The Solomon R. Guggenheim (Black), (Black + White), (Spectrum + Gold), 1965-66
Fibre-glass and cellulose, three reliefs, each 121.92 x 121.92 x 19.1 cm
The Solomon R. Guggenheim Museum, New York

Richard Hamilton
Towards a Definitive Statement on the Coming Trends in Men's Wear and Accessories, 1960
Oil, collage, plastic foil on wood, 61 x 81.3 cm
Tate Gallery, London

arranges objects and human figures so that equal weight is attached to both and demonstrates complete freedom of facture.

Hamilton's work was further developed by his experience of various methods of technical reproduction and their effect on everyday life and, especially, on people's habits of viewing: the use of photography, film, television, advertising, design, packaging and popular literature to reinforce social and gender roles and stereotypes of behaviour (man/woman – job/leisure).

His programmatic collage *Just what is it that makes today's homes so different, so appealing?* (p. 65) heralded a new and intermedial conception of art. Hamilton had conceived it as a poster design for the exhibition "This is Tomorrow", which was organized by the Independent Group in 1956 for the Whitechapel Gallery in London, and whose view to the future included exhibits comprehending such areas as mixed-media art, communications, the home, design and technology. The title of the collage is derived from advertising. In this early example of Pop Art he presents us with a selection of typical social and gender role clichés. The sources of the content and formal range used in this collage are to be found in Hamilton's own artistic work. The individual identity of people and objects blurs within the mosaic of this domestic institu-

212

tion; both have become merely passive pieces within the jig-saw of technological progress. Hamilton combines symbols and consumer images, progress and nostalgia, appealing to both the intellect and the senses. His mechanical technique has a softening effect, his hard realism seems sugary and "nice", while the outlandish elements appear kitschy – all in all the collage feels chaotic and disturbing. The view through the window makes the outside world a part of the apartment. In his sketches in later years Hamilton investigated the individual pieces of this mosaic: vacuum cleaner, telephone, fridge, pinups, gramophone, car, furniture, kitchen fittings.

In 1964 he produced *My Marilyn (paste up)* (p. 15), a sequence of photographs arranged askew and apparently in haste. Like a fashion photographer, Hamilton crosses out the uninteresting shots with red oil paint. We see how the photos which come closest to the expectations of the consumer are selected from a series of professional shots showing Marilyn in different poses. The picture with the most vivid, the most superficial, most beautiful, most smiling portrayal of Marilyn is marked "good". Hamilton's own criteria, his own preferences and rejections, remain undeclared here. Is *My Marilyn* the picture which represents her real character, her personality, or is this the Marilyn the

Richard Hamilton
Interior II, 1964
Oil, collage, relief in aluminium on wood,
121.9 x 162.6 cm
Tate Gallery, London

Richard Hamilton
Trafalgar Square, 1965-67
Oil and photography on wood, 80 x 120 cm
Museum Ludwig, Cologne

artist prefers himself, the one whose pose and features are what is usually expected of a sex symbol? In fact, the original models for this Marilyn Monroe photo sequence had already been labelled and struck out by Marilyn herself: "she" is the source of the word "good" on the only photo not crossed out, and which Hamilton repeats in the sequence in an enlarged version.

Several works from 1967/68, like the painting *I'm dreaming of a White Christmas* (p. 215) and a series of painted-over prints and photos, illustrate clichés of happiness in everyday life, or on special occasions. Hamilton traces the dreams, the unspoken thoughts and secret desires and captures them as if in snapshots. He presents variations of the same scene by colouring almost identical impresssions of it differently. He plays about with the negative and positive effects of the original photgraph so that the emotional expections of the figure in the picture become distorted.

In *Fashion plated (cosmetic study)* in 1969, a comparable series produced with a similar technique, he portrays the behaviour of a model and of a fashion photographer with his accessories. These pictures use mixed media with painting, and also cosmetics on lithographed paper. In a later series of studies for the painting *Soft Pink Landscape* (1971/72) Hamilton uses a sixties advertisement for toilet paper.

This landscape, a picnic with beautiful girls seen among green trees —

based on a long ancestry of famous models from the Rococo to the Impression-
ists – is his version of an idyll confronted with the realities and refuse of
contemporary life, an idyll grown implausible and seedy. This work may be
able to provide us with a broad definition of the subjects favoured by Pop: Pop
brings reality back into ideal images which veil the real state of the world.
While the media merely enact reality, embellishing and idealizing it and
making it endurable and serviceable, the artist turns advertising and design,
whose theory and practice he commands, into their opposite.

Hamilton gives the artificial gloss on objects an uncomfortably close
"adornment" of things which stink – excrement, garbage, litter – illustrating the
fragility and susceptibility of standardized images of "the good, the true and
the beautiful". The air and the human beings seem so enthralled by their world
of illusions and manipulated romanticism that they no longer notice the extent
of their own pollution.

Richard Hamilton
I am Dreaming of a White Christmas,
1967-68
Oil on canvas, 106.5 x 160 cm
Kunstmuseum Basel, Basle, Ludwig
Collection

PAGES 216/217:
Richard Hamilton
Swingeing London 67 II, 1968
Oil and silkscreen on canvas, 67 x 85 cm
Museum Ludwig, Cologne

David Hockney

"I paint what I like when I like and where I like" is often quoted as the guiding principle of David Hockney's biographical realism. Hockney sees his own biography as a key to his work. In his book "David Hockney by David Hockney", he goes into great detail in explaining the most important sources of his pictorial world. Besides giving us significant details from his private life, he traces the influences on his work back to art history and the history of the media.

Hockney weaves decorative detail, light and atmosphere, physiognomy, bodily expression, materials and fabrics into a pictorial lattice through which he projects his different states of mind. He takes his inspiration from objects and situations; in return, he gives these a vital, independent existence. The composed balance of his pictures allows naivety, playfulness and wit to coexist beside melancholy, boredom and longing.

Hockney speaks of the "balance between form and content" in his painting. The artist should not permit ambitions of form to mask his content – a danger Hockney sees in some abstract-expressionist painting; but neither should form be subordinated to content – a characteristic of Victorian painting at the turn of the century. Hockney's own criterion is one which may be found throughout the Pop movement: all objects and formal qualities in a picture should be given equal weight, whether the design of a chair, a human face, the colour of a curtain, the pattern of a carpet or less definable, symbolic elements.

Hockney discovered his vocation at an early age: "At the age of eleven I'd decided, in my mind, that I wanted to be an artist, but the meaning of the word 'artist' to me then was very vague – the man who made Christmas cards was an artist, the man who painted posters was an artist, the man who just did lettering the posters was an artist. Anyone was an artist who in his job had to pick up a brush and paint something . . . Of course I knew there were paintings you saw in books and in galleries, but I thought they were done in the evening, when the artists had finished painting the signs of the Christmas cards or whatever they made their living from." Hockney does not disguise the relationship in his work between his own subjective needs and expectations and the anonymous models he finds in the world around him – the world of advertisements and packaging, folk art and children's paintings. His bunches of flowers, palms and cactuses are reminiscent of the inculcated naiveté of school-childrens' drawings. His own naiveté is neither whimsical nor calculated, but springs from an original clarity of perception and need for a personal vision. A self-portrait of 1954 shows him as a 17-year-old, helpless as a school-boy and seemingly unaffected by the world around him – except that he is taking in its abundance, its wealth of forms and colours in thoughtful stillness. The crisp contours of the body, the equal weight given to decorative elements, free forms and objects in

"There was a packet of Typhoo tea, a very ordinary popular brand of tea, so I used it as a motif. This is as close to pop art as I ever came. But I didn't use it because I was interested in the design of the packet or anything; it was just that it was a very common design, a common packet, lying around, and I thought it could be used in some way."
DAVID HOCKNEY

David Hockney
A Bigger Splash, 1967
Acrylic on canvas, 242.6 x 243.8 cm
Tate Gallery, London

this drawing already radiate those qualities which were to become so characteristic of his drawings in the sixties. Hockney's imagination appears to bathe in atmospheric exuberence; he translates exact perceptions of his surroundings into a clear and diversified language which reflects the calmness of his own temperament.

When Hockney arrived at the Royal College in London in 1959, he was faced with a tense situation. On the one hand, he found himself confronted with the progagation of an academic naturalist style, and on the other with an equally routine Abstract Expressionism. R.B. Kitaj, with whom he was later to become closely acquainted, was the first of the slightly more experienced artists Hockney met there. He later got to know him better at the Royal Academy; Kitaj's greater experience at the Royal College enabled him to help Hockney find his own style. From 1960 Hockney began to bring his own experience to bear on his painting and to paint subjects from his own life, in which his own interests and values were given full prominence. It was during this period that Richard Hamilton began to take note of Hockney's work. (Hamilton was teaching Design at the Royal College.)

These pictures ushered in a first, prolific and expressive phase of his work, lasting until 1964. With their rich contrasts of sombre hues and garish, luminous reds, their dissonant perspectives and distorted compositions, these paintings depict confrontations between a personal, inner world and restless influences from the outer world, such as graffiti or advertising imagery. His *Tea-Paintings* (1960/61) evoke recurrent tensions between elements of the consumer world on the one hand, and the freely painted line and free movement in space on the other. Hockney himself pointed out that these paintings brought him closer to Pop Art than he had ever been. Parallel to these, Hockney painted his *Love Paintings,* in which physical and spiritual feeling is introduced into a world of visual symbols and free associations. The languages of design and advertising play with symbols of love against a dynamically expressive background. The figurative representation of personal experience was one of Hockney's central concerns. One of his main works during this period was the set of etchings *A Rake's Progress,* after the opera by Benjamin Britten. This was his first, major graphic work; the techniques he used here were to become increasingly important in his later work.

In 1961 Hockney went to New York; however, the only artist he met there was Claes Oldenburg in Richard Bellamy's Green Gallery. A photo taken in 1963 shows him in Los Angeles with Andy Warhol and Henry Geldzahler, one of Pop Art's first great interpreters. In 1963 he moved to Los Angeles and remained there until 1968. R.B. Kitaj was at this time teaching at Berkeley. Hockney lived in Santa Monica where his work was inspired by the milieu of villas and satiated affluence, by the palm trees and swimming pools, and by the California light and heat (pp. 218, 224, 225). In his paintings and detailed graphic work he uses strong lines and fine colour nuance to observe the Californian "dolce far niente", the long, slow rhythms of idle pleasure, and to characterize the sensation of savouring a cornucopia whose every appearance is exotic and paradisiacal. In these surroundings, Hockney's clear colours and simple spatial compositions depict the correlation of light and space, of still and moving waters and colourfully ornamented swimming pools, the patterns of materials, household articles such as furniture, bric-a-brac, domestic appliances and showers (pp. 70, 223) – "Americans take showers all the time – I knew that from experience and physique magazines."

With their scrupulous, matter-of-fact accuracy, his pictures illustrate the

David Hockney
Man Taking Shower in Beverly Hills, 1964
Acrylic on canvas, 167.3 x 167 cm
Tate Gallery, London

atmospheric nexus between quite separate, and even disparate, things. Perception appears to link things together; the fact that a curtain is just like a painting and that one is a picture oneself or that one could hang up a curtain like a picture fascinates him. Pictures are not translations of illusions; in a certain sense, they are themselves reality. Pictures of water are pictures of movement. His pictures capture both vital and hackneyed aspects of everyday life in what seem to be passing still lifes.

In his drawings Hockney employs a maximum of figurative readability. His use of line crisply defines atmospheric, material, outer and inner states. His lines are bold, and yet drawn with great care; they react highly sensitively to observation – their theme, in other words, is the act of seeing.

Hockney's relationship to art and cultural history is revealed in his nonchalant but confident use of ready-made images and stories. Children's books and fairy tales had always fascinated him. In 1961 he began his graphic illustrations of *Mirror, Mirror on the Wall* and *Rumpelstiltskin*. He felt the world of children's experience was close to his own. His pictorial representation is characterized here by its simplicity and sensuality, its discovery of the unusual in inconspicuous detail.

Hockney uses photography to show the artificiality and dishonesty of the media. He tends to expose the role of the viewer or photographer, who influences the behaviour of his subjects. He had always taken photographs parallel to his painting, but it was not until the late eighties that he began to engage in photography's playful dialogue of art and artificiality. Using very large formats, he combined photographic techniques such as alienation, distortion, double exposure, elongation, superimposition, etc. These techniques then also influenced his painting.

Hockney has a singular relationship to art history. In 1965 he painted several abstract paintings with the intention – as he explained – of showing that an abstract picture was an object. Non-figurative elements, on the other hand, also have an effect on his figurative painting, especially on its decorative or ornamental passages (materials, curtains, carpets). Earlier artists who interested him were Pierro della Francesca, Fra Angelico and Pablo Picasso – especially the latter's "classical" pictures of the twenties. What interested him in Egyptian art was not its symbolic quality, but its impersonal language of expression, the fact that "there's no individualism in the paintings...". It was "...the anonymous aspect of the artist, but not the art," which was important to him. And yet David Hockney linked this anonymity – a self-declared characteristic of Pop Art – with his own personal experience, perhaps more so than any other artist. His language of both free and figurative forms allows different levels of interpretation to merge.

PAGES 224/225:
David Hockney
Sunbather, 1966
Acrylic on canvas, 183 x 183 cm
Museum Ludwig, Cologne

222

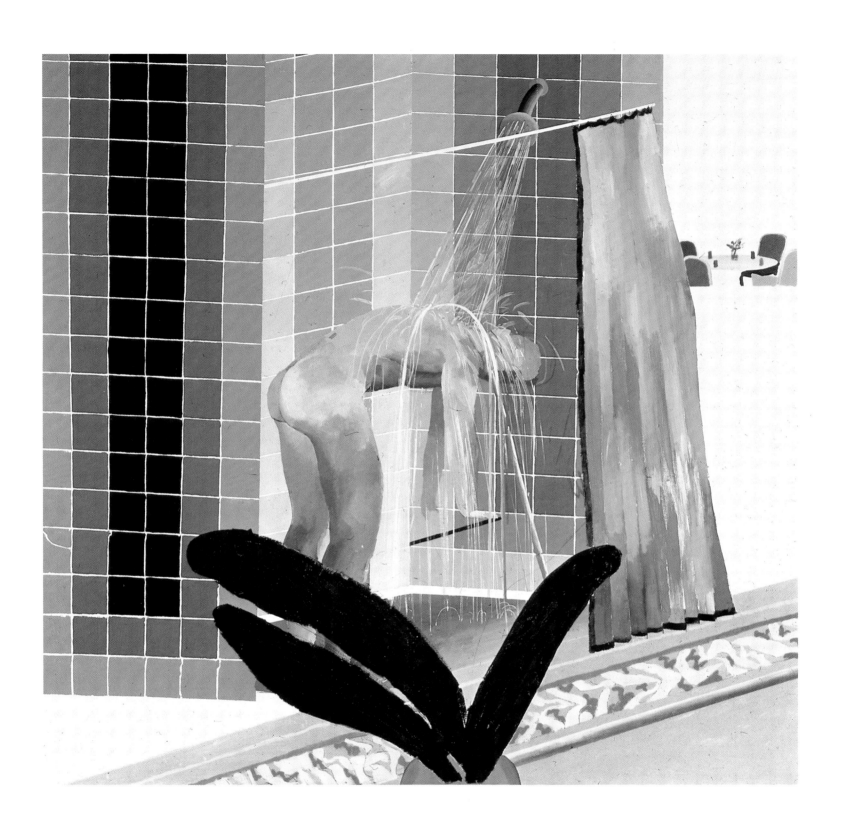

Afterword

Pop Art is conceptual. Pictures become things, and things become pictures. In the publication "America Discovered", published by Arturo Schwarz in Milan, the American Billy Klüver, who knew many of the Pop artists personally, described them as "factualists". Klüver characterizes the sixties generally as a period dominated by the belief in facts, by the tendency to see objects, conditions and feelings ("Happiness is a fact") as "facts". The terse "That's a fact" became a standard phrase in American English for dealing with all kinds of situations and dilemmas. In an interview with Gene Swanson in 1964, Tom Wesselmann had declared that all painting was fact. Andy Warhol had told the interviewer the same thing in 1963. Jasper Johns also speaks of some of his paintings as "facts" (Swanson interview, 1964). Claes Oldenburg has also confirmed in interview Klüver's definition as the most accurate and convincing characterization yet of the artists associated with Pop Art. Historically speaking, the term "Factualists" could replace the term "Pop Art." Hardly any of the artists identify with "Pop Art" as a comprehensive term. "Pop" could then be used to characterize a cultural movement which had to do with a particular generation, and in which art and artists entered into very different relationships with popular culture and their social environment in general.

An essential characteristic which links these artists is their ironic attitude towards the facts, or rather their tendency to see the facts themselves as ironic (Billy Klüver also says that facts are essentially ironic). This tendency goes hand in hand with their highly developed sense of reality and their analytical, reflective ideas. It is these qualities which explain the early, positive reaction enjoyed by Pop Art in Europe, especially in Germany – a reaction registered in exhibitions, in tendencies on the art market, in acquisitions by private and museum collectors, in publications and in controversial discussions. Pop Art's novel and unabashed interest in breaking down the barriers between art and non-art, and in replacing the hitherto typically inward-looking criteria for art with criteria orientated more towards the outer world, was felt as a considerable challenge to traditional attitudes towards art. For Americans it was easier to see the connection between the concretization of content and the reification of form. The Minimalist and critic Ad Reinhard's sentence, "You see what you see", might also have been spoken by a Pop artist; indeed, it was also uttered by the British artist Nigel Henderson, a member of the Independent Group. A clear sense of reality, an orientation towards the factual and a conceptual approach are incidentally almost mandatory qualities for representatives of both Minimilist Art and Pop Art.

It is easier to see the connection in retrospect. A later generation of artists has taught us a more exact perception of subjective and objective elements by

James Rosenquist
Horse Blinders, 1968
Lithograph, 73 x 102 cm
Suermondt-Ludwig-Museum,
Aachen, Ludwig Collection

bringing us into a more concrete confrontation with art, given us a clearer knowledge of the conceptual semantics of the artistic reflection of popular images. Marcel Broodthaers, who took part in a debate on Pop Art in 1968, developed these tendencies theoretically in his installations of the sixties and seventies. Elaine Sturtevant began to copy Warhol and Stella, Johns, Beuys and Duchamp in New York in the sixties. The work of Broodthaers and Sturtevant forms a bridge to the work of contemporary artists who are once again copying, and creating environments with, art and consumer goods, or staging performances in museums with historical objects. The younger generation of artists, especially in the USA – Jeff Koons or Haim Steinbach for example – acknowledges its affinities to Pop Art. In their statements they also provide us with the theoretical background for their renewed analytical interest in Pop Art and today's popular culture, habits in taste and status symbols, etc. Their intention is that facts and objects should be perceived in a new way, should be experienced realistically – it is art's job to make them transparent. Art today is the process, similar to that in the fifties, of repudiating neo-Expressionist tendencies; an art about art is emerging, an art about philosophy, about foreign cultures, mass cultures, about the mass media. Just as the development of Pop Art in 1960 corresponded to the spread of colour television in the USA, it is the aesthetics of the computer image which today forms the background of our communication media.

However one judges these phenomena, one thing is clear: Pop Art is having a renewed impact on the reception of art – in fact, a renaissance. And in today's mass, or popular, culture, Neo-Pop, the Pop knick-knack and fashion industries, Pop-style advertising and its attendant slogans and vulgar phraseology are experiencing a regular boom. It is a tendency which can also be seen in popular journalism (the magazine "Pop", published in Frankfurt in 1989, was distributed in enormous numbers at the art fair "Art Frankfurt"). It is a boom well worth thinking about: "Everything is Pop" and "Pop is everything".

Arman

Born as Armand Fernandez in 1928 at Nice, the son of an antique dealer. His first lessons in painting were given him by his father. He took his Baccalauréat in philosophy and mathematics in 1946 and began to study painting at the École Nationale d'Art Décoratif, Nice. In 1947 he met Yves Klein and Claude Pascal in Paris and accompanied them on a hitch-hiking tour of Europe. Completing his studies in Nice in 1949, he enrolled as a student at the École du Louvre, where he concentrated on the study of archaeology and oriental art. His pictures at this time were influenced by Surrealism. In 1951 he became a teacher at the Bushido Kai Judo School. He completed his military service as a medical orderly in the Indo-Chinese War. He did abstract paintings in 1953. He took part in actions with Yves Klein, with whom he had been discussing subjects such as Zen Buddhism and astrology since 1947. He married Eliane Radigue. He was impressed by a Kurt Schwitters exhibition in Paris in 1954 which inspired him to begin his work with stamp imprints, the Cachets. He earned his living during this period through occasional jobs, selling furniture and harpoon fishing. He had his first one-man exhibitions in London and Paris in 1956. In 1957 he travelled in Persia, Turkey and Afghanistan. In 1958 he dropped the "d" in his name, inspired by a printer's error. He started his monotypes using objects, his *Allures*. In 1959 he did his first *Accumulations* and *Poubelles*. The *Accumulations* were assemblages of everyday objects and similar consumer articles displayed in boxes. The *Poubelles* were similar, but used collections of rubbish. In 1960 he became a founding member of the Nouveaux Réalistes. Through this group he made contact with members of the Zero group. He showed in New York and Milan in 1961 and made his sliced and smashed objects *(Coupes, Colères)*. In 1962 he showed in various European cities and also in Los Angeles, where he was assisted by Edward Kienholz. He started his so-called *Combustions,* or burned objects, in 1963. He also took up part-time residence in New York. In 1964 he had his first

museum retrospectives at the Walker Art Center, Minneapolis, and at the Stedelijk Museum, Amsterdam. Polyester now became his most important material. In 1965 and 1966 he was given large retrospective exhibitions in Krefeld, Lausanne, Paris, Venice and Brussels. In 1967 he initiated a collaboration between art and industry with the company Renault and represented France at "Expo '67", Montreal. He showed at the Venice Biennale and at documenta 4 in Kassel in 1968, and was given a teaching post at the University of California, Los Angeles. In 1970 he began his *Accumulations* in concrete and exhibited at the World's Fair in Osaka. In 1971 he began a series with organic garbage embedded in plastic. In 1972 he gained American citizenship in addition to his French nationality. In 1974 he toured with a retrospective through five North American cities, and returned to Paris. Since 1975 he has lived in New York – where he has a studio – and in Paris.

Richard Artschwager

Born in 1924 at Washington. He spent his childhood in New Mexico. From 1941 to 1948 he studied at Cornell University, Ithaca, N.Y. His studies were interrupted by active service in Europe. He moved to New York and studied at the Amédée Ozenfant Studio School. He constructed "furniture". He had his first exhibition at the Leo Castelli Gallery, New York. He was represented in a number of group exhibitions in the USA in 1966/67, and at the documenta "4", "5", "7" and "8", Kassel. He had a one-man exhibition at the Museum of Contemporary Art, Chicago, in 1973. In 1974 was shown in the "American Pop Art" exhibition at the Whitney Museum, New York. In 1978 he exhibited at the Hamburger Kunstverein and at the Neue Galerie, Aachen. In 1980 he was represented at the Venice Biennale. He also had a one-man show at the La Jolla Museum of Contemporary Art, California. He participated in the group exhibition "Westkunst", Cologne, in 1981. In 1985 he exhibited at the Kunsthalle, Basle, and at the Stedelijk Van Abbemuseum, Eindhoven, in 1986 at the Musée d'Art Contemporain de Bordeaux. In 1987 he was awarded the Kokoschka Prize, Vienna. In 1988 he was given a comprehensive retrospective at the Whitney Museum of Modern Art, New York, and at the Museum of Modern Art, San Francisco, and in 1989 at the Museum of Contemporary Art, Los Angeles.

Clive Barker

Born in 1940 at Luton. He studied from 1957 to 1959 at the Luton College of Technology and Art. In 1962 he was represented at the exhibition "Young Contemporaries" at the RBA Galleries, London. In 1967 he showed in a number of collective exhibitions, including: "Salon de la Jeune Peinture", Musée d'Art Moderne, Paris, "Englische Kunst", Galerie Bischofberger, Zurich, and "Young British Artists", Museum of Modern Art, New York. In 1968 he had his first one-man exhibition at the Robert Frazer Gallery, London. He has shown at various exhibitions of British artists in Europe, and also at the exhibition "Pop Art" in

1987 in Japan. He is known for his bronze casts of inconspicuous everyday objects, painting tools and star symbols (such as Marlon Brando's cowboy boots), in which the aura of the precious metal gives the banal object a strange, enigmatic effect.

Billy Al Bengston

Born in 1934 at Dodge City, Kansas. From 1953 to 1957 he studied at different colleges in Los Angeles and San Francisco, finishing at the Los Angeles County Art Institute. In 1956 he exhibited for the first time in a collective exhibition at the Six Gallery, San Francisco. He had his first one-man exhibition at the Ferus Gallery, Los Angeles, in 1958. In 1965 he was represented at the 8th São Paulo Biennale. In 1968/69 he exhibited in various museums in the USA. In 1971 he was represented at the "USA West Coast" exhibition, which was also shown in Hamburg, Hanover, Cologne and Stuttgart. In 1987 he was represented in the exhibition "Pop Art" (USA-UK), which was shown in several Japanese cities.

Peter Blake

Born in Dartford, Kent, in 1932. From 1946 to 1951 he studied at Gravesend Technical College and School of Art, and from 1950 to 1956 at the Royal College of Art, London. From 1951 to 1953 he served in the Royal Air Force. He studied folk art in various European countries with a research award. From 1959 he did collages with pin-up photos, star images, posters, LP covers and trivial images. Between 1960 and 1962 he taught at St. Martin's School of Art, London, and from 1962 to 1964 at the Walthamstow School of Art. In 1961 he obtained First Prize in the John Moore Exhibition, Liverpool, for "Self-Portrait with Badges". In 1963 he married Jann Haworth and travelled to Los Angeles to do drawings for the "Sunday Times". From 1974 to 1976 he taught at the Royal College of Art, London. In 1969 he was given his first retrospective by the City Art Gallery in Bristol. He moved to Wellow, Avon, and continued to live there until 1974. In 1973 and 1974 he had retro-

Gallery, New York, in 1966. In 1965 he was represented at the Biennale des Jeunes, Paris, in 1967 at the International Exhibition of Graphic Art, Ljubljana, Yugoslavia. In 1973 he illustrated the poems of Jules Laforgue for the Petersburg Press. In 1977 he exhibited at Santa Monica, California, in 1978 at the Tate Gallery and was given retrospective exhibitions at the Tate Gallery and the Walker Gallery, Liverpool, in 1981. His pictures combine levels of illustrative expression found in comics with a naive pictorial language, in which personal, social, political and artistic images meet. He has a predilection for referring to work by the Old Masters.

Christo

Javacheff Christo, born in 1935 at Gabovo, Bulgaria. Between 1952 and 1956 he studied painting, sculpture and stage design at the Academy of Fine Arts, Sofia. In 1956 he worked briefly in Prague. In 1957 he studied sculpture for one term under Fritz Wotruba at the Academy of Fine Arts, Vienna. In 1958 he settled in Paris. He became temporarily associated with the Nouveau Réalistes. In 1958 he began to package objects. His assemblages of oil drums were shown in Cologne in 1961. He exhibited in 1963 at the Galerie Schmela, Düsseldorf. In 1964 he moved to New York where he made his first "store fronts". In 1966 his "store fronts" were shown at the Stedelijk Van Abbemuseum, Eindhoven, and at the Leo Castelli Gallery, New York. In 1968 he packaged the Berner Kunsthalle – his first packaged building. He was represented at the documenta exhibitions "4", "5" and "6" in Kassel in 1968, 1972 and 1974, and in 1972 and 1976 at the Venice Biennale. He produced overdimensional packaging projects for buildings, skyscapes and landscapes. His especially well-known large-scale projects were "Valley Curtain", Rifle, Colorado in 1972 and "Running Fence", California, in 1976. In 1977 his exhibition "Christo – The Running Fence" toured Rotterdam, Bonn, Hanover, Humblebaek, Hövikoden, Zurich, Brussels and Grenoble. In 1978 he produced the project "Berlin Reichstag". In 1980 he took part in the exhibition "Mein Kölner Dom" for the 100th anniversary of the cathedral (but his project was not realized). In 1981 he produced the project "Surrounded Islands": ten islands in Biscayne Bay near Miami, Florida, were packaged in pink polypropylene fabric. The documentation of this project also went on tour.

Allan d'Arcangelo

Born in 1930 at Buffalo, New York. Between 1948 and 1953 he studied at the University of Buffalo, New York. In 1953 he studied history at the New School of Social Research. In 1957 he taught at the School of Visual Arts, New York. In 1961 he had his first one-man exhibition at the Long Island University, New York. In 1964 he was included in the "American Landscape Painting" exhibition at the Museum of Modern Art, New York. In 1965 he taught at the Institute of Humanistic Studies in Aspen, Colorado. In 1967 he was represented at the São Paolo Biennale and had a one-man exhibition

spectives in Amsterdam, Hamburg, Brussels and Arnheim. He was made A.R.A in 1974 and R.A. in 1981. In 1975 he and his wife Jann Haworth were founder members of the "Brotherhood of Ruralists", who had their first exhibition at the Royal Academy in 1976. He became separated from Jann Haworth in 1981 and returned to London. In 1983 he was given a large retrospective exhibition at the Tate Gallery and at the Kestner-Gesellschaft, Hanover.

Derek Boshier

Born in 1937 at Portsmouth. Between 1953 and 1957 he studied at the Yeovil School of Art in Somerset. From 1959 to 1962 he studied at the Royal College of Art, London. In 1959 he was first included in the "Young Contemporaries" exhibition at the RBA Galleries, London. He had his first one-man exhibition at the Grabowski Gallery, London. He was awarded a travel scholarship to go to India. His pictures confront the world of consumer goods, symbols used in mass communications and human gestural behaviour. In 1963 he was represented at the Paris Biennale. He taught at the Central College of Art and Design and at the Hornsea College of Art, London. In 1964 he travelled in the USA. He was included in Pop Art exhibitions at the Hague, Vienna and Berlin. From 1973 he taught at the Royal College of Art, London. In 1975 he was Guest Teacher at the University of Victoria, Vancouver Island, Canada.

Patrick Caulfield

Born in London in 1936. Between 1956 and 1960 he studied at the Chelsea School of Art, and from 1960 to 1963 at the Royal College of Art, London. In 1961 he was included in the "Young Contemporaries" exhibition, London. From 1963 to 1971 he taught at the Chelsea School of Art. He worked briefly with wooden grids which he laid across his canvas, and then later destroyed; this method led to his first black and white paintings. He had his first one-man exhibition at the Robert Frazer Gallery, London. He exhibited at the Robert Elkon

at the Württembergischer Kunstverein, Stuttgart. In 1969 he exhibited at the "Gegenverkehr", Aachen. In 1976 he was included in the exhibition "American Art since 1945" at the Museum of Modern Art, New York. He had a one-man exhibition at the Virginia Museum of Fine Arts, Richmond, in 1979. The subjects of his pictures during the early sixties were images of "stars", but his later subjects revolved almost exclusively around the symbols of American highway culture. The precision of his colour surfaces and outlines encourages the interplay of abstract and figurative perception.

Jim Dine

Born in 1935 at Cincinnati, Ohio. He studied at the University of Cincinnati and at the Boston School of Fine and Applied Arts in Boston, Massachusetts from 1953 to 1957. In 1957 he received a Bachelor of Fine Arts degree from the Ohio State University, Columbus. He moved to New York in 1959. He staged his first Happenings with Claes Oldenburg and Allan Kaprow at the Judson Gallery, New York. he had his first one-man exhibition at the Reuben Gallery, New York. Between 1960 and 1965 he had various guest professorships, among others at Yale University, New Haven, and Oberlin College, Ohio. He was represented at the Venice Biennale in 1964, and at the "documenta 4" in Kassel in 1968. Since 1967 he has taught at the College of Architecture, Cornell University, Ithaca, New York. He lives in New York and London. In his paintings, drawings, sculptures, graphics, collages and assemblages he combined different techniques with handwritten texts and words and set real everyday objects against undefined backgrounds. The objects were both commonplace and personal, both poetic and ironic, reflecting his own feelings about life. His constantly varied bathrobe, transparent to the gaze of the world, was a kind of metaphor for a self-portrait. In the 70s he turned to representational painting of a traditional kind.

Erró

Born in 1932 in Olafsvik, Iceland. Between 1952

and 1954 he studied at the Academy in Reykjavik and in Oslo. From 1955 to 1958 he studied at the Academy in Florence and learned the art of mosaic. He made several mosaic floors in Reykjavik. In 1957 he travelled to Israel. In ⁻958 he moved to Paris. His work was included in the "Antiprocès" exhibition in Paris in 1960. From 1961 to 1966 he exhibited at the "Salon de Mai". In 1962 he staged the Happening "Catastrophe" with J.J. Lebel, made his first film and first "Mécanifest" in Venice. In 1963 he exhibited in New York and did his second "Mécanifest" in Venice. In 1964 he began his film "Grimaces" and travelled to Russia. He was also represented at the Tokio Biennale, at the exhibition "Le surréalisme", Galerie Charpentier, Paris, in "L'Art et la Révolution algérienne", Algiers, and his work was included at the São Paulo Biennale. He visited New York. In 1965 and 1966 he had exhibitions in Rome and Paris ("La Figuration narrative dans l'art contemporain"). In 1966 he made the film "Stars". In 1967 he exhibited in "Le Monde en question" at the Musée d'Art Moderne de la Ville de Paris, and in "Science Fiction" at the Kunsthalle, Berne. His paintings combined elements of the comic and science fiction with stylistic techniques influenced by Surrealism to form pictorial political manifestos. During this period he travelled to Cuba. In 1968 he travelled to the Soviet Union and to the USA. He had exhibitions in Paris and Cologne ("Surrealismus in Europa"), in 1969 at the A.R.C., Paris, in Essen and at the Kunstverein Karlsruhe ("Kunst und Politik"). In 1971 he spent a year in Berlin and travelled to the U.S.S.R. In 1972 he made several longer visits to Thailand, and in 1975 to the Far East.

Öyvind Fahlström

Born in 1928 in São Paulo of Scandinavian parents. In 1939 he moved to Sweden. Between 1949 and 1952 he studied art history and archaeology. He worked as a writer from 1950 to 1955. In 1953 he published a manifesto in Stockholm in favour of concrete poetry. From 1956 to 1959 he lived in

Paris. In 1957 he began to introduce elements of the comic strip into his paintings. In 1959 he won the Grand Prix at the São Paulo Biennale. In 1960 he was included in an international exhibition of contemporary art at the Carnegie Institute, Pittsburgh. He was awarded a stipend to visit the USA in 1961. He settled in New York, spending his summers in Sweden. It was at this time that he developed his comic-strip style of painting with elements of collage from different areas of mass-produced culture, and partly including elements of sculpture, such as souvenirs. From 1962 he resumed his literary activities and took part in performances and Happenings with various New York artists. From this time onwards he gave his work the character of alterable collages, variable pictures, whose loose components were equipped with hinges and could be moved about the picture surface with magnets by the spectator. In 1964 he exhibited at the Venice Biennale, and represented Sweden there in 1966. In 1966 he organized Happenings in New York and worked on his writing. His work was included in many international exhibitions of contemporary art. In 1970 he made several so-called "playable" pictures (monopolies). From 1974 he had several one-man shows at the Galerie Buchholz in Munich. In 1975 he joined Erró, Baruchello and Liebig in the exhibition "Let's mix all feelings together" at Munich and Frankfurt. He died in 1976 in Stockholm. In 1979 the Moderna Museet in Stockholm devoted a comprehensive retrospective exhibition to his work.

Joe Goode

Born in 1937 at Oklahoma City. From 1959 to 1961 he studied at the Chouinard Art Institute, Los Angeles. In 1962 he had his first one-man exhibition at the Dilexi Gallery, Los Angeles, and was included in the exhibition "New Painting of Common Objects" at the Pasadena Art Museum. In 1968 he exhibited at the Kornblee Gallery, New York, and had an exhibition with Ed Ruscha at the Newport Art Museum, California. In 1969 he was represented in the touring exhibition "West Coast 1945-1969", organized by the Pasadena Art Museum, which was shown at the Hamburger Kunstverein and the Würtembergischer Kunstverein in 1971. In 1974 he was included in the "American Pop Art" exhibition at the Whitney Museum of American Art, New York. In 1987 he was represented in the POP ART exhibition, shown in different Japanese cities.

Red Grooms

Born in 1937 at Nashville. He studied at the New School for Social Research, the Chicago Art Institute School and the Hans Hofmann School, Provincetown. In 1959 he staged a Happening in New York entitled "The house that burns", a mixture of Disneyland, vaudeville and Punch and Judy show situated somewhere between nostalgic melodrama and impassioned protest. He also collaborated with Claes Oldenburg. In 1961 he produced his first film. In 1966 he was represented at the Venice Biennale. In 1970 he was included in the exhibition "Happening & Fluxus" at the Kunstver-

ein Cologne and at the Württemberischer Kunstverein, Stuttgart.

Raymond Hains

Born in 1926 at Saint-Brieuc. In 1945 he enrolled in the sculpture course at the École des Beaux-Arts, Rennes. In 1945 he collaborated with E. Sougez as a photographer for France-Illustration. In 1946/47 he did his first abstract photographs (Photographies hypnagogiques), which were shown in Paris in 1948. In 1950 he invented the concept of the "Ultra-lettre" and devoted himself to his "lettres éclatées" (shattered letters). In 1957 he exhibited his "torn posters" in Paris. In 1959 he exhibited at the Salon des Réalités Nouvelles and was represented at the first Paris Biennale. In 1960 he exhibited an illustration from the Encyclopédie Clartés at the Salon Comparaisons (he was known as "Raymond the abstract") and travelled to Italy. In 1961 he was represented at the exhibition "Bewogen Beweging", Stedelijk Museum, Amsterdam, also shown at Stockholm and Humblebaek, and at "The Art of Assemblage", Museum of Modern Art, New York, later shown at Dallas and San Francisco. He distanced himself from "Nouveau Réalisme" in 1963. In 1964 he was represented at the Venice Biennale. His "torn posters" were shown at the Galleria Apollinaire, Milan, in 1965. Between 1968 and 1971 he lived in Venice. He showed three very enlarged books of matches at the "documenta 4", Kassel. He returned to Paris in 1971.

Richard Hamilton

Born in 1922 in London. In 1934 he attended evening classes in art. In 1936 he worked in the publicity department of an electrical firm. He studied at Westminster Technical College and the St. Martin's School of Art. In 1937 he worked in the publicity department of the Reimann Studios. From 1938 to 1940 he studied painting at the Royal Academy Schools. He enrolled for a course in technical drawing and worked as a draughtsman from 1941 to 1945. He was readmitted to the Royal Academy

Schools in 1946 but was expelled in the same year as a result of apparently unsatisfactory work. He began his National Service. In 1947 he married Terry O'Reilly. He studied painting at the Slade School of Art, 1948-51. His etchings from this period were exhibited at his first one-man exhibition at Gimpel Fils, 1950. The first exhibition he designed himself was "Growth and Form" at the ICA, London, 1951. In 1952 he became a teacher of silver work, typography and industrial design at the Central School of Arts and Crafts. One of his colleagues there was Eduardo Paolozzi, with whom Hamilton was a founder member of the "Independent Group" at the ICA. This was a group of artists and intellectuals who met to discuss cultural change in the age of technology. In 1953 he became lecturer in the Fine Art Department at the King's College in the University of Durham. In this post he worked with Victor Pasmore and taught a course in basic design which was also attended by art students. In 1955 he exhibited his paintings at the Hanover Gallery, London. His paintings at this time were influenced by Cubism. In the same year he devised and designed the exhibition "Man, Machine and Motion" at the ICA. In 1956 he made his first Pop collage as a design for the poster and catalogue of the exhibition "This is Tomorrow" at the Whitechapel Gallery, which he had helped to organize with other members of the Independent Group. From 1957 to 1961 he taught interior design at the Royal College of Art. In 1960 he was awarded the William and Norma Copley Foundation Prize for Painting. He also published a typographical version of Marcel Duchamp's "Green Box". His wife died in a car accident in 1962. In 1963 he visited the USA for the first time. In 1965 he began his reconstruction of Marcel Duchamp's "Le Grand Verre". He organized the Duchamp retrospective at the Tate Gallery in 1966. His works on the theme of the Guggenheim Museum were also shown at the Robert Fraser Gallery. In 1969 he helped to make a film of his work for the Arts Council. In 1970 he showed his "Cosmetic Studies". He was awarded the Talins Prize Interna-

tional, Amsterdam, 1970. In 1977 and 1978 he collaborated with Dieter Roth at Cadaqués. He was given his first comprehensive retrospective exhibition in 1979 at the Tate Gallery, also shown at the Kunsthalle, Berne. In 1974 he had retrospectives at the Guggenheim Museum, New York, the Städtische Galerie, Munich, and the Kunsthalle, Tübingen. In 1982 his writings, notes and documents were published by Thames and Hudson, London.

David Hockney

Born in 1937 at Bradford. Between 1953 and 1957 he studied at the Bradford School of Art. A conscientious objector, he spent his National Service working in a hospital until 1959. From 1959 to 1962 he studied at the Royal College of Art, London. Here he met R.B. Kitaj and other founders of English Pop Art and saw American Abstract Expressionist paintings. From 1960 he began showing in the "Young Contemporaries" exhibitions at the RBA Galleries and read the Complete Works of Walt Whitman. By 1961 he had done his first "Tea Paintings" and "Love Paintings", painted compositions consisting of consumer goods images and pyschograms. More than any others, these pictures showed his proximity to Pop Art. In 1961 he was represented at the Paris Biennale and awarded the Guiness Award for Etching. He also visited New York for the first time. He taught at Maidstone College of Art in 1962. In 1963 he travelled to Egypt and Los Angeles, where he met Henry Geldzahler, Andy Warhol and Dennis Hopper. He did his first paintings of showers at this time and developed his "Californian" style. From 1963 to 1964 he taught at the University of Iowa. In 1964 he settled in Los Angeles, painted his first swimming-pool pictures and made his first polaroids. From 1965 to 1967 he held teaching posts at the University of Colorado and the University of California, Berkeley. In 1967 he travelled to Italy and France, and in 1968 to Germany and Ireland. He had a retrospective exhibition in London in 1970, also shown at Hanover and Rotterdam. Between 1973 and 1975 he lived in Paris. An exhibition of his works was shown at the Musée des Arts Décoratifs in 1974. He designed the set for Igor Stravinsky's "The Rake's Progress" in 1975. In 1976 he returned to Los Angeles and worked intensively with photography. In 1978 he designed the décor for Mozart's "The Magic Flute", produced at the Glyndebourne Festival, and in 1980 he developed a programme for the Metropolitan Opera with works by Satie, Poulenc, Ravel and Stravinsky. In 1981 he travelled to China, following which his "China Diary" (with Stephen Spender) was published by Thames and Hudson. He designed covers for VOGUE in 1984 and 1985, the set for Wagner's "Tristan and Isolde" at the Los Angeles Music Center in 1986/87, and carpet patterns for a company in 1988.

Robert Indiana

Born in 1928 at New Castle, Indiana, as Robert Clark. Between 1945 and 1948 he studied at art schools in Indianapolis and Utica, and from 1949

to 1953 at the Chicago Art Institute School and the Skowhgan School of Painting and Sculpture, Maine. In 1953 and 1954 he studied at the Edinburgh College of Art and London University, after which he settled in New York. He took up contact with the painters Kelly, Smith and Youngerman. His early works were inspired by traffic signs, automatic amusement machines, commercial stencils and old tradenames. In the early sixties he did sculpture assemblages ("Cuba") and developed his style of vivid colour surfaces, involving letters, words and numbers. In 1966 he had exhibitions in Düsseldorf, Eindhoven (Van Abbemuseum), Krefeld (Museum Haus Lange) and Stuttgart (Württembergische Kunstverein). He was represented at the "documenta 4" exhibition, Kassel, in 1968. He became known for silkscreen prints, posters and sculptures which took the word "LOVE" as their theme. The brash directness of these works stemmed from their symmetrical arrangements of colour and form.

Jasper Johns

Born in 1930 at Augusta, Georgia. He grew up in South Carolina. He was drafted into the army and stationed in Japan. Between 1959 and 1951 he studied at the University of South Carolina, Columbia. From 1952 to 1958 he worked in a bookshop in New York. He also did display work with Robert Rauschenberg for Bonwit Teller and Tiffany. In 1954 he painted his first flag picture. He had his first one-man exhibition in 1958 at the Leo Castelli Gallery, New York. He was represented at the Venice Biennale during the same year. His picture "Grey Numbers" also won the International Prize at the Pittsburgh Biennale. In 1959 he took part with Rauschenberg in Allan Kaprow's Happening "Eighteen Happenings in Six Parts". He was included in the collective exhibition "Sixteen Americans" in the same year at the Museum of Modern Art. In 1960 he began working with lithographs. In 1961 he did his first large map picture and travelled to Paris for an exhibition at the Galerie Rive Droite. In 1964 he was given a comprehensive ret-

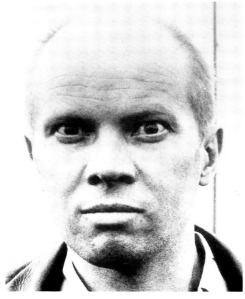

one-man exhibition at the Willard Gallery. His portraits of the fifties were the first Pop Art illustrations of idols. His pictures of these stars (e.g. Elvis Presley) were parodies. He later applied this burlesque technique to pictures of Magritte and Mondrian.

Allen Jones

Born in 1937 at Southampton, studied painting and lithography from 1955 to 1961 at Hornsey College of Art in London, where the teaching method was based largely on Klee's "Pedagogical Sketchbook". During this period he travelled to Provence and to Paris, where he was highly impressed by the work of Delaunay. In 1959 he visited the Musée Fernand Léger in Biot. In 1960 he was expelled from the Royal College of Art, where he had studied with R.B. Kitaj, Peter Phillips, David Hockney and Derek Boshier. Between 1961 and 1963 he taught lithography at Croydon College of Art and drawing at the Chelsea School of Art. His work in the early sixties was influenced by psychology and by his reading of Nietzsche, Freud and Jung. In 1963 he received the Prix des Jeunes Artistes at the Paris Biennale. In 1964 he moved to New York and travelled throughout the USA. In New York Hockney drew his attention to the world of mass-produced consumer goods imagery. He worked on a three-dimensional illusionism with obvious erotic components. In 1969 he made the sculptures "Table Sculpture" and "Hat Stand". From 1968 to 1970 he was Guest Lecturer at the Hochschule für Bildende Künste, Hamburg. In 1969 he was Visiting Professor at the University of South Florida, Tampa. In 1970 he designed the set and costumes for "O Calcutta" in London and for the TV production "Männer, wir kommen" (Westdeutsche Rundfunk). In 1972 he provided costume designs for "The Body Show", ICA, London. In 1973 he was Guest Lecturer at the University of Los Angeles, Irvine. He visited Japan in 1974. He toured Canada in 1975. In 1976 he designed Barbet Schroeder's film "Maitresse". In 1977 he was Guest Lecturer at the University of California, Los Angeles, and in the summer of the same year, Visiting Director of Studies in painting and drawing at the Banff Centre School of Fine Arts in Alberta, Canada. He designed a hoarding in 1978 for the hosiery factory "Fogal" at Basle station. He had a large retrospective exhibition in 1979 at the Walker Art Gallery, Liverpool, also shown at the Serpentine Gallery, London, at Sunderland, Baden-Baden and Bielefeld. From 1982 to 1983 he was Guest Professor at the Hochschule der Künste, Berlin. In 1986 he was made R.A.

Howard Kanovitz

Born in 1929 at Fall River, Massachusetts. Between 1945 and 1951 he studied at the Rhode Island School of Design, Providence. In 1951 he moved into a studio in New York. He did display work for shop windows and became a pupil of Franz Kline. He had his first one-man exhibition in 1962 at the Stable Gallery, New York. From 1963 he based his work on photographic illustrations, and used the spray gun technique from 1967. In 1966 he had a

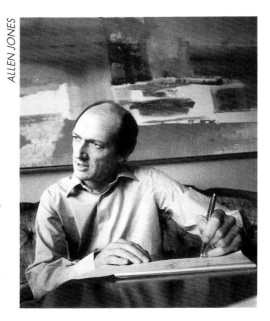

large one-man exhibition at the Jewish Museum, New York. His next large individual exhibition was in 1974 at the Wilhelm-Lehmbruck-Museum, Duisburg. In 1972 he was represented at the "documenta 6", Kassel. He has been shown at various exhibitions in Germany as a protagonist of new aspects of realism. He has a systematic, conceptual approach to realism. He quotes details from the real world, but dislocates them from their spatial environment, thus irritating the viewer's habitual sense of perspective.

Edward Kienholz

Born in 1927 at Fairfield, Washington. He studied at Eastern Washington College of Education and, briefly, at Whitworth College, Spokane, but did not receive any formal artistic training. He earned his living as a nurse in a psychiatric hospital, as the manager of a dance band, as a dealer in second-hand cars, a caterer, decorator and vacuum cleaner salesman. In 1953 he moved to Los Angeles. In 1954 he made his first reliefs in wood. In 1956 he founded the NOW Gallery, and in 1957 the Ferus Gallery with Walter Hopps. In 1961 he completed his first environment "Roxy's", which caused a stir at the "documenta 4" exhibition in 1968. His retrospective at the Los Angeles County Museum of Art in 1966 provoked the County Board of Supervision to attempt to close the exhibition. The theme of his environments is the vulnerability of the private life of the individual to intervention by the environment and social convention. In 1972 he met Nancy Reddin in Los Angeles. In 1973 he was guest artist of the German Academic Exchange Service in Berlin. He moved to Berlin with his wife Nancy. His most important works during this period were the "Volksempfänger" (radio receiving apparatus from the National Socialist period in Germany). Since then he has lived in Berlin and Hope, Idaho, spending six months of the year in each. In 1975 he received a Guggenheim Award. In 1977 he opened "The Faith and Charity in Hope Gallery" with his wife. Since the exhibition "Die Kienholz-Frauen" at the

rospective at the Jewish Museum, New York. The catalogue included texts by John Cage and Alan Solomon. He was represented at the Venice Biennale in the same year. In 1965 he had a retrospective at the Passadena Art Museum, organized by Walter Hopps. During the same year he saw a Duchamp exhibition and won a prize at the 6th International Exhibition of Graphic Art, Ljubljana, Yugoslavia. In 1966 he had a one-man exhibition of drawings at the National Collection of Fine Arts, Washington. In 1967 he rented a loft in Canal Street and painted "Harlem Light" using a tile motif. He also illustrated Frank O'Hara's book of poems "In Memory of My Feelings". He was Artistic Adviser for the composer John Cage and Merce Cunningham's Dance Company until 1972, collaborating with Robert Morris, Frank Stella, Andy Warhol and Bruce Naumann. In that year he was represented at the "documenta 4", Kassel, designed costumes for Merce Cunningham's "Walkaround Time" and spent seven weeks at the printers Gemini G.E.L., Los Angeles. In 1973 he met Samuel Beckett in Paris. He moved to Stony Point, N.Y. He was given a comprehensive retrospective at the Whitney Museum of American Art, New York, in 1977, shown in 1978 at the Museum Ludwig, Cologne, Musée National d'Art Moderne, Paris, Hayward Gallery, London, and Seibu Museum of Art, Tokyo. He was represented at the Venice Biennale in 1978. In 1979 the Kunstmuseum Basle put on an exhibition of his graphic work which toured Europe. In 1988 he was awarded the Grand Prix at the Venice Biennale.

Ray Johnson

Born in 1927 in Detroit. He studied at Black Mountain College from 1945 to 1948. In the fifties he developed the technique of the "moticos" – small photographs mounted on walls and floors to form alienated scenes or environments which, in turn, were documented by means of photography. In 1962 he founded the New York Correspondence School of Art, out of which came "The Marcel Duchamp Club" in 1971. In 1965 he had his first

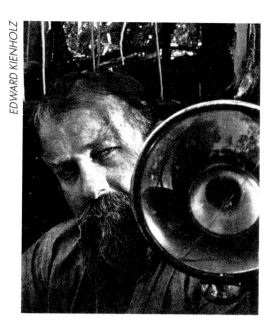

Galerie Maeght in Zurich, 1981, he has authorized his work with his wife, Nancy Kienholz.

R.B. Kitaj

Born in 1932 at Cleveland, Ohio. In 1950 he went to sea on a Norwegian freighter which called at Havanna and Mexico. He studied one term at the Cooper Union for the Advancement of Science and Art in New York. In 1951 he became a merchant seaman and signed on various tankers. He then went to Europe for the first time and studied until 1954 at the Akademie der Bildenden Künste, Vienna, under Albert Paris Gütersloh and Fritz Wotruba. He returned to sea and to New York, travelled through Europe drawing, and spent the winter at the Mediterranean port of Sant Felio de Guixols, Catalonia. He corresponded with Ezra Pound. He served in the American army from 1955 to 1957, following which he studied at Oxford with a G.I. scholarship and from 1960 to 1962 at the Royal College of Art in London. He was a friend of David Hockney at the Royal College and showed in the "Young Contemporaries" exhibitions at the RBA Galleries. Between 1961 and 1967 he taught at Ealing Technical College, at the Camberwell School of Arts and Crafts and at the Slade School. In 1962 he collaborated with Paolozzi and started using collage. In 1963 he had his first one-man exhibition at the Marlborough New London Gallery. In 1964 he was represented at the Venice Biennale and the "documenta 3", in 1968 at the "documenta 4", Kassel. In 1965/66 he visited the USA and was given his first retrospective at the Los Angeles County Museum of Art, shown in 1967 at the Stedelijk Museum, Amsterdam. In the same year he was Guest Professor at the University of California, Berkeley. In 1968 he returned to England and became a friend of Jim Dine. In 1968 a retrospective exhibition of his entire graphic work went on tour to Stuttgart, Munich, Düsseldorf, Lübeck and Bonn and he worked on a project for the exhibition "Art and Technology" at the Los Angeles County Museum of Art. In 1971 he returned to London. He went to Cadaqués to meet

Richard Hamilton. In 1976 he was included in the exhibition "Pop Art in England" shown at Hamburg, Munich and York. In 1978-79 he concentrated entirely on drawing from models in pastel. In 1981 he was represented at the exhibition "A New Spirit in Painting" at the Royal Academy of Arts, London. He also had a large retrospective exhibition of his work from 1958 to 1981 at Washington, Cleveland and Düsseldorf. Kitaj shows the political and social effects of contemporary mass culture in his pictures, partly with reference to historical events and their manipulation and consumption via the mass media.

Roy Lichtenstein

Born in 1923 in New York. In 1939-40 he studied under Reginald Marsh at the Art Students' League, New York, and 1940-43 and 1946-49 at Ohio State University, Columbus, where he completed his studies with an M.A. Between these two periods of study he did his military service in Europe. Between 1949 and 1951 he taught at Ohio State University. In 1951 he had his first one-man exhibition at the Carlebach Gallery, New York. Until 1957 he worked as a commercial artist and designer and did display work for shop windows. His paintings and drawings at this time were parodies of American twenties' art, e.g. Remington's cowboy-and-Indian scenes. From 1957 to 1960 he taught at New York State University, Oswego, New York. His work passed through a non-representational, Abstract-Expressionist phase. In 1960 he became acquainted with Allan Kaprow and Claes Oldenburg. He began to use typical elements of commercial art, comics and advertisements in his drawings and painting. From 1960 to 1963 he taught at Douglas College, Rutgers University, New York. In 1962 he had a one-man exhibition at the Leo Castelli Gallery, New York. In 1963 he moved to New York. He was commissioned by the architect Philip Johnson to produce large format paintings for the New York State Pavilion at the World's Fair in New York and had his first one-man exhibition in Europe at the Galerie Ileana Sonnabend, Paris. He was given his first American retrospective exhibition at the Museum of Modern Art, Cleveland. He was represented at the Venice Biennale in 1966, 1968 and 1970. In 1967/68 he had a retrospective at the Pasadena Art Museum, also shown at Minneapolis, Amsterdam, London Berne and Hanover. He was represented at the "documenta 4" and "5", Kassel, in 1968 and 1972 respectively. In 1969 he was given a retrospective at the Soloman R. Guggenheim Museum, New York. He had a retrospective of his drawings in 1975 at the Centre National d'Art Contemporain, Paris, also shown at Berlin. In 1979 he received his first public commission for a sculpture. He made the "Mermaid" for the Theatre of the Performing Arts, Miami Beach, Florida. He painted the series "American Indians". In 1981 the St. Louis Art Museum organized a comprehensive retrospective of his work which toured the USA, Europe and Japan. In 1982 he rented a loft in New York in addition to his studio in Southampton. In 1985 he produced a mural for the Equitable Center, New

York. In 1987 he had a retrospective of his drawings at the Museum of Modern Art, New York, and at the Kunsthalle, Frankfurt, 1988.

Richard Lindner

Born in 1901 at Hamburg. His mother was American. He grew up in Nuremberg and studied there at the Kunstgewerbeschule. From 1924 to 1927 he lived in Munich and studied there from 1925 at the Kunstakademie. He moved to Berlin and stayed there until 1928 when he returned to Munich to become art director of a publishing firm. He remained here until 1933, when he was forced to flee to Paris, where he became politically engaged, sought contact with French artists and earned his living as a commercial artist. He was interned when the war broke out in 1939 and later served in the French army. In 1941 he went to the USA, worked in New York as an illustrator of books and magazines and made contact with New York artists and German emigrants. In 1948 he became an American citizen. From 1952 he taught at the Pratt Institute, Brooklyn, from 1967 at Yale University School of Art and Architecture, New Haven. In 1965 he became Guest Professor at the Akademie für Bildende Künste, Hamburg. His paintings at this time used the sexual symbolism of advertising and investigated definitions of gender roles in the media.

Marisol

Born as Marisol Escobar in 1930 in Paris of well-to-do Venezuelan parents. In 1949 she studied at the École des Beaux-Arts and the Académie Julian, Paris. In 1950 she moved to New York and continued her studies between 1951 and 1954 at the Hans Hofmann School, Provincetown, and at the Art Students' League, New York. She began to make her sculptures in wood and synthetic materials. In 1958 she had her first individual exhibition at the Leo Castelli Gallery, New York. Her work was represented at the "Festival of Two Worlds", Spoleto. From 1960 she constructed wooden sculptures with casts of human faces and limbs

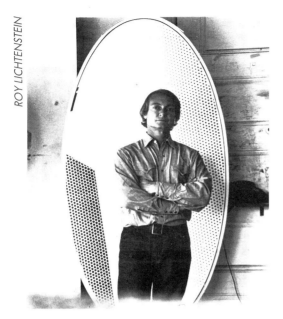

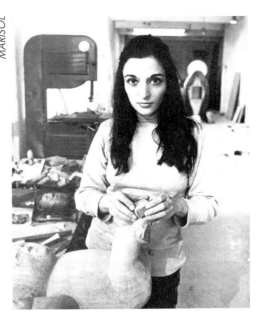

arranged in groups. In 1961 she was included in the "Art of Assemblage" exhibition at the Museum of Modern Art, New York. In 1967 she had an individual show at the Hanover Gallery, London, and was included in the exhibition "American Sculpture of the Sixties". In 1968 she had an individual exhibition at the Boymans van Beuningen Museum, Rotterdam, and was represented at the Venice Biennale. In 1969 her work was included in an exhibition of Pop Art at the Hayward Gallery. She showed at the Moore College of Art, Philadelphia, 1970, at the Art Museum, Worcester, 1971, and at the Cultural Center, New York, 1973.

Claes Oldenburg

Born in 1929 at Stockholm. The son of a Swedish Consul General, he came to Chicago in 1936. After finsihing his studies at Yale University, New Haven, he started work as a reporter. In 1952 he attended a course at the Chicago Art Institute, published drawings in several magazines and began to paint pictures influenced by Abstract Expressionism. In 1956 he moved to New York and came into contact with Jim Dine. In 1958 he met Allan Kaprow and took part in his Happenings. In 1958/9 he arranged his first sculptural, Neo-Dadaist assemblages of plaster and garbage soaked in striking colours. These led to his environments ("The Street", "The Store" etc.). He also started at this time to make replicas of foods like "Hamburgers", ice-cream and cakes, which prepared the ground for his "soft sculptures". From 1965 he designed his "colossal monuments". In 1964 and 1968 he was represented at the Venice Biennale, and in 1968 and 1972 at the "documenta 4" and "documenta 5", Kassel. In 1972 he arranged his "Mouse Museum". A comprehensive retrospective of his projects, documents and sketches was shown at the Museum of Modern Art, New York, in 1969. He was given a retrospective in 1970 by the Stedelijk Museum, Amsterdam. From 1976 he collaborated on large-scale projects with Coosje van Bruggen, whom he married in 1977. He was represented at the "documenta 6", 1977, and

"documenta 7", 1982, at Kassel. He was given a retrospective of his drawings in 1977 by the Moderna Museet, Stockholm, and the Kunsthalle Tübingen. His environment "Mouse Museum/Ray Gun Wing" was arranged in 1979 at the Museum Ludwig, Cologne. In 1983 he made his large sculpture of a toothbrush for the Museum Haus Esters, Krefeld. In 1984 he made his proposals for the large project "The Course of the Knife" for Venice, which was then shown in collaboration with the architect Frank O'Gehry at the Campo dell' Arsenale, accompanied by performances which he took part in himself. He then went on to collaborate with Gehry on other projects related to architecture, e.g. in Boston and Los Angeles. In 1989 the Wilhelm Lehmbruck Museum, Duisburg, organized the exhibition "Claes Oldenburg – Coosje van Bruggen, A Bottle of Notes and Some Voyages".

Eduardo Paolozzi

Born in 1924 at Edinburgh of Italian parents. He studied at the Edinburgh College of Art in 1943. He completed his National Service in 1944. He then studied at St. Martin's School of Art, changing to the Slade School in 1945. In 1947 he had his first one-man exhibition at the Mayor Gallery, London. In the same year he moved to Paris where he met Giacometti, Hélion, Tzara, Arp, Brancusi, Braque and Léger, and was influenced by Surrealism and Dubuffet's "art brut". In 1949 he returned to London and taught textile design at the Central School of Art and Design until 1955. He began to experiment with serigraphic techniques. In 1951 he designed textiles and wallpaper and sculpted a well for the Festival of Britain. In 1952 he was a founder member of the Independent Group at the ICA, London. His slide projections "Bunk", started in 1947, with their collage of cuttings from advertising, comic-strips, design and magazines, provoked a controversial debate which had a considerable influence on the development of Pop Art. In 1952 he showed at the Venice Biennale. In 1953 he made wooden reliefs to hang on a park wall in Hamburg. In 1953 he collaborated with other members of the Independent Group in organizing the exhibition "Parallel of Life and Art" at the ICA. Its themes were the mass media, science and technology and their significance for contemporary art. From 1955 to 1958 he taught at St. Martin's School of Art. In 1956 he was represented in the "This is Tomorrow" exhibition at the Whitechapel Gallery, London. He exhibited sculptures at the Hanover Gallery, London, 1958, and in 1960 at the Betty Pasons Gallery, New York, and the Venice Biennale. He toured Europe in the same year and made the cartoon collage-film "History of Nothing". His robotlike, pseudo-mechanical sculptures began to take on geometrical proportions at the beginning of the sixties. He studied the works of the philosopher Ludwig Wittgenstein. From 1960 to 1962 he was a guest teacher at the Hochschule für Bildende Künstler, Hamburg. In 1964 he showed sculptures at the Museum of Modern Art, New York. In 1967 he received the First Prize for Sculpture at the Carnegie International

Exhibition of Contemporary Painting and Sculpture, Pittsburgh. In 1968 he exhibited at the Rijksmuseum Kröller-Müller, Otterlo, and in 1969 his work was shown at Düsseldorf and Stuttgart. In 1968 he was a guest teacher at the University of California, Berkeley, and he also taught in the Ceramics Department at the Royal College of Art, London. In 1971 the Tate Gallery devoted a comprehensive retrospective to his work. In 1974 he went to Berlin on the artists' exchange scheme; of the DAAD, where he was given a comprehensive retrospective in 1975. From 1977 to 1981 he was Professor of Ceramics at the Art and Design Department of the Fachhochschule, Cologne. In 1981 he became Professor of Sculpture at the Akademie der Bildenden Künste, Munich. In 1986 he was made "Her Majesty's Sculptor in Ordinary for Scotland" by the Queen.

Peter Phillips

Born in 1939 at Birmingham. From 1953 to 1955 he studied at Moseley Road Secondary School of Art, Birmingham, from 1955 to 1959 at the Birmingham College of Art. In 1959 he visited Paris and started to exhibit at the RBA Galleries, London. Between 1959 and 1962 he studied at the Royal College of Art, London, with Kitaj, Jones, Boshier, Caulfield and Hockney. There he saw reproductions of work by Jasper Johns and Robert Rauschenberg. He was particularly aligned to American culture and reflected its commercial iconography and aggressive advertising style in his dynamic montage paintings. From 1962 to 1963 he taught at the Coventry and Birmingham Colleges of Art. In 1963 he was represented at the Paris Biennale, and in 1964 his work was included in the "Pop Art" exhibition shown at the Hague, Vienna and Berlin. From 1964 to 1966 he lived in New York and travelled in the USA with Allen Jones. In 1965 he had his first one-man exhibition at the Kornblee Gallery, New York. From 1968 to 1969 he was guest teacher at the Hochschule für Bildende Künste, Hamburg. He travelled in Africa, the Far East and the USA. In 1972 he had a retrospective at the Westfälischer

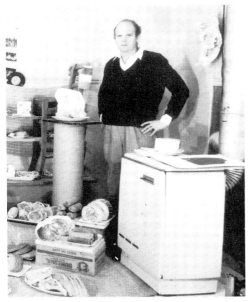

Kunstverein, Münster, and in 1976 at the Tate Gallery, London. In 1981 he visited Australia. In 1982-3 he had a retrospective which was shown at six British museums.

Mel Ramos

Born in 1935 at Sacramento, California. Between 1954 and 1958 he studied at the Sacramento City College, the San José State College and the Sacramento State College, finishing with an M.A. From 1958 he taught at various institutions including Elk Grove High School, Mira Loma High School and California State College. In 1962/63 he began a series of garishly coloured super-heroes taken from comic strips using a thick oleaginous pigment. In 1963 he was first included in a collective exhibition in "Pop Goes the East" at the Contemporary Art Museum, Houston. In 1964 he had his first one-man exhibition at the Bianchini Gallery, New York. In 1965 he developed a specific kind of Pop Art iconography by combining nude pin-up girls from American magazines and advertisements with branded products. In 1966 he exhibited at the Galerie Ricke, Kassel. In 1969 he was represented in the exhibition "Human Concerns" at the Whitney Museum, New York, and had a one-man show at the "Gegenverkehr", Aachen. He exhibited at the Utah Museum of Fine Arts, Salt Lake City, in 1972, and was represented at the "Pop Art" exhibition at the Whitney Museum, New York, in 1974. In 1975 he had a retrospective at the Museum Haus Lange, Krefeld, and in 1977 at the Oakland Museum, California. In 1978 he was included in the exhibition "Art about Art", Whitney Museum, New York. Since 1980 he has taught painting at California State University, Hayward.

Robert Rauschenberg

Born 1925 at Port Arthur, Texas. In 1942 he studied pharmacy briefly at the University of Texas, following which he served in the U.S. Marines. From 1947 to 1948 he studied various subjects at the Kansas City Art Institute, including art history, sculpture and music. During this time he did window displays, executed film sets and designed photographic studios. In 1948 he attended the Académie Julian, Paris, met Susan Weil, who was later to become his wife, and returned to the USA to study under Joseph Albers at the Black Mountain College, North Carolina. There he met the choreographer Merce Cunnnigham and the composer John Cage in 1949 and collaborated closely with both of them from then on. In the same year he moved to New York and studied at the Art Students' League until 1952. He did window displays for Bonwit Teller and Tiffany, had his first one-man exhibitions in 1951 and returned to Black Mountain College in 1952. Here he met Buckminster Fuller, Robert Motherwell and Franz Kline. He travelled with Cy Twombly in Italy, France and Spain and had an exhibition in 1953 at Florence and Rome. He moved into a studio in New York in the same year and started to paint his red pictures, replacing the all-white and all-black paintings. He erased a drawing by Willem de Kooning. Between 1954 and 1965 he intensified his work for the Merce Cunningham Dance Company. In 1955 he moved into a studio in the same neighbourhood as Jasper Johns. In 1958 he had his first exhibition at the Leo Castelli gallery and began his drawings to illustrate Dante's "Inferno". He also organised a retrospective with Jasper Johns for John Cage. In 1959 he was represented at the "documenta 2", Kassel, and at the Paris and São Paulo Biennales. In 1960 he met Marcel Duchamp. In 1962 he first used the technique of silkscreen on canvas, mixed with painting, collage and affixed objects (Combines). He also did his first lithographic work, for which he was awarded the Grand Prix at Ljubljana. In 1963 he was given his first retrospective exhibition in Europe at the Galerie Sonnabend, Paris, also shown at the Jewish Museum, New York. He produced his first dance performance "Pelican". In 1964 he had a retrospective at the Whitechapel Gallery, London, and won the Grand Prix at the Venice Biennale. He went on world tour with Cage and Cunningham's Dance Company. He had his first exhibition in Germany at the Museum Haus Lange, Krefeld. In 1967 he made his "Revolvers" – with revolving plexiglass discs. In 1967 he worked at the art printer's Gemini. That year (the same year as Martin Luther King) he was made honorary doctor of Grinnel College, Iowa. In 1968 he was invited by NASA to witness the liftoff of Apollo 11 at Kennedy Space Center and to use the theme in his work. He set up the foundation "Change Inc." for destitute artists in 1970, and a house with art studios in Florida in 1971. In 1974 he collaborated with the writer Alain Robbe-Grillet. He also travelled to Israel, where he had an exhibition at Jerusalem. In 1975 he travelled to India, received the Honorary Degree of Fine Arts from the University of South Florida, Tampa, and, together with James Rosenquist, became involved in appealing for a re-examination of taxation for non-profitmaking art institutions. A large retrospective of his work was shown in several American cities from 1976-78. In 1980 he had retrospectives at Berlin, Düsseldorf, Humblebaek/Copenhagen, Frankfurt, Munich and London. In 1981 his

photographs were shown at the Centre Pompidou, Paris. He lives in New York City and on Captiva Island, Florida. In 1989 his work went on world tour, including an exhibition in Moscow.

Gerhard Richter

Born in 1932 at Dresden. Between 1949 and 1952 he worked as an advertisement and stage painter in Zittau. He studied at the Academy of Fine Arts, Dresden, from 1951 to 1956. In 1961 he moved to Düsseldorf. From 1961 to 1963 he studied under K.O. Götz at the Academy of Fine Art, Düsseldorf. He exhibited with Konrad Lueg in 1963 at the furniture department store Berges, Düsseldorf. In 1964 he had exhibitions at the Galerie Heiner Friedrich, Munich, Galerie Alfred Schmela, Düsseldorf, and Galerie René Block, Berlin. From 1962 onwards he used amateur photographs, advertisements and book and magazine illustrations as models for his photographic realism, and used his own photographs from 1968. In 1967 he was guest teacher at the Hochschule der Bildenden Künste, Hamburg, and won the Kunstpreis Junger Westen, Recklinghausen that same year. He was a school art teacher from 1968 to 1969. From 1971 he was a professor at the Academy of Fine Art, Düsseldorf. In 1971 he was given a retrospective at the Kunstverein für die Rheinlande und Westfalen. In 1972 he showed his photographic technique at Utrecht. In 1972 he was represented at the Venice Biennale with "48 portraits", which subsequently went on tour. From 1972 to 1987 he was represented at the "documenta" exhibitions "5", "6", "7" and "8". In 1974 he exhibited his "grey paintings" at the Städtisches Museum, Mönchengladbach. In 1976 he had retrospectives in Brussels and Bremen, and another retrospective in 1977 at the Centre Pompidou. In 1978 his "abstract paintings" were shown at the Stedelijk Van Abbemuseum, Eindhoven. He also became guest teacher at the Nova Scotia College of Art and Design, Halifax, Canada. Between 1978 and 1981 he exhibited in London, New York, Rome, Essen, Eindhoven and Düsseldorf.In 1985 he won the Oskar Kokoschka

Prize, Vienna. In 1986 the Kunsthalle Düsseldorf organized a retrospective of Richter's complete work (with inventory and catalogue), which was later shown at Berlin, Berne and Vienna.

Larry Rivers

Born in 1923 in the Bronx, New York, as Larry Grossberg. His father was a plumber, later owning a small forwarding agency. In 1940 he began a musical career as a jazz saxophonist and changed his name to Larry Rivers. In 1943 he was declared medically unfit for military service. Until 1945 he worked as a saxophonist in various jazz bands in the New York area. In 1944-45 he studied theory of music and composition at the Juilliard School of Music, New York. His first encounter with fine art was through a musical motif based on a painting by Georges Braque. He began painting in 1945. In 1946 he moved to an appartment in Manhattan, met poets, painters and dancers. In 1947-48 he studied at the Hans Hofmann School. In 1948 he studied under William Baziotes at New York University and met Willem de Kooning. In 1949 he had his first one-man exhibition at the Jane Street Gallery, New York. In 1950 he travelled to Europe and spent eight months in Paris. He painted and wrote poetry. On his return he met Helen Frankenthaler. In 1951 he graduated in art from New York University and met Jackson Pollock. His works were subsequently shown by John Myers until 1963. In 1952 he designed the stage set for Frank O'Hara's play "Try! Try!". In 1953 he completed "Washington Crossing the Delaware". In 1954 he had his first exhibition of sculptures at the Stable Gallery, New York. In 1955 the Museum of Modern Art, New York, bought "Washington Crossing the Delaware". In 1956 he began a series of large-format paintings and was included with ten other American artists in the "IV. Bienal Do Museu de Arte Moderna de São Paulo", Brazil. In 1957 he made his first sculptures from soldered metal. He collaborated with Frank O'Hara in 1959 on the series "Stones". He won $32,000 in the TV-show "The $64,000 Question". In 1958 he spent a month

in Paris and played in various jazz bands. He also collaborated with the poet Kenneth Koch on the collection of picture-poems "New York 1959-1960". In 1961 he married Clarice Price, an art and music teacher of Welsh extraction. He lived in Paris until 1962 and collaborated with Jean Tinguely, who had a neighbouring studio. In 1965 he had his first comprehensive retrospective in five important American museums. His final work for this exhibition was "The History of the Russian Revolution". Until 1967 he was in London collaborating with Howard Kanovitz. In 1967 he became separated from Clarice Price. He travelled in Central Africa and made the TV-documentary "Africa and I" with Pierre Gaisseau. In 1969 he began to use spray cans, in 1970 the air brush, and later, video tapes. In 1972 he taught at the University of California in Santa Barbara. In 1973 he had exhibitions in Brussels and New York. In 1974 he finished his Japan series. In 1975 he travelled to Africa and, in 1976, to the Soviet Union, where he held lectures on contemporary American art. He was represented at the "documenta 6", Kassel, in 1977. In 1978 he began his "Golden Oldies Series", revising his own works of the fifties and sixties. In 1980/81 he was given his first European retrospective at Hanover, Munich and Berlin.

James Rosenquist

Born in 1933 at Grand Forks, North Dakota. His family moved to Minneapolis in 1944. In 1948 he began his studies of art at the Minneapolis Art Institute. In 1953 he continued his studies of painting at the University of Minnesota. He earned his living as a painter of industrial plant and petrol stations in different States. In 1954 he received his first contracts to paint billboards. He travelled to Cuba and became interested in the Impressionists and Old Masters exhibited in the Chicago Art Museum. In 1955 he had a scholarship to go to the Art Students' League, New York, where he met George Grosz, Robert Indiana and Nicholas Krushenik. During this period he painted small format abstract paintings and worked part-time as a driver. In 1957 he met Jasper Johns, Ellsworth Kelly, Agnes Martin and Robert Rauschenberg. He also rented a studio on Broadway and intensified his work as a billboard painter. In 1959 he was in the same drawing class as Claes Oldenburg and Robert Indiana and was made "head painter" by the Artcraft Strauss Corporation. He gave up billboard painting in 1960. He married the textile designer Mary Lou Adams. In the same year he rented a loft in the neighbourhood of Robert Indiana and Ellsworth Kelly, did window displays for Bonwit Teller and Tiffany and began to paint over transparencies with garish, neon-like luminous paints and advertising iconography, producing perspective gradation in an optically constructed pictorial panorama. During the election he produced the picture "President Elect" in which John F. Kennedy's face is combined in a kind of collage with sex and automobile imagery. In 1961 Richard Bellamy, Leo Castelli, Henry Geldzahler, Ivan Karp and Ileana Sonnabend visited his studio. His first one-man exhibition, in the Green Gallery, in

1962, was sold out. In 1963 he obtained a commission for a mural for the New York State Pavilion at the World's Fair. He also worked on several sculptures during this period, had a number of exhibitions at the Galerie Ileana Sonnabend, showed his work at the Dwan Gallery, Los Angeles, and taught at Yale University. In 1965 he began to work with lithographs. In the same year he made the 26 metre-wide picture "F-111", which was shown at the Jewish Museum, New York, at Moderna Museet, Stockholm, and in other European cities. He travelled to Leningrad via Stockholm. In 1966 "F-111" continued to be shown in various museums. With Jasper Johns, Ed Reinhardt and Clement Greenberg he travelled to Tokio for the opening of the exhibition "Two Decades of American Painting", organized by the Museum of Modern Art, and remained in Japan for a month, returning via Alaska, Sweden and Paris. "F-111" is one of his most important works. The spatial organization of the composition into layers suggests the interrelationship of contemporary historical symbols and signs of affluence and military hardware, a vision of American culture expressing the proximity of euphoria and catastrophe. In 1967 he moved to East Hampton. In 1968 he was given his first retrospective by the National Gallery of Canada, Ottowa. In 1969 he turned his attention to experimenting with film techniques. In 1970 he went to Cologne for the opening of his exhibition at the Galerie Rolf Ricke. In 1971 he experimented with video and lived in London, working on lithographs for the Petersburg Press. During the public protest against the Vietnam War he was briefly detained in Washington. During the same year he had comprehensive retrospectives at the Wallraf-Richartz Museum, Cologne, and the Whitney Museum, New York. In 1973 he rented a studio in Florida. In 1974 and 1975 he lobbied the Senate on the legal rights of artists. He became separated from his wife and designed his own house with an open-air studio at Indian Bay, Aripeka, Florida. In 1977 he bought a building in downtown New York. In 1978 "F-111" was exhibited in the International

began to work on his drawings of handwriting. He produced further books and the silk-screen print "Hollywood". In 1969 he published the folder "Stains", his first use of organic substances. He taught printing and drawing at the University of California, Los Angeles. For the 1970 Venice Biennale he made the "Chocolate Room", which consisted of 360 sheets of paper printed by silkscreen with chocolate and stuck to the entire wall-surface of a room. He made the film "Premium", and in 1975, the film "Miracle". In 1976 he built himself a house in the desert. In 1978 he produced the book "Hard Light" with Lawrence Weirner. In 1979 he painted his first wide-screen pictures. In 1982 the San Francisco Museum of Modern Art put on the exhibition "I Don't Want No Retrospective – The Works of Edward Ruscha". In 1984 he acted the part of the director of a radio station in the film "Choose Me". In 1985 he obtained a commission for a mural for the Miami Dade Public Library and made eight panels with the words "Words Without Thoughts Never to Heaven Go". He has had comprehensive retrospectives in Lyon, Nassau and Münster.

Pavilion at the Venice Biennale. In his work of the late seventies and eighties, e.g. "4 New Clear Women", 1983, images of women are confronted with machine aesthetics, usually in large oblong compositions. The themes of these dynamic compositions also include fire, progress and war machinery which he shows in rotating pictorial narratives. Between 1985 and 1987 Rosenquist's entire development as an artist was shown in a comprehensive retrospective at six American museums.

Edward Ruscha

Born in 1937 at Omaha, Nebraska. In 1942 he moved to Oklahoma City. Inspired by a friend, he began to draw comics of everyday life in 1947. In 1948 he took painting lessons from a portraitist. In 1949 he made his first visit to California. From 1953 to 1956 he took art classes at high school and showed a keen interest in printing techniques and typography. He read books on Dadaism. In 1955 he went to Mexico City. He took courses in graphics in Los Angeles and studied at the Chouinard Art Institute and the school for Walt Disney illustrators. In 1957 he was impressed by the work of Jasper Johns and and Robert Rauschenberg. He studied book printing in 1959. In 1960-61 he worked for an advertising agency. In 1961 he made reliefs in wood, book objects, collages and photographs. He also travelled in Europe. In Paris he took many photographs of street scenes, but hardly took notice of the fine arts. He made his first pictures using words ("Honk", "Radio", "Olof"). In 1962 he completed his first picture using three-dimensional lettering ("Large Trademark with Eight Spotlights"). In 1963 he published his book "Twenty-six Gasoline Stations". He met Marcel Duchamp at the Duchamp Retrospective at the Pasadena Art Museum. In 1964 he began his drawings of words on strips of paper. In 1965 his book "Some Los Angeles Apartments" was published. For two years he designed the layout for the art magazine Artforum, using the pseudonym Eddie Russia. In 1966 his book "Every Building on the Sunset Strip" was published. He

George Segal

Born in 1924 in New York. His father was of Russian and Polish extraction and owned a butcher's shop in the Bronx. In 1940 his family moved to South Brunswick, New Jersey. He remained in New York, studied in 1941-42 at the Cooper Union of Art and Architecture in Manhattan, worked on his father's poultry farm, and obtained his diploma in 1944. From 1942 to 1946 he studied philosophy, history and literature part-time at Rutgers University, New Brunswick. In 1946 he married Helen Steinberg. In 1947-48 he studied at the Pratt Institute of Design, Brooklyn, and in 1948/49 at the educational faculty of the New York University, graduating with with a Bachelor of Science in art education. Among his fellow students were Larry Rivers and Alfred Leslie. In 1949 he bought his own poultry farm. He spent six months building the sheds for his hens – which he uses today as an atelier. In 1953 he met Allan Kaprow, who was teaching at Rutgers University. He organized an exhibition for Hans Hofmann's students. From 1955 he taught at Highland Park Community Center. In 1956 he had his first one-man exhibition at the Hansa Gallery. In 1957 he was represented at the exhibition "The New York School: Second Generation" at the Jewish Museum, New York. In 1958 he turned his attention to sculpture, experimenting with plaster, burlap and wire mesh. During the same year Allan Kaprow staged his first Happening on Segal's farm. He taught commercial art at Piscataway High School. In 1959 he took part in Allan Kaprow's 18 Happenings at the Reuben Gallery. He also exhibited in Richard Bellamy's new Green Gallery, New York. In 1961 he taught painting at New Brunswick. He discovered the technique of using medical bandages as material for his art and used himself as a model for "Man at a table", his first plaster cast using bandaging. His wife applied the plaster-soaked dressings according to his instructions. From 1961 to

1964 he taught at Roosevelt Junior High School. In 1963 he received a Master of Fine Arts from Rutgers University and travelled in Europe. In Paris he met Alberto Giacometti. He was represented at the VII. São Paulo Biennale, Brazil, in the same year, and exhibited at the Galerie Ileana Sonnabend, Paris. In 1964 he taught at Hunter College. In 1968 he had his first one-man museum exhibition at the Museum of Contemporary Art, Chicago, and was represented at "documenta 4", Kassel. He designed a Lincoln Center Poster for the New York City Ballet. In 1968 and 1969 he taught visual art and sculpture at Princetown University. His "Cinema" was shown at the Hayward Gallery during the "Pop Art" exhibition in 1969. His work tended increasingly towards the portrayal of autobiographical scenes. In 1970 he was awarded the degree of honorary doctor at Rutgers University. In 1971-72 he had a retrospective at Zurich, Munich, Cologne, Rotterdam, Paris, Leverkusen and Tübingen. In 1972 he was Associate Guest Professor at City University, New York. In 1973 he received a commission from the Tel Aviv Foundation for Literature and Art, Israel, to produce a work on the theme "The sacrificing of Isaac". He also received other commissions at this time. He visited the USSR on a cultural exchange programme as an American specialist. In 1977 he worked on a sculpture for the Franklin D. Roosevelt monument in Washington. In 1978 he was given a comprehensive retrospective at Minneapolis, San Francisco and New York. In 1979 he published a pamphlet on plaster cast technique in Rome which was brought out by the Metropolitan Museum of Art. In 1981 he travelled to China and Japan. In 1982 a retrospective of his work toured Japan. In 1983 he designed a cover for Time magazine. He visited Egypt and Israel. He was the winner of a competition for the design of a Holocaust memorial.

Richard Smith

Born in 1931 at Letchworth, Hertfordshire. He studied at the Luton School of Art, London, 1948-

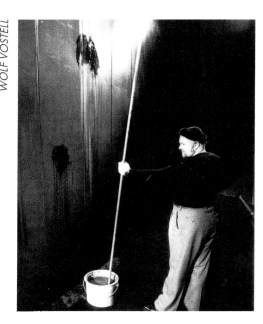

an artist in 1947, he worked as a sign painter, cartoonist, commercial artist, illustrator, designer and publicity manager in New York and California. From 1942 to 1945 he served in the Air Force and painted murals for the army. In 1949-50 he studied at the San José State University and from 1950 to 1953 at the California State University, Sacramento. In 1951 he had his first one-man exhibition at the Crocker Art Gallery, Sacramento, California. From 1954 to 1957 he produced eleven educational films, for which he won the Scholastic Art Prize in 1961. From 1951 to 1961 he taught at Sacramento City College, and from 1960 to 1976 at the University of California, Davis. He has had many exhibitions in the USA, including one at the Walker Art Center, Minneapolis, Minnesota, in 1981. In 1972 he was in the "documenta 5", Kassel. Using oleaginous pigment and the over-emphatic colours and well-defined shadows of advertisements, he paints everyday imagery – usually sweet and creamy cakes and pastries – whose sensuous attraction is reduced to absurdity by the conceptual and illusionistic structures of his painting.

Joe Tilson

Born 1928 in London. From 1944 to 1946 he worked as a carpenter and cabinet maker. He served in the R.A.F. from 1946 to 1949. From 1949 to 1959 he studied at St. Martin's School of Art. He participated in the "Young Contemporaries" exhibitions at the RBA Galleries from 1950. Between 1951 and 1959 he studied at the Royal College of Art, London. He received a travel award to go to Rome in 1955, and travelled widely in Italy and Spain until 1957. From 1958 to 1963 he taught at St. Martin's School of Art, London. In 1960 he received an award from the Gulbenkian Foundation. In 1961 he was represented at the Paris Biennale. In 1962 he had his first one-man exhibition at the Marlborough Gallery, London. He was Guest Lecturer at the Slade School, London, and at King's College in the University of Durham, Newcastle upon Tyne, 1962-63. His typographical compositions combined visual symbols and words in an unusual manner (combination pictures). In 1965 he won first prize at the International Exhibition of Graphic Art, Ljubljana. In 1966 he lectured at the School of Visual Arts, New York. He was Guest Lecturer at the Hochschule für Bildende Künste, Hamburg, 1971-72. Between 1973 and 1975 he had retrospectives at Rotterdam and Parma.

Wolf Vostell

Born 1932 at Leverkusen. Between 1950 and 1953 he studied photolithography. In 1954-55 he studied painting and typography at Wuppertal, and painting, graphic art and anatomy at the École des Beaux-Arts, Paris. He noticed the word "décollage" in connection with a plane crash on the front cover of the FIGARO. He used the term to refer to the process of tearing down posters, and for the use of mobile fragments of reality. During this period, he got to know the composer Karlheinz Stockhausen. In 1957 he studied at the Düsseldorf Academy, at the same time engaging in studies of

the Talmud and iconographic investigations of the paintings of Hieronymous Bosch. From 1958 he organized his "décoll/age happenings". He also studied the psychology of C.G. Jung and travelled to Spain. In 1960 he married Dona Mercedes Guardado Olivenza. In 1962 he was one of the founders of FLUXUS in Wiesbaden. The first FLUXUS Festival was held at Wiesbaden, later going on tour to Copenhagen and Paris. From 1963 to 1965 he had one-man exhibitions and organized Happenings in New York. In 1964 he carried out the first FLUXUS events and Happenings at the Galerie Block, Berlin. The largest and most complex Happening, lasting for six hours in twenty-four places, was held in Ulm. In 1965 he published the documentary volume "Happening, Fluxus, Pop Art, Neuer Realismus" with Jürgen Becker. In 1966 he carried out the Happening "Dogs and Chinese not allowed" in New York, which lasted 14 days, took place all over New York and used the entire subway network. He was also given a retrospective by the Kölner Kunstverein. In 1968 he founded LABOR with Kagel, Feussner and Heubach. In the same year he realized the "Electronic Décoll/age Happening Space" which was shown in Nuremberg and in a special exhibition at the Venice Biennale. In 1969 he founded the "Kombinat 1" in Cologne and made his first car set in concrete. In 1971 he moved to Berlin. In 1972 the Neuer Berliner Kunstverein commissioned him to make the film "Désastres", in which a sleeping-car and bodies were set in concrete. In 1974 he had his first large retrospective in the ARC 2 at the Musée d'Art Moderne de la Ville de Paris, an expanded version of which was shown at the Nationalgalerie, Berlin, in 1975. In 1976, the Museo Vostell Malpartida was founded. He was included in the "documenta 6", Kassel, in 1978. In 1978-79 he was given three large retrospectives in Spain. In 1981 he created a mobile museum in Nordrhein-Westfalen in the form of a "FLUXUS TRAIN", consisting of containers with environments. The train stopped at 15 stations.

50. After doing National Service in the Royal Air Force stationed in Hong Kong, 1950-52, he studied at St. Alban's School of Art, 1952-54. He became acquainted with the theories and writings of Marshall McLuhan and took an interest in packaging design, consumer goods imagery and the mass media. From 1954 to 1957 he taught at the Royal College of Art, London. He began showing in the "Young Contemporaries" exhibitions at the RBA Galleries in 1954. In 1957 he travelled in Italy and visited New York for the first time. From 1957 to 1958 he taught at the Hammersmith College of Art, London. Between 1959 and 1961 he visited the USA on a fellowship. There his own paintings of colour surfaces were influenced by the Colour Field painters. In 1961 Richard Bellamy gave him his first one-man exhibition at the Green Gallery, New York. To understand more about the distortions of reality produced by the cinema, he made the film "Trailer" in 1962. Returning to England, he taught at St. Martin's School of Art, London. From 1963 to 1965 he lived in New York again. He taught at Aspen, Colorado, at the University of Virginia, Charlottesville, and at the University of California, Irvine, and in 1976 at Davis. In 1966 the Whitechapel Gallery, London, gave him a retrospective exhibition. In the same year he was represented at the Venice Biennale and, in 1967, won the Grand Prix at the São Paulo Biennale. He was painting large abstract canvases in strong colours suggesting everyday imagery. He often turned these into three-dimensional, sculptural works. In 1972 he was awarded the C.B.E. In 1976 he settled in New York. In 1976 he was given a comprehensive retrospective by the Tate Gallery, London, a reconstruction of six previous shows, starting in 1961. In 1977 he was given a show at the Massachusetts Institute of Technology, which was also shown in several other American cities. Since then he has had several other national and international exhibitions.

Wayne Thiebaud

Born in 1920 at Mesa, Arizona. Before becoming

Andy Warhol

Born in 1930 at Pittsburgh of Czechoslovak immigrant parents. In 1954 he left school with a high school diploma. Between 1945 and 1949 he studied pictorial design and art history, sociology and psychology at the Carnegie Institute of Technology, Pittsburgh. Met Philip Pearlstein and moved to New York with him in 1949. He worked for "Vogue" and "Harper's Bazaar", did window displays for Bonwit Teller and his first advertisements for the I. Miller shoe company. In 1952 he had his first one-man exhibition at the Hugo Gallery, New York. He designed stage sets, dyed his hair straw-blond and moved into a house in Lexington Avenue with his mother and several cats. In 1954 he was in a collective exhibition at the Loft Gallery, New York. In 1956 he had an individual exhibition of his drawings for "Boy Book" at the Bodley Gallery, and his "Golden Shoes" were exhibited in Madison Avenue. He travelled in Europe and Asia. In 1960 he made his first pictures based on comic-strips and company trade names. In 1962 he produced his silkscreen prints on canvas of dollar notes, Campbell's Soup Cans, Marilyn Monroe, etc. He was also included in the exhibition "The New Realists" at the Sidney Janis Gallery, New York, and started his series of disaster pictures: "Car Crash", "Suicide" and "Electric Chair". Between 1962 and 1964 he produced over 2,000 pictures in his "Factory". In 1963 he made the films "Sleep" (6 hours long) and "Empire" (8 hours long). In 1964 his "Flower Pictures" were exhibited at the Galerie Sonnabend, Paris. He was also forced for political reasons to paint over his "Thirteen Most Wanted Men" which he had attached to the wall of the New York State Pavilion for the World's Fair in New York. He made his first sculptures with affixed silkscreen prints of company cartons. In 1965 he had an exhibition at the Institute of Contemporary Art, Philadelphia. Between 1966 and 1968 he made several films with the band "Velvet Underground". His "Cow Wallpaper" and "Silver Pillows" were shown at the Leo Castelli Gallery. In 1968 he had an exhibition at the Moderna Museet, Stockholm. In July of the same year he was shot down, and dangerously wounded, by Valerie Solanis, the only member of S.C.U.M. (The Society for Cutting Up Men). In 1968 he brought out his novel "a", which consisted of telephone calls recorded in his Factory. He made his first film for the cinema, "Flash", with Paul Morissey, followed by "Trash" in 1970. In 1969 the first number of the magazine "Interview" appeared, which Warhol helped bring out. Between 1969 and 1972 he was commissioned to do a number of portraits. In 1972 he showed at the Kunstmuseum, Basle. The first edition of his book "THE Philosophy of Andy Warhol (From A to B and Back Again)" was published in 1975. In 1976 the Württembergischer Kunstverein showed "The Graphic Work – 1942-1975", also shown at Düsseldorf, Bremen, Munich, Berlin and Vienna. In 1978 he showed at the Kunsthaus, Zurich, and at the Louisiana Museum, Humblebaek. The Whitney Museum of American Art, New York, showed "The Portraits of the 70s" in 1979. In 1980 he became production manager of the cable TV station "Andy Warhol's TV". In the same year "Joseph Beuys by Andy Warhol" was shown at the Centre d'Art Contemporain, Geneva, he showed "Ten Portraits of Jews of the Twentieth Century" at the Lowe Art Museum, University of Miami, and at the Jewish Museum, New York, and "POPism, The Warhol '60s" was published. In 1981 the exhibition "Andy Warhol – Paintings 1961-1968" was shown at the Kestner-Gesellschaft, Hanover, and at the Städtische Galerie im Lenbachhaus, Munich. The Museum des 20. Jahrhunderts, Vienna, showed "Warhol '80". From 1982 to 1986 he made pictures of disasters. In 1982 he exhibited a series of oxidations and pictures of Nazi architecture at the "documenta 7" exhibition. He exhibited "Guns, Knives, Crosses" at the Leo Castelli Gallery, New York, and at the Galeria Fernando Vijande, Madrid. He exhibited "Warhol's Animals: Species at Risk" at the American Museum of Natural History, New York, and at the Cleveland Museum of Natural History, Cleveland. In 1986 he made portraits of "Lenin" and self-portraits. In 1987 he died as the result of an operation. In 1988 the Hamburger Kunstverein showed Death Pictures. In 1989 the Museum of Modern Art, New York, organized the hitherto largest retrospective exhibition of his work. His estate was auctioned at Sotheby's. His will provided for an endowment fund for the patronage of art.

Tom Wesselmann

Born in 1931 at Cincinnati, Ohio. After studying psychology at the University of Cincinnati, he studied at the Art Academy of Cincinnati, 1955-56, and from 1956 to 1959 studied under Nicolas Marsicano at the Cooper Union School of Art and Architecture, New York. He was painting in the style of Abstract Expressionism, influenced by de Kooning. In 1959 he turned to experimenting with small, abstract collages. In 1960 he changed to painting objects and landscapes. He had his first one-man exhibition at the Tanager Gallery, New York, in 1961. In 1962 he participated in the exhibition "The Figure" at the Museum of Modern Art, New York.

In 1963 he was included in "Pop Goes the East" at the Contemporary Arts Museum, Houston, and in 1965 in the "Young America 1965" exhibition at the Whitney Museum, New York. He was represented at the São Paulo Biennale, 1967, and at the "documenta 4" and "6", Kassel, in 1968 and 1977 respectively. His exhibition "Early Still-Lifes 1962-1964" began its tour of the USA at Balboa, California, in 1970. In 1974 his exhibition "The Early Years: Collages 1959-62" toured the USA. In the same year he was included in the exhibition "American Pop Art", Whitney Museum, New York, and in "Illusions of Reality" at the Art Gallery of New South Wales, Sydney, in 1976. His work started with brash collages, assemblages and environments using commonplace commodity articles and modelled on advertising catalogues – usually combined with the exhibitionistic pose of a female body. In the course of his work on the series "Great American Nudes" he enlarged the format of his canvases.

H.C. Westermann

Born in 1922 at Los Angeles. In 1940 he went to Los Angeles City College. In 1941/42 he worked as a woodcutter, stone mason and carpenter. Between 1942 and 1946 he served in the U.S. Marine Corps. In 1946-47 he worked as an acrobat and toured the Orient. He studied commercial art, 1947-52, and painting, 1952, at the Art Institute of Chicago. Fought in the Korean War. In 1954 he made his first sculptures. He had his first one-man exhibition in 1956. In 1959 he was included in the exhibition "New Images of Man" at the Museum of Modern Art, New York. In 1968 he was given a retrospective at the Los Angeles County Museum of Art and the Museum of Contemporary Art, Chicago. He was represented at the "documenta 4" and "5". In 1973 he won the Grand Prix at the São Paulo Biennale. In 1976 he showed at the Venice Biennale. In 1978-79 he had a retrospective at the Whitney Museum of American Art, which was shown in several cities in the USA. In 1980/81 the Arts Council organized a retrospective exhibition for a tour of Great Britain.

BIBLIOGRAPHY

Includes mainly recent, general publications with extensive bibliography:
Acid, Neue amerikanische Szene, eds. R.D. Brinkmann and R.R. Rygulla, Darmstadt 1969. *Alloway, Lawrence:* American Pop Art, New York 1974 (bibliography). *Amaya, Mario:* Pop as Art, A Survey of the New Super Realism, London 1965. *American Pop Art,* Stedelijk Museum, Amsterdam 1964. *Boorstin, Daniel J.:* Das Image oder was wurde aus dem amerikanischen Traum, Hamburg 1964. *Compton, Michael:* Pop Art, London, New York, Sydney, Toronto 1970. *Dienst, Rolf Günter:* Pop Art, Eine kritische Information, Wiesbaden 1965. *documenta IV,* Vol. 1 and 2, Kassel 1968. Englische Kunst im 20. Jahrhundert, ed. Susan Compton, Munich 1987. *Foner, Philip S., Reinhard Schultz:* Das andere Amerika, Geschichte, Kunst und Kultur der amerikanischen Arbeiterbewegung, Berlin 1983. *Geldzahler, Henry:* Pop Art, 1955-70, International Cultural Corporation of Australia, 1985. *Haskell, Barbara:* Blam! The Explosion of Pop, Minimalism and Performance, 1958-1964, W.W. Norton in cooperation with the Whitney Museum of American Art, New York 1984. *Hermand, Jost:* Pop International, Eine kritische Analyse, Frankfurt/M. 1971. *Jacob, Jürgen:* Die Entwicklung der Pop Art in England ... von ihren Anfängen bis 1957, Frankfurt/M., Berne, New York 1986 (bibliography). *Kaprow, Allan:* Assemblage, Environments and Happenings, New York 1966. *Kerber, Bernhard:* Amerikanische Kunst seit 1945, ihre theoretischen Grundlagen, Stuttgart 1971. *Klüver, Billy:* The Factualist, America Discovered, ed. A. Schwarz, Milan n.d. *Lippard, Lucy R.:* Pop Art, London 1966, Munich-Zurich 1968, London 1985. *McLuhan, Marshall:* Die magischen Kanäle, Understanding Media, Düsseldorf, Vienna 1968. *Mixed Media and Pop Art,* Albright-Knox Art Gallery, Buffalo N.Y. 1963. *Neue Realisten und Pop Art,* catalogue by Werner Hofmann, Akademie der Künste, Berlin 1964. *Rose, Barbara:* Amerikas Weg zur modernen Kunst, Von der Mülltonnenschule zur Minimal Art, Cologne 1969 (1967). *Pop Art in England, Anfänge einer neuen Figuration 1947-63,* ed. Uwe M. Schneede, Kunstverein Hamburg 1976. *Pop Art U.S.A. – U.K. American and British Artists of the '60s in the '80s,* eds. Lawrence Alloway, Marco Livingstone, Tokyo 1987. *Realität/Realismus/Realität,* Von der Heydt-Museum, Wuppertal 1972. *Russel, John and Suzi Gablik:* Pop Art Redefined, New York, Washington D.C. 1969. *Sandler, Irving:* American Art of the 1960s, New York 1988 (bibliography). *Stich, Sidra:* Made in USA. An Americanization in Modern Art. The '50s & 60s, Berkeley, Los Angeles, London 1987 (bibliography). *Taylor, Joshua Charles:* America As Art, New York 1976.

WORKS ON SPECIFIC ARTISTS:

Richard Artschwagger, Kunsthalle Basle 1985 (bibliography). *Peter Blake,* Tate Gallery, London and Kestner-Gesellschaft, Hanover 1978 (bibliography). *Christo, Projekte in der Stadt 1961-1981,* Museum Ludwig, Cologne 1981 (bibliography). *D'Arcangelo, Allan:* Paintings, 1963-70, Institute of Contemporary Art, Philadelphia 1971. *Shapiro, David:* Jim Dine, New York 1981. *Red Grooms, Retrospective, 1956-1984,* Pennsylvania Academy of Fine Arts, Philadelphia. *Richard Hamilton, Collected Works 1953-1982,* Stuttgart 1982. *Richard Hamilton,* The Tate Gallery, London 1970. *David Hockney, A Retrospective,* eds. Maurice Tuchman and Stephanie Brown, Los Angeles County Museum of Art, 1988 (bibliography). *Echo and Allusion in the Art of Jasper Johns,* Los Angeles 1987. *Jasper Johns,* Kunsthalle Cologne 1978. *Allen Jones. Retrospective of Paintings 1957-78,* Walker Art Gallery, Liverpool, Staatliche Kunsthalle Baden-Baden 1979 (bibliography). *Wilson, William S.:* Ray Johnson, New York 1977. *Howard Kanovitz, Arbeiten 1951-1978,* Akademie der Künste, Berlin 1979. *Edward Kienholz 1960-1970,* Kunsthalle Düsseldorf 1970. *Alloway, Lawrence:* Roy Lichtenstein, New York, Munich, Lucerne 1984 (bibliography). *Rose, Bernice:* Roy Lichtenstein, Die Zeichnungen 1961-1986, The Museum of Modern Art, New York 1987, Schirn Kunsthalle, Frankfurt/M. 1988 (bibliography). *Busche, Ernst A.:* Roy Lichtenstein, Das Frühwerk 1942-1960, Berlin 1988 (bibliography). *R.B. Kitaj,* Kunsthalle Düsseldorf 1982 (bibliography). *Richard Lindner,* Kunsthalle Nuremberg 1987. *Claes Oldenburg,* Städtische Kunsthalle Düsseldorf 1970. *Bruggen, Coosje van:* Claes Oldenburg: Mouse Museum/Ray Gun Wing, Rijksmuseum Kröller-Müller, Otterloh/Museum Ludwig, Cologne 1979. *Konnertz, Winfried:* Eduardo Paolozzi, Cologne 1984. *Retro Vision, Peter Phillips, Paintings 1960-1982,* Walker Art Gallery, Liverpool 1982 (bibliography). *Larry Rivers. Retrospektive Zeichnungen,*
Retrospektive Bilder und Skulpturen, ed. Carl Haenlein, Kestner-Gesellschaft, Hanover 1981 (bibliography). *Robert Rauschenberg,* catalogue by L. Alloway, Washington, Smithsonian Institution, New York, MOMA, San Francisco, Museum of Modern Art 1977 (bibliography). *Robert Rauschenberg (Werke 1950-1980),* Kunsthalle und Kunstverein Düsseldorf, Staatliche Kunsthalle Berlin 1980. *Gerhard Richter, Bilder, Paintings 1962-1985,* ed. Jürgen Harten, Städt. Kunsthalle Düsseldorf, Cologne 1986 (bibliography). *James Rosenquist,* Wallraf-Richartz-Museum, Cologne 1972. *The Works of Edward Ruscha,* New York 1982. *Hunter, Sam:* George Segal, New York 1984. *Richard Smith. Seven Exhibitions 1961-75,* Tate Gallery, London 1975. *Coplans, John:* Wayne Thiebaud, Passadena Art Museum 1968. *Wolf Vostell. Retrospektive, 1958-1974,* Berlin 1974 (bibliography). *Andy Warhol, Retrospektive,* Kynaston Mc Shine, New York 1989, Munich 1989 (bibliography). *Stealingworth, Slim:* Tom Wesselmann, New York 1980.

LIST OF ILLUSTRATIONS

We wish to thank the following institutions and photographers for permission to reproduce the illustrations on the pages mentioned:
Albright-Knox Art Gallery, Buffalo, N.Y.: 32; Thomas Ammann Fine Art Ltd, Zurich: 178, Front cover; Art Gallery of Ontario, Toronto: 143; The Art Institute of Chicago, Chicago: 133, 142; The Arts Council of Great Britain, London: 61, 81, 109; Leo Castelli Gallery, New York: 156; Geoffrey Clements, New York: 57, 105, 131, 134, 147, 159, 164, 199, 201; Badischer Kunstverein, Karlsruhe: 205; Galerie Claude Bernard, Paris: 98, 208; Galerie Bruno Bischofberger, Zurich: 75, 167; Rudolf Burckhardt, New York: 196 (above); Centro de Arte Moderna, Fundação Calouste Gulbenkian, Lisbon: 14, 19, 69; City Art Galleries, Sheffield: 71; County Museum of Art, Los Angeles: 107, 132; Dallas Museum of Art, Dallas: 161; Carmelo Guadagno: 146; Carmelo Guadagno and David Heald: 113, 210; Anne Gold, Aachen: 18; Goodman: 30; The Solomon R. Guggenheim Museum, New York: 113, 148, 153, 197, 210; David Heald: 153, 197; Hirshhorn Museum and Sculpture Garden, Smithsonian Institution, Washington D.C.: 13, 99, 108; Sidney Janis Gallery, New York: 30, 43; Allan Kaprow: 90, 91; Bernd Kirtz, Duisburg: 110; Hamburger Kunsthalle, Hamburg: 77; Kunsthalle Tübingen, Tübingen: 65; Kunstmuseum Basel, Basle: 39; Kunstsammlung Nordrhein-Westfalen, Düsseldorf: 85, 160; Wilhelm-Lehmbruck-Museum, Duisburg: 110; Louisiana Museum, Humlebæk: 152; Marlborough Fine Art Ltd., London: 72; Marlborough Gallery Inc., New York: 87; Robert McKeever: 36; The Minneapolis Institute of Arts, Minneapolis: 86; Moderna Museet, Stockholm: 12, 95; Musée National d'Art Moderne, Centre Georges Pompidou, Paris: 84; Museum Abteiberg, Mönchengladbach: 171, 176; Museum für Moderne Kunst, Frankfurt/M.: 40, 60, 198, 200; Museum moderner Kunst, Vienna: 175; Museum Ludwig, Cologne: 21, 22/23, 24, 26, 29, 34, 37, 38, 47, 76, 78, 82, 100, 102, 103, 111, 114, 116, 117, 118, 119, 120, 127, 139, 144, 151, 173, 182, 187, 202, 204, 214, 216/217, 224/225; The Museum of Contemporary Art, Los Angeles: 28, 33; Collection, The Museum of Modern Art, New York: 10, 89, 96, 101, 135; Museum van Heedendaagse Kunst, Ghent: 74; Ann Münchow, Aachen: 16, 48, 49, 116, 122, 137; National Galleries of Scotland, Edinburgh: 138; Neue Galerie – Sammlung Ludwig, Aachen: 15, 16, 18, 20, 41, 48, 49, 104, 116, 121, 122, 137, 155, 158, 162/163, 166, 180/181, 186, 192, 195, 215, 227; Larry Ostrom: 143; Michael Pauseback, Cologne: 230 (right), 236 (left); Plastic Products Inc.: 161; Prudence Cuming Associates Ltd., London: 56; Galerie Thaddaeus Ropac, Salzburg: 51, 128; Rheinisches Bildarchiv, Köln: 22/23; Saatchi Collection, London: 55, 56, 97, 170; Sammlung Tom Eliasson, Stockholm: 27; Sammlung J.W. Fröhlich, Stuttgart: 124, 125, 177; Steven Sloman: 106; Sonnabend Gallery, New York: 35, 149; Soskine: 98; Squidds & Nunns, Los Angeles: 28, 33; Staatsgalerie Stuttgart, Stuttgart: 169; Lee Stalsworth: 99; Stedelijk Museum, Amsterdam: 54, 59, 123, 140, 165; Stedelijk van Abbe Museum, Eindhoven: 94; Tate Gallery, London: 52, 62, 67, 206, 207, 212, 213, 218, 221, 223; John Tennant: 108; Jerry Thompson: 112, 199; Thyssen-Bornemisza Foundation, Lugano, Switzerland: 209; VAGA, New York: 36, 45, 50, 53, 58, 92, 93, 183; Waddington Galleries Ltd., London: 70, 73, 79, 197, 203; Walker Art Center, Minneapolis: 25; Elke Walford, Hamburg: 77; Collection of Whitney Museum of American Art, New York: 31, 57, 105, 106, 112, 131, 134, 147, 159, 164, 199, 201; John Webb: 109; Wim Cox, Cologne: 236 (right).

Photographs not listed above are from the archives of the publisher and author.